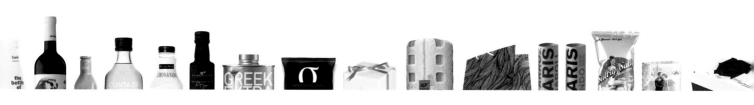

!

PACK! PACK!

Copyright © 2010 INSTITUTO MONSA DE EDICIONES

Editor, concept, and project director
Josep Maria Minguet

Co-Author
Miquel Abellán

Art director, design, and layout
Miquel Abellán, and Anna Jordà

Translation
Babyl Traducciones

INSTITUTO MONSA DE EDICIONES
Gravina, 43 (08930)
Sant Adrià del Besòs
Barcelona
Tel. +34 93 381 00 50
Fax +34 93 381 00 93
monsa@monsa.com
www.monsa.com

ISBN 978-84-96823-15-0

DL B-11262-2010
Printed by GRABASA

pack! pack!

monsa

pack! pack! index

pack! pack! index

pack! pack! pack! pack! pack! pack! pack! pack! pack! pack! pack! pack! pack! pack! pack! pack!

Practically everything has or requires some form of
packaging whether in the form of paper, cartons or plastic.
Nature itself has a tendency to protect every natural
element with some form of covering, with a shell or skin.
The purpose behind the packaging, aside that is from
containing, categorizing and protecting products, is to
speak of the contents. In many cases the product itself is
expressed through the packaging and extends beyond the
pack for the consumer to see.
On other occasions the packaging amounts to a tempting
container of intriguing mysteries which stimulate and
awaken desires and sensations.

Packaging is a complete form of expression.

Packaging is used to develop brand name recognition, to
create loyalty and confidence. Packaging is, above all, a
visual presentation providing information on the contents
and their philosophy.
The consumer's interest must be stimulated and for this
reason there are many different arts, implicit or otherwise,
used to generate the image of a pack by way of different
visual codes.

Packaging is a highly influential and strategic Marketing
resource.

By using the right paper, carton, bottle or covering with
the most detailed finishing touches, each and every
product is sure to achieve the perfect look to put their
message across.

Pack! Pack! is a superb selection with a wide range of
innovative packaging ideas on an international level.

Anna Jordà & Miquel Abellán

Prácticamente todos los objetos tienen o necesitan un envase, un papel, una caja, un plástico. La propia naturaleza tiene tendencia a proteger cada elemento con un revestimiento, con una cáscara o una piel.

La función del envase es, además de contener, organizar y proteger, la de hablar de su contenido. Así, muchas veces el propio producto traspasa las paredes del envase para mostrarse ante el consumidor expresandose a través de su envoltorio.

Otras veces, el envase es un contenedor de intrigantes misterios que tienta al espectador, que inquieta y despierta deseos y sensaciones.

El packaging es todo un mundo de expresión.

A través de él se construye posicionamiento de marca, se crea fidelidad o confianza. Un envase es sobretodo, una tarjeta de presentación visual que ofrece información sobre el contenido y su filosofía.

Muchas son las artes, implícitas o no, que generan la imagen de un pack mediante diferentes códigos visuales; es necesario provocar emociones al consumidor.

El Packaging es un potente recurso estrátegico para el Marketing.

A través de un papel, un cartón, una botella, un barniz, perfilando hasta el último detalle, cada producto debe conseguir el traje perfecto con el que comunicarse.

Pack! Pack! es una exquisita selección con un amplio espectro de tendencias de packaging innovadoras a nivel internacional.

Anna Jordà & Miquel Abellán

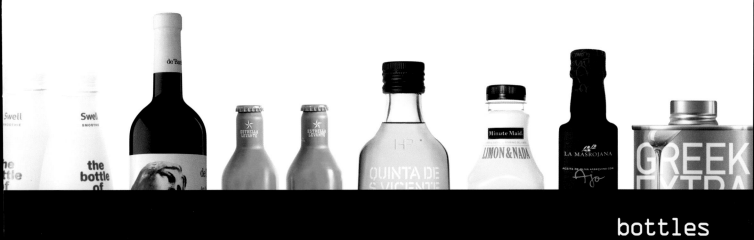

bottles

Hugo Boss

client ⌐ Hugo Boss fragrances
studio ⌐ Karim Rashid.Inc
New York ⌐ USA
designer ⌐ Karim Rashid
www.karimrashid.com

La fragancia HUGO Man ha dado un gran paso adelante en el diseño de envases. El diseñador Karim Rashid crea un frasco exclusivo de edición limitada para la fragancia HUGO Man, basado en el patrón de un fluido topográfico digital.

Inspirado por la fluidez de la fragancia, el frasco y el envase están adornados con unos efectos gráficos digitales que representan un terreno rocoso y una topografía fluyente. El frasco se encuentra en un moderno envase esférico elaborado en plástico ABS inyectado.

Con tan solo 1.000 frascos numerados, la exclusiva edición limitada de HUGO Man es uno de los "objetos de deseo" más codiciados y exclusivos.

HUGO Man fragrance takes package design to the next level. Designer Karim Rashid creates an Exclusive Limited Edition bottle for the HUGO Man fragrance inspired by a fluid digital topographic pattern.

Inspired by the fluidity of the fragrance, the bottle and packaging are adorned with unique digital data-fluid graphic effects signifying a rocky terrain and a flowing topography. The bottle is encased in an avant garde spherical package which is made of injected ABS plastic.

With just 1.000 numbered bottles, the HUGO Man Exclusive Limited Edition is set to be one of the most coveted and exclusive "objects of desire".

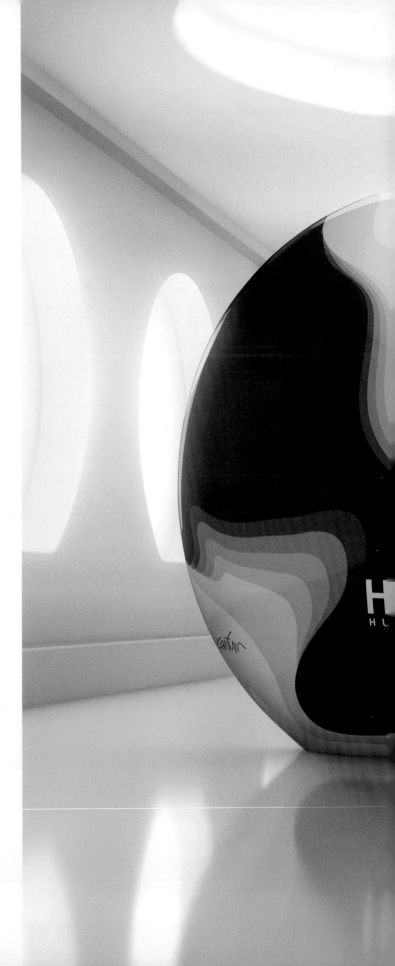

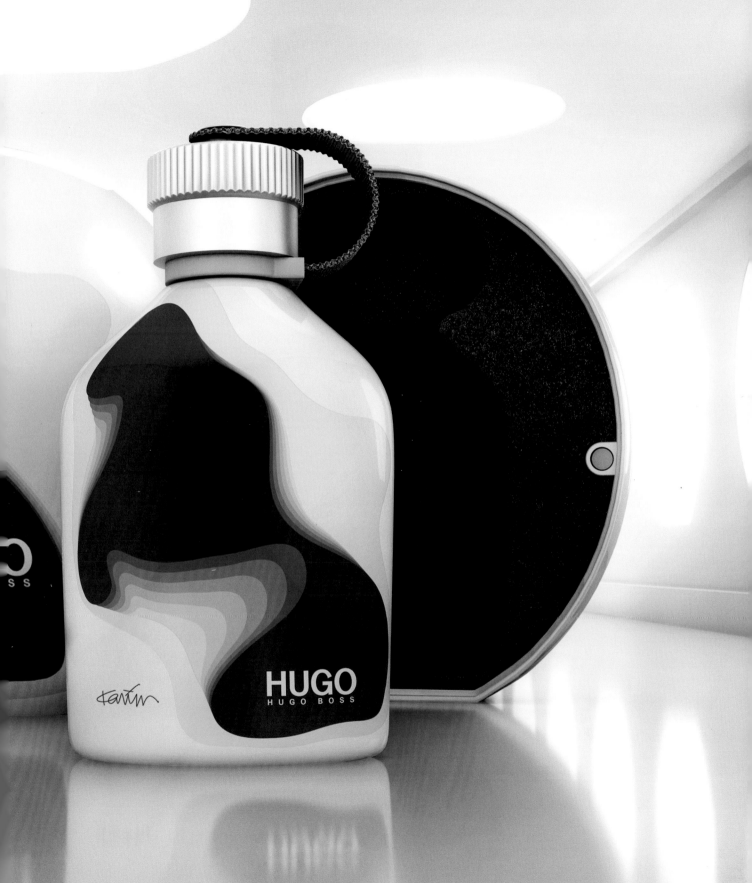

Domaine de Canton

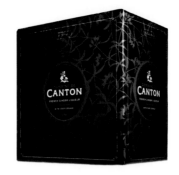

≫≪ p.84

client ⌐ **Domaine de Canton**
studio ⌐ **Mucca Design**
New York ⌐ **USA**
creative director ⌐ **Matteo Bologna**
art director ⌐ **Andrea Brown**
designers ⌐ **Andrea Brown, Ariana Dilibero**
www.muccadesign.com

Domaine de Canton es un licor de jengibre con
coñac francés inspirado en el espíritu exótico de la
Indochina francesa. Nuestro cliente quería que el
envase expresara la combinación única de culturas
de la época colonial, así que diseñamos la etiqueta
con un aire francés de finales de siglo y un estilo de
tipo que contrastara con la apariencia asiática de la
botella. El resto de materiales mantiene la fuerte
sensación de tradición y sofisticación con una paleta
de color de negro sobre negro, unos diseños sutiles y
una tipografía histórica.

Domaine de Canton is a premium ginger liqueur
with French cognac that was inspired by the exotic
spirit of French Indochina. Our client wanted the
packaging to express the unique combination of
cultures from the colonial era, so we designed the
label with a turn-of-the-century French sensibility
and type style to contrast the Asian look of the
bottle. The rest of the materials maintain this rich
sense of tradition and sophistication with a
black-on-black color palette, subtle patterns and
historical typography.

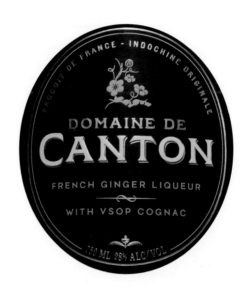

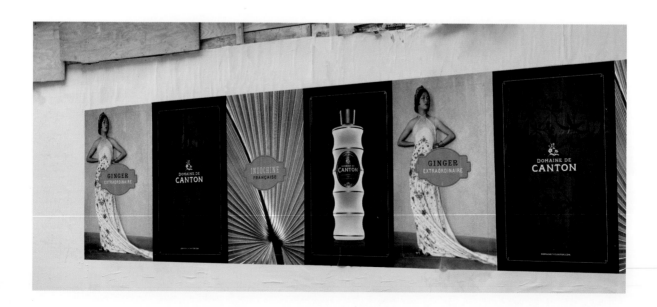

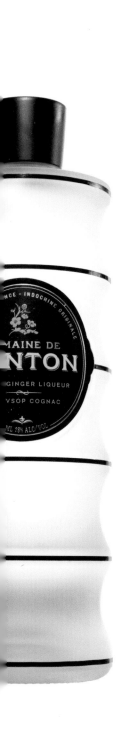
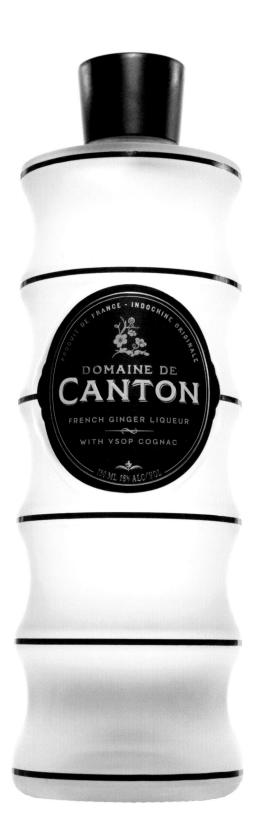

client ¬ **Carchelo**
studio ¬ **Eduardo del Fraile**
Murcia ¬ **Spain**
www.eduardodelfraile.com

Carchelo fué una de las bodegas pioneras en los vinos de Jumilla, España.
La bodega esta generando nuevos vinos muy cuidados y actualmente exporta gran parte de su producción.
El encargo pedía distinguir claramente las botellas para evitar errores a la hora de diferenciar los vinos en las distribuidoras y de cara al cliente.
Cada inicial de la gama se personaliza con una ilustración que representa las cualidades de la variedad.

Carchelo, one of the leading wineries in Jumilla, Spain, is currently producing some superb new wines, a good deal of which is actually exported.
The task was to ensure the bottles were clearly distinguished to avoid mistakes being made when it came to identifying the wines at the distributors and with a view to the customer.
Every initial in the range features its very own illustration depicting the qualities of that particular variety.

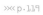
≫≪ p.119

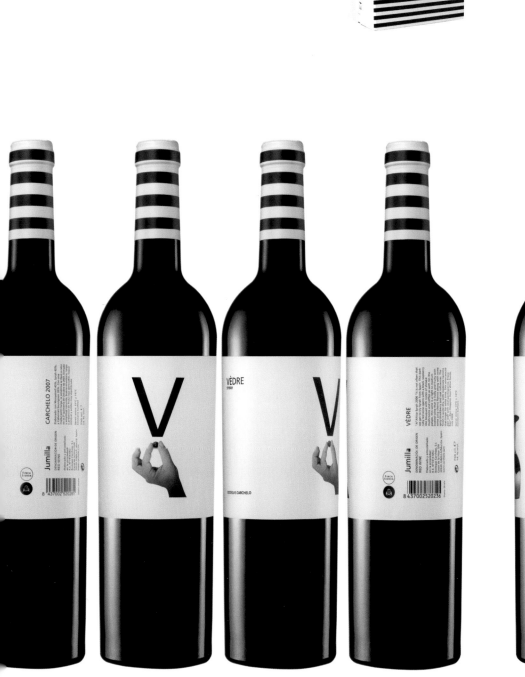

Quinta de S.Vicente

client ⌐ Herdeiros Passanha
studio ⌐ BaseDesign
product designer ⌐ Michael Young
www.basedesign.com

En 2008, los hermanos Passanha reactivan la fábrica
de aceite de la familia, fabricante desde el s. XVIII, con
el fin de obtener "el mejor aceite de oliva de Portugal".

Se creó el nombre de la marca (Herdeiros Passanha)
y del producto (Quinta de Sao Vicente), vinculándolo
a su lugar de producción, armonizando tradición y
modernidad. El logo icónico: una gota de aceite,
evoca pureza y esencia.
La tipografía Stencil contemporánea, aplicada en el
logo, botella y textos.
La botella diferenciadora y práctica refleja e integra
el logo, una botella con dos partes desiguales para
evocar el concepto de presión y enfatizar el color
del aceite.

In 2008, the Passanha brothers revived the family's
oil factory, originally producers since the 18th
century, with the objective of producing
"Portugal's finest olive oil".

The newly created brand name (Herdeiros
Passanha) and the name of the product (Quinta
de Sao Vicente) were linked to the production
location, a balance between modern and
traditional. The iconic logo: a drop of oil evokes
purity and essence.
The contemporary Stencil typography applied to
the logo, the bottle and the texts.
The practical and distinctive bottle incorporates
and reflects the logo, a bottle with two different
parts designed to reflect the concept of pressing
and to highlight the colour of the oil.

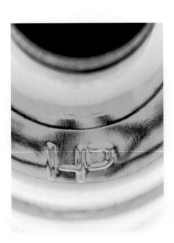

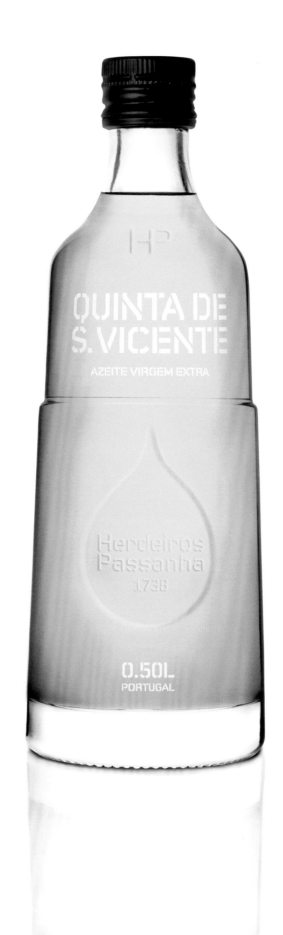

QUINTA DE
S. VICENTE

AZEITE VIRGEM EXTRA

Herdeiros
Passanha
1738

0.50L
PORTUGAL

Jaqk Cellars Wine

>>< p.82

client ¬ Jaqk Cellars
studio ¬ Hatch Design
San Francisco, Ca. ¬ USA
art director ¬ Katie Jain & Joel Templin
designer ¬ Katie Jain, Joel Templin, Ryan Meis, Eszter T. Clark
illustrator ¬ Paul Hoffman, Eszter T. Clark, Ryan Meis
www.hatchsf.com

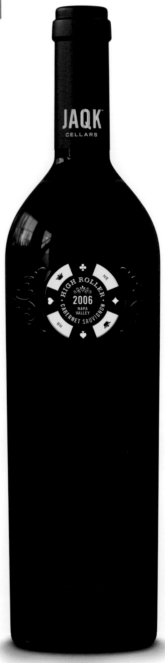

JAQK Cellars es el resultado de la juguetona colaboración entre los fundadores de Hatch Design y un conocido vinicultor de Napa Valley. Jack Cellars recibe su nombre en honor a la sota (Jack) de la baraja de cartas, ya que es una nueva empresa que se dedica a "jugar". Los nombres y diseños de los 8 vinos de la oferta inaugural evocan el encanto y la sofisticación del mundo del juego: High Roller, Soldiers of Fortune (las sotas), Black Clover (tréboles), Pearl Handle (la pistola derringer que domaba los salones de juego), 22 Black (ruleta), Bone Dance (dados), Her Majesty (la Reina), y Charmed (cuanta más suerte mejor).

JAQK Cellars is the offspring of a playful collaboration between Hatch Design founders and a renowned Napa Valley winemaker. Named after the Jack, Ace, Queen, and King in the deck of cards, JAQK Cellars is a new company dedicated to "play". The names and designs of all 8 wines in the innagural offering evoke the allure and sophistication of the world of gaming: High Roller, Soldiers of Fortune (the Jacks), Black Clover (clubs), Pearl Handle (the derringer that tamed the gambling saloons), 22 Black (roulette), Bone Dance (dice), Her Majesty (the Queen), and Charmed (the luckier the better).

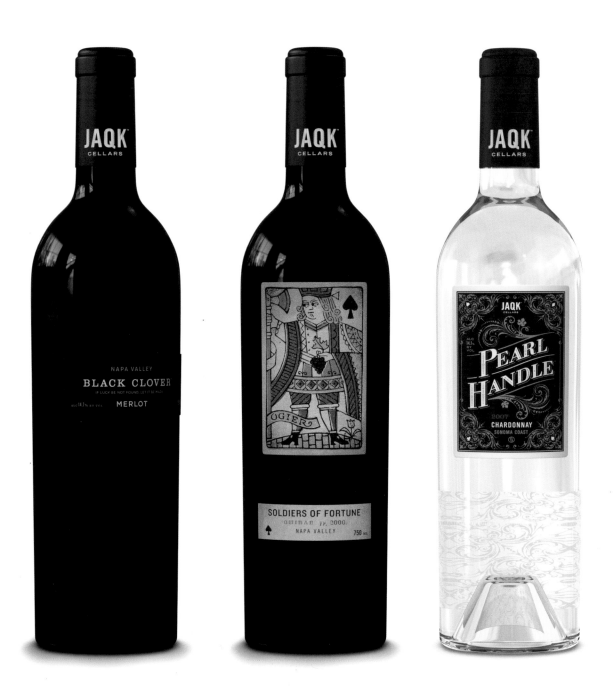

Kraftstoff (Powerfuel)

client ﹁ The Deli Garage
studio ﹁ KOREFE / Kolle Rebbe From und Entwicklung
Hamburg ﹁ Germany
creative director ﹁ Katrin Oeding
art director ﹁ Reginald Wagner
copywriter ﹁ Katharina Trumbach
graphic ﹁ Jan Simmerl
illustrator ﹁ Heiko Windisch
www.korefe.de

"Powerfuel" es un vodka con sabor a melón y menta, jengibre y cilantro y espreso. Envasado en unas cómodas petacas de bolsillo cuidadosamente ilustradas, caben en cualquier mono de trabajo. Cuando mejor saben es al salir del trabajo.

"Powerfuel" is a vodka with the inconvenient tastes of melon and mint, ginger and coriander and espresso. Filled in handy, lovingly illustrasted pocket flasks, they fit in every boilersuit and taste the best right after knock off.

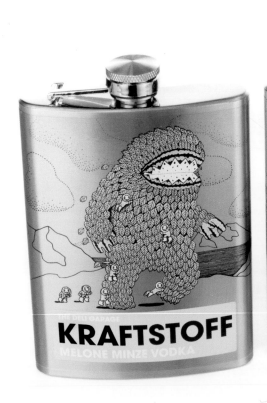

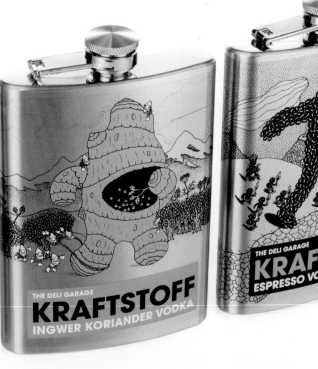

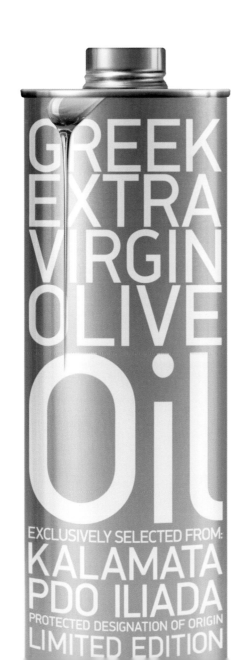

client ⌐ **Agrovim**
studio ⌐ Mouse Graphics
Athens ⌐ Greece
creative director ⌐ Gregory Tsaknakis
designer ⌐ Vassiliki Argyropoulou
www.mousegraphics.gr

El encargo para el diseño del envase de este aceite de oliva, que intenta captar a un público internacional de clase alta, se podría definir en prácticamente dos palabras clave: primera calidad y diferenciación visual. En un espacio en góndola atiborrado, donde todos los productos luchan por convencer mostrando visualmente lo obvio, este envase se aleja a propósito de los símbolos tradicionales de la calidad del aceite de oliva o de los clichés de procedencia.
Este diseño de packaging se dirige a la mente; la estética es la principal razón para comprarlo. Una gota de aceite muy realista en la lata es lo único que lo retiene en la sección de comida de los supermercado; si algún día hubiera que añadir un eslogan, éste sería "simplemente aceite".

Based on a brief that essentially could be distilled in two key words – Premium Quality & Visual differentiation – this olive oil packaging targets an international high-end audience. In an otherwise crowded shelf space were all fight to convince by visually stating the obvious, this packaging is deliberately moving away from traditional symbols of olive oil quality or clichés of provenance. This pack design targets the mind; aesthetics is the real reason to buy. Almost as an afterthought, a very realistic-looking drop of oil on the tin is what keeps it grounded into the food section of a super market; if ever there was a slogan attached to it, then this would read "simply oil".

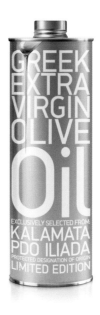

Punt i apart

client ⌐ La Vinyeta
designer ⌐ Lluís Serra Pla
Girona ⌐ Spain
illustration ⌐ Marta Altés (Punt i apart 07)
www.elhombredelalata.com

Como si se tratara de un zoótropo, la botella gira sin parar y muestra una secuencia interminable. Como el vino que ha calentado las barricas de roble y que en la botella continúa un largo proceso, la botella busca el punto ideal para dar lo máximo de sí misma.

As if it was a zootrop, the bottle turns and turns and shows a sequence that never ends. As the wine that has warmed the oak tanks and in the bottle continues a long process, the bottle looks for the ideal point in which to give the maximum of itself.

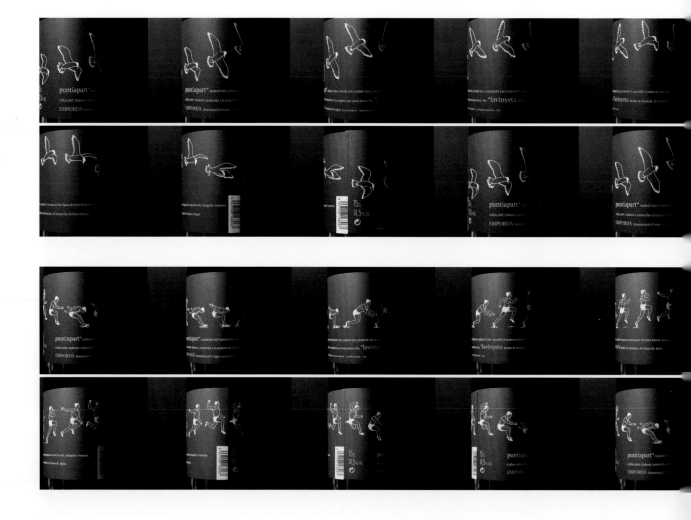

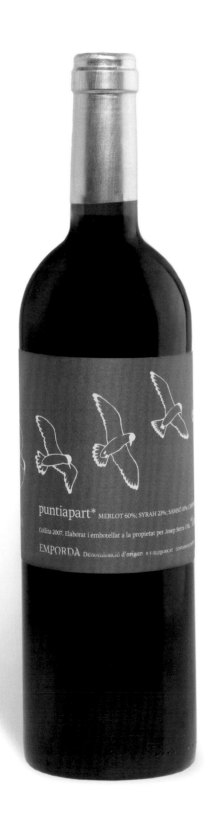

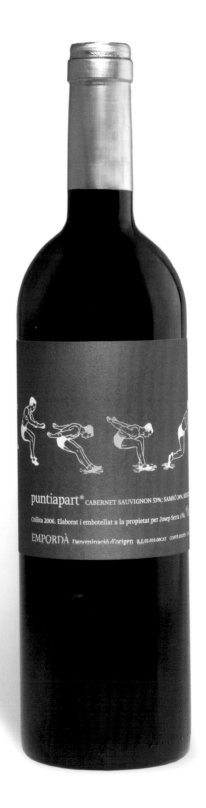

Ecolean

client ꞁ Ecolean
Helsingborg ꞁ Sweden
design ꞁ Ecolean
www.ecolean.com

El envase ligero Ecolean pesa aproximadamente un
50-60% menos que un envase convencional.
El menor uso de materias primas ahorra energía
durante la producción, el transporte y la manipulación
de desechos.
Puedes extraer prácticamente la totalidad del
contenido.
Cuando productos viscosos como el yogur se
venden en envases convencionales de un litro, casi
un decilitro se queda en el envase. Cuando está
vacío, el envase es plano como un sobre.
Su morfología proporciona un diseño innovador.

The lightweight Ecolean package weights
approximately 50-60% less than a conventional.
Less use of raw materials saves energy during
production, transport and waste handling.
You can squeeze out practically 100 % of the
content.
When viscous products like yoghurt are sold
in conventional one litre packages, nearly one
deciliterstays in the package. Once empty,
package is flat as an envelope.
Their morphology provides an innovative design.

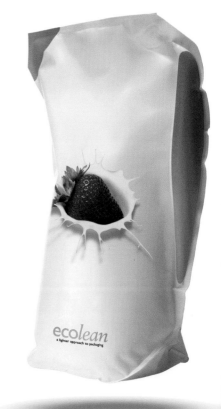

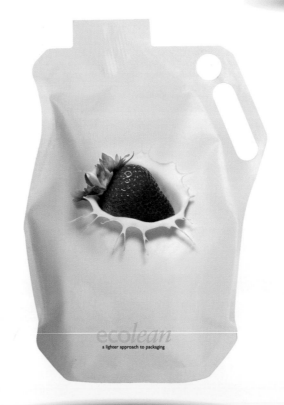

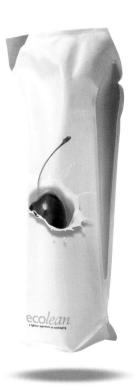

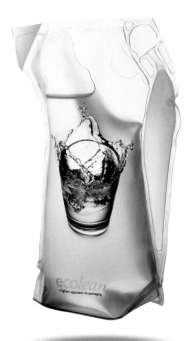

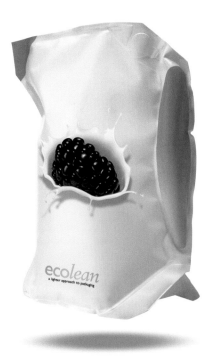

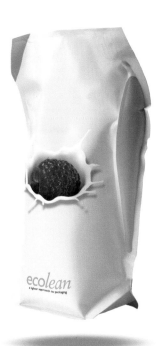

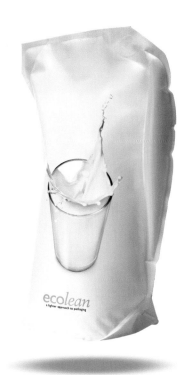

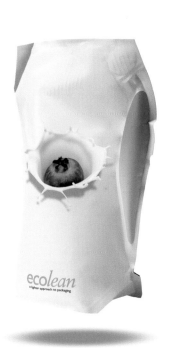

Raimonda

client ┐ Bodegas Torelló
studio ┐ Enric Aguilera Asociados
Barcelona ┐ Spain
art director ┐ Enric Aguilera
designer ┐ Mercè Fernández
www.enricaguilera.com

Este tinto Reserva de Torelló rinde homenaje a la "pubilla Raimonda" que vivió los orígenes de esta bodega.
Diseño de etiqueta singular para un vino de calidad con nombre de mujer.

Reserva de Torelló, is a vintage red wine which pays tribute to "Pubilla Raimonda" who lived at the start of this winery.
An unusually designed label for a fine quality wine bearing the name of a woman.

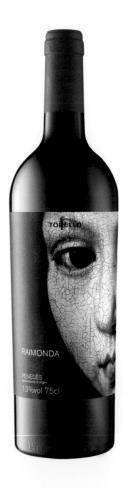

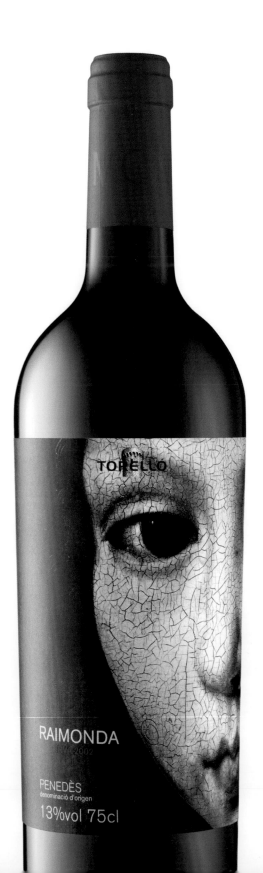

GRB

client ˥ **GRB**
studio ˥ **Erick Fletes**
San Francisco ˥ USA
designer ˥ **Erick Fletes**
www.oherick.com

La intención al crear GRB era introducir un regalo de
edición limitada que se presentaría a un perfil demográfico
con mentalidad de coleccionista.
Las botellas de tapón mecánico se pueden reutilizar después
de su consumo.

The idea behind GRB was to introduce a limited edition
gift that would be presented to a demographic that was
focused on the collectors mindset.
The swing top bottles could be reusable after
consumption for many purposes.

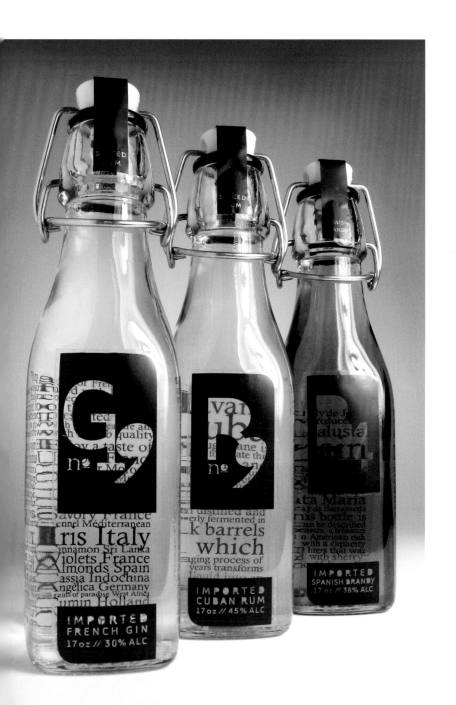

Marlborough Sun

client ᴎ **Malborough Valley Wines Ltd.**
studio ᴎ **The Creative Method**
Sydney ᴎ **Australia**
designer ᴎ **Andi Yanto**
creative director ᴎ **Tony Ibbotson**
art director ᴎ **Tony Ibbotson, Andi Yanto**
typographer ᴎ **Andi Yanto**
www.thecreativemethod.com

El cliente quería crear una nueva serie de etiquetas de vino. Debían incluir la marca, la identidad y el diseño de la etiqueta.
La marca y la etiqueta tenían que aprovechar el reconocimiento de los vinos de Marlborough en todo el mundo.
Las etiquetas debían tener un claro punto de diferenciación respecto a las otras etiquetas, así como destacar en el estante, tener sentido del humor y sobre todo, dar que hablar. Había que intentar que las etiquetas pudieran reinventarse cada año, puesto que todas las variedades de uvas fueron específicamente seleccionadas y había que mostrar las características individuales.

The client wanted to create a new series of wine labels from scratch. This was to include naming, identity and label design.
The name and label needed to take advantage of the high profile of Marlborough wines across the globe.
The range needed to have a clear point of difference from other labels, as well as needing to standout on shelf, have a sense of humour and most importantly, create a talking point. If there was a way that the labels could re-invent themselves each year this would also be an advantage as the grapes were specifically selected for each variety and needed to display individual characteristics.

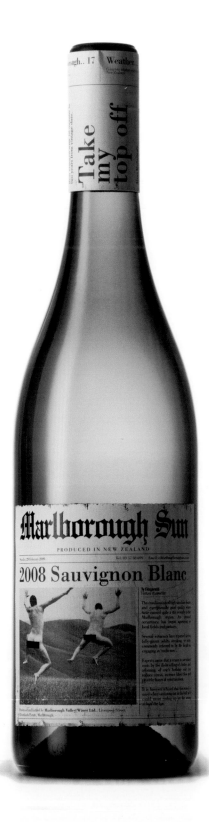

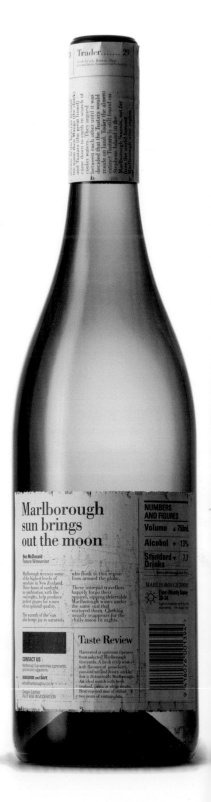

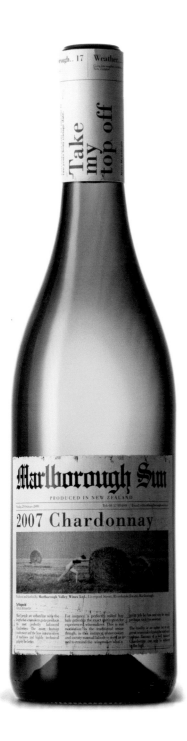

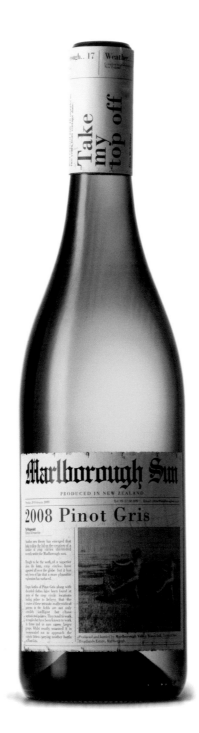

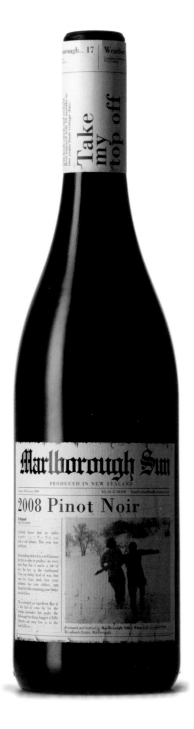

Fuensanta

client ¬ **Aguas de Fuensanta**
studio ¬ **Pati Núñez Associats**
Barcelona ¬ **Spain**
designer ¬ **Pati Núñez**
photographer ¬ **Artur Muñoz**
www.patinunez.com

El encargo constaba de una serie de tres diseños
para estampar sobre botella de cristal de 75 cl.
destinada a clientes de hostelería y tiendas gourmet.
El objetivo es posicionar Fuensanta en el mundo
de las aguas de diseño y llegar a puntos de venta
más chic.
El origen de Fuensanta está asociado a la naturaleza
asturiana y dado que eso es lo que se quería
comunicar, se probó a imitar la acción de la madre
naturaleza, imaginando qué le pasaría a una botella
de agua si se dejase en medio de un paraje frondoso:
la vegetación rodearía la botella.
Este es el primer diseño de la serie, serigrafiado en
tres colores, dos tonos de verde y blanco para la
tipografía.

The mission here consisted of coming up with
three designs to print on 75 cl glass bottles,
specially designed for the hotel and catering
industry and gourmet shops.
The aim was to establish Fuensanta amongst
designer waters and to reach out to more 'chic'
establishments.
The origins of Fuensanta are associated with
Asturian nature and, given that this was what they
wanted to put across, an attempt has been made
to imitate the action of Mother Nature, imagining
what would happen to a bottle of water if it were
left in the midst of a leafy green spot: the vegetation
would wrap itself all around the bottle.
This is the first of what is to be a series of designs,
screen printed in three colours, two shades of
green and white for the typography.

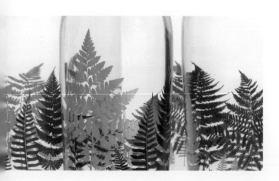

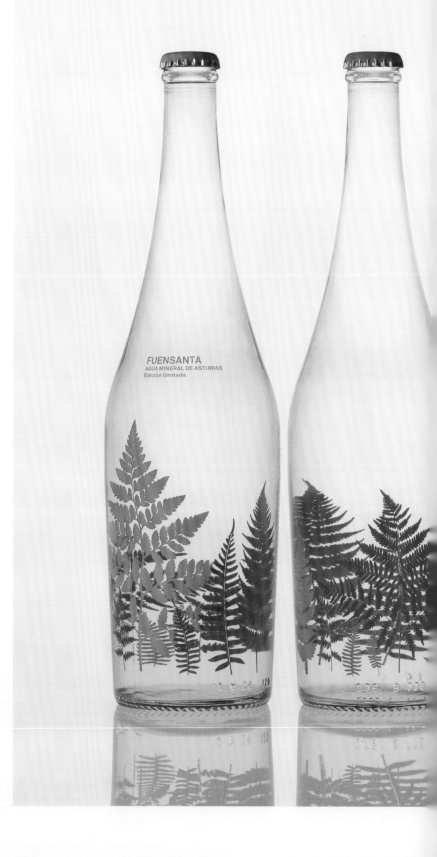

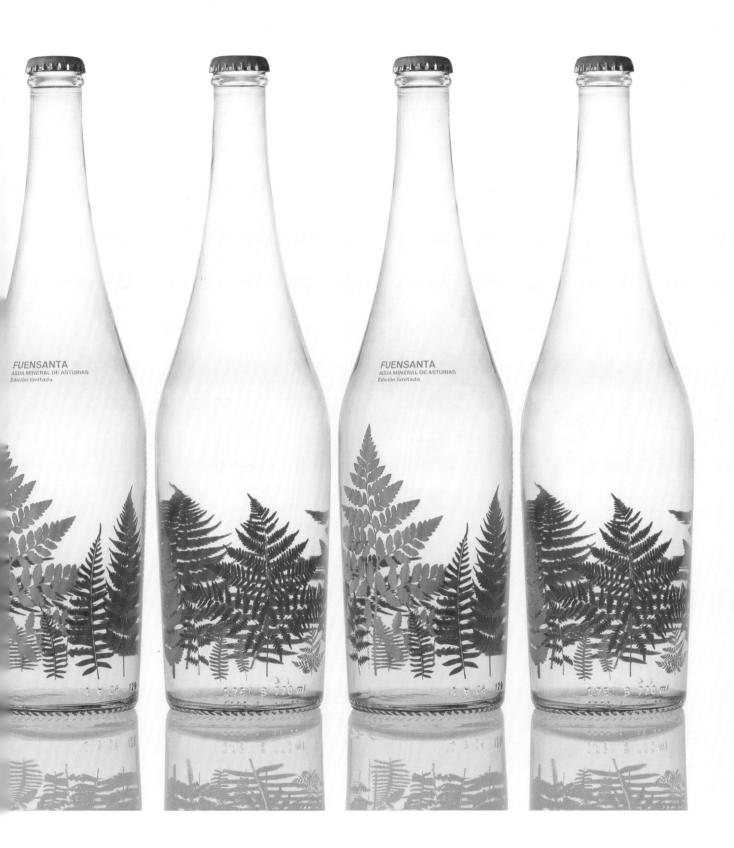

FUENSANTA
AGUA MINERAL DE ASTURIAS
Edición limitada

FUENSANTA
AGUA MINERAL DE ASTURIAS
Edición limitada

Minute Maid

client ⌐ Coca Cola Company
studio ⌐ **Enric Aguilera Asociados**
Barcelona ⌐ Spain
art director ⌐ Enric Aguilera
designer ⌐ Mercè Fernández
www.enricaguilera.com

Diseño de imagen para zumos Minute Maid, aplicación en
el envase de restauración.
Combina el tratamiento de la imagen en b/n y en color.
Valores de tradición y artesanía se funden de forma divertida
y exagerada con la fruta que aporta sabor a estos zumos.

An illustration designed for Minute Maid juices, for use
on catering packs.
The image processing is a combination of b/w and
colour.
Traditional values and craftsmanship are merged in an
amusing and embellished way with the fruits supplying
the flavours for these juices.

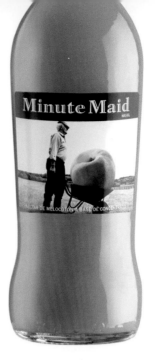

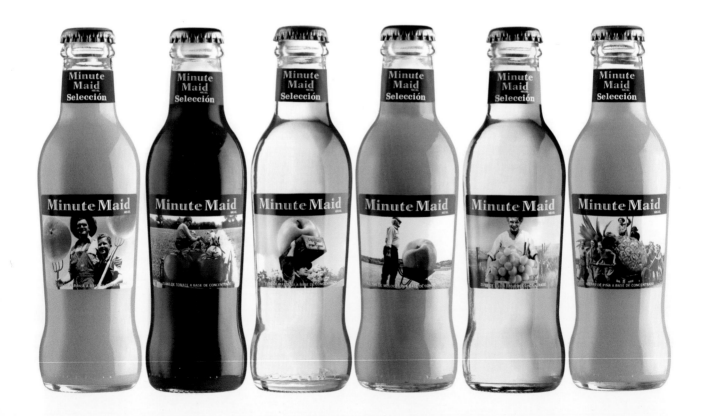

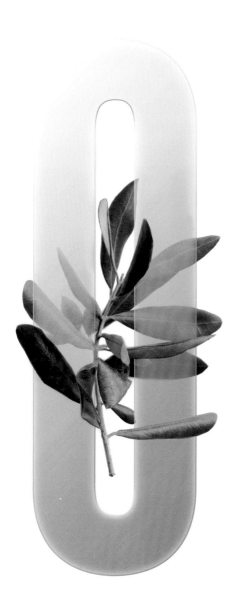

Olynthia

client ꓹ **Olynthia**
studio ꓹ **SVIDesign**
London ꓹ **United Kingdom**
creative director ꓹ **Sasha Vidakovic**
designers ꓹ **Sasha Vidakovic, Sarah Bates**
illustration ꓹ **Sasha Vidakovic**
www.svidesign.com

La creación de una imagen icónica fuerte era fundamental para destacar en el estante del supermercado. La letra O dorada y oleosa abraza suavemente una rama de olivo en una composición que declara visualmente que las fuerzas opuestas siempre están presentes en la producción de aceite de oliva de calidad.

Creation of strong iconic image was essential in order to stand out on a supermarket shelf. Golden and oily letter O embraces gentle olive branch in a composition which a visual statement of contasting forces always present in production of good quality olive oil.

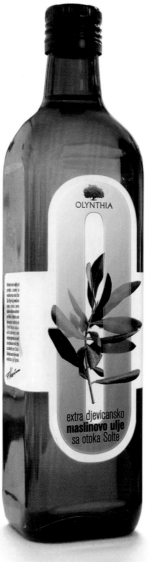

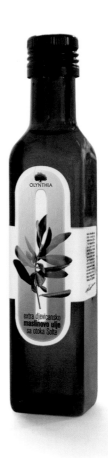

Aceites La Masrojana

client ┐ La Masrojana
studio ┐ ATIPUS, Graphic Design Barcelona
Barcelona ┐ Spain
designer ┐ Javier Suárez, ATIPUS
digital retouching ┐ ATIPUS
www.atipus.com

Estos aceites se producen mediante el prensado conjunto de las aceitunas y los diferentes ingredientes (naranja, limón, ajo...). Así se obtiene un aceite de alta calidad orientado, en el ámbito de los aceites de aliño, a una nueva cultura gastronómica, ofreciendo una experiencia mucho más sibarita y actual.
En estos aceites el aroma no se incorpora como un aroma obtenido químicamente, sino en el mismo proceso mecánico. Y es esta idea del producto, muy físico y de elaboración artesanal, que hizo apostar por mostrarlo como una naturaleza muerta muy pictórica. Corte clásico en cuanto a calidad y proceso, pero con un resultado final sofisticado y novedoso.

These oils are produced by pressing the olives along with the various other ingredients (orange, lemon, garlic...). The result is a first rate oil which focusses, within the field of oil dressings, on a new gastronomic culture, providing a much more sophisticated gourmet experience. In these oils the aroma isn't something which has been chemically added but acquired through the same traditional processes. This highly physical and traditional method of production made me opt for depicting this in the form of a highly picturesque still life. A classic in terms of quality and production processes but with a new and highly sophisticated result.

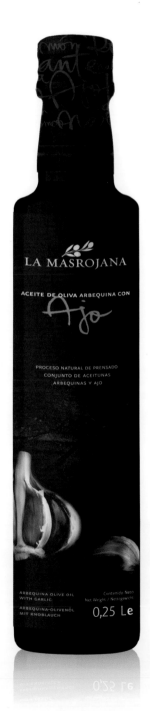 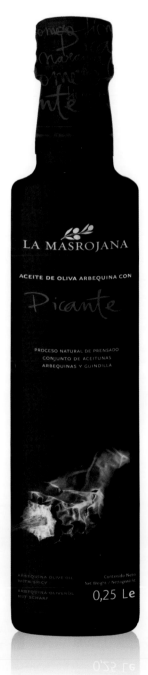 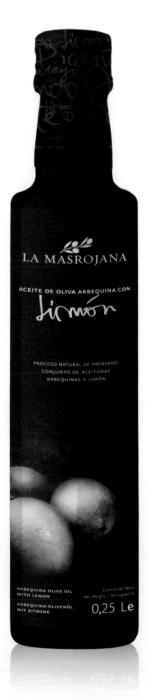

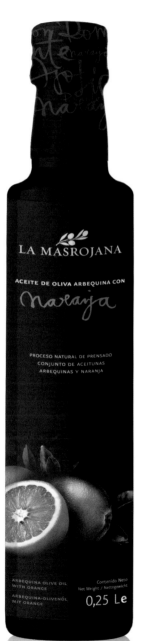

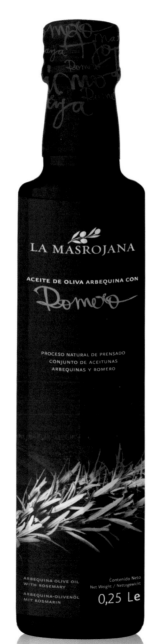

Oli Fosc

client ˥ La Vinyeta
designer ˥ Lluís Serra Pla
Girona ˥ Spain
www.elhombredelalata.com

Oscuro es el nombre de un olivar virgen que durante más de 100 años había sido abandonado y en el que, debido al espesor de la vegetación, no penetraba la luz del sol. El aceite Oscuro, 100% de la variedad autóctona ampurdanesa Argudell, es un aceite puro, extravirgen, que mantiene la esencia del olivar que lo ha visto crecer. El packaging sólo nos remite a sus orígenes. Oscuridad reflejada por tintas oscuras, tipografías de madera y materiales nobles.

A virgin olive grove which has been abandoned for more than 100 years and which, due to the dense vegetation, is devoid of sunlight and can actually be described as dark (oscuro).
Oscuro oil, produced 100% from the local Argudell variety of olives in the area of Emporda, is a pure extra virgin olive oil in which the essence of the olive grove itself has been preserved. The packaging simply puts across the very origins of this oil. Darkness is reflected by dark inks, typographies in wood and noble materials.

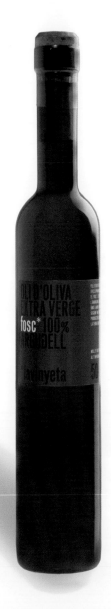

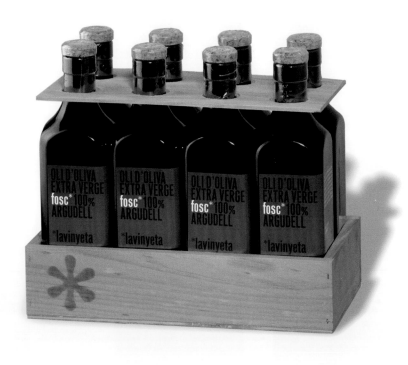

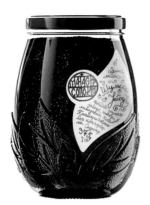

Sopocani 100% Juice

client ˥ Monastery Sopocani
studio ˥ Peter Gregson Studio
Novi Sad ˥ Serbia
art director ˥ Jovan Trkulja
designer ˥ Marijana Zaric
www.petergregson.com

Identidad de marca, de packaging y visual para zumos
artesanales y productos gourmet. Diseñamos un nuevo
isotipo y packaging: botellas para zumos y tarros para los
productos gourmet serbios, elaborados en el monasterio de
Sopocani. Todos los productos son orgánicos y naturales.
La etiqueta está escrita a mano, reafirmando el espíritu de
la marca.

Brand, packaging and visual identity for home made
juices and delectably products. We designed a new
brandmark and packaging, bottles for juices and jars for
serbian delectably products, made in monastery
Sopocani. All products are organic and natural. The label
is handwritten, implementing the spirit of the product.

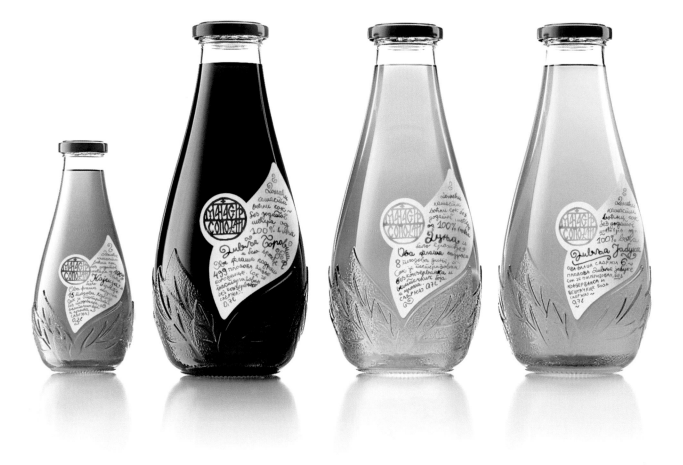

Russian soft drink

client ⌐ **Russian soft drink**
studio ⌐ **Playoff Creative Services**
Moscow ⌐ **Russia**
designer ⌐ Balykin Pavel
www.p-off.ru

Refrescos rusos tradicionales como Buratino, Dushes, Cream
Soda y Tarkhun son algunas de las marcas favoritas de los
rusos. El envase les proporciona una identificación moderna.
La diferenciación de los productos se lleva a cabo a través
de los gráficos y los colores.

Traditional Russian soft drinks Buratino, Dushes, Cream
Soda and Tarkhun – favourite brands of Russians.
Packing has through modern identification.
The differentiation of products is carried out on means
of a graphics and colours.

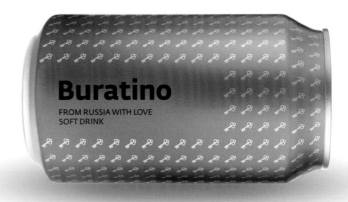

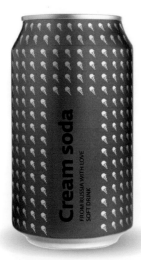 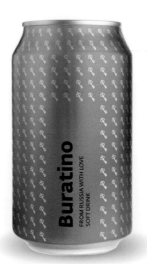 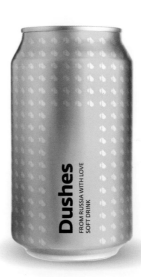 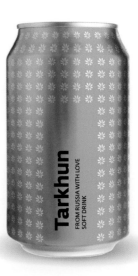

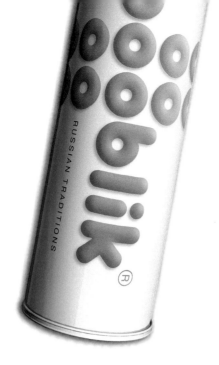

Booblik

client ⌐ **Booblik**
studio ⌐ **Playoff Creative Services**
Moscow ⌐ **Russia**
designer ⌐ **Balykin Pavel**
www.p-off.ru

El envase de Booblik es el envase de un producto de confitería típico ruso. Es una de las exquisiteces más populares y sabrosas, y se asocia al tiempo libre. La sencillez es la idea principal del envase, que tiene una forma y unos gráficos simples.

Booblik pack is a packing of a traditional Russian confectionery product. Idle time, tasty and all a favourite delicacy. Simple is a basic idea of packing. The simple form, the simple graphic.

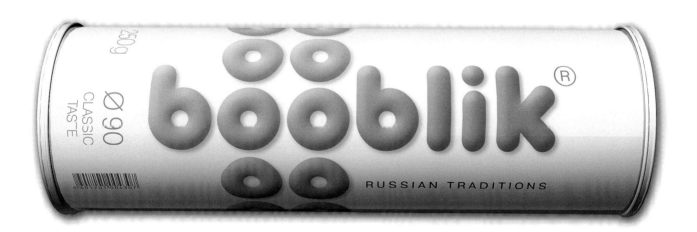

Minute Maid - Vergelia

client ˥ Compañía de servicios de bebidas
refrescantes, S.L.
studio ˥ Batllegroup
Barcelona ˥ Spain
art director ˥ Enric Batlle
photographer ˥ Alexis Taulé
www.batllegroup.com

Vergelia Minute Maid es una nueva creación en la
categoría de zumos. Un diseño simple y fresco.
Los beneficios de las frutas y las verduras se
comunican mediante el uso de la imagen simple.
Unas fotografías sencillas, claras y bien definidas se
combinan con un importante uso del blanco para
transmitir naturalidad. La tipografía desempeña un
papel importante resaltando el concepto de
elaboración artesanal. El resultado final muestra un
surtido de frutas sin utilizar imágenes ya vistas.

Vergelia Minute Maid is a new juice cathegory
construction. A simple and fresh design.
The benefits of vegetables and fruits are
communicated trough the use of image, simple,
clear and clean photografies are combined with
an important use of white transmitting naturality.
Tipography, plays and important role enhanzing
the handmade concept. A final result that shows
a fruit assortment without using "already seen"
images.

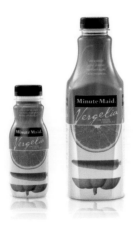
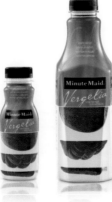
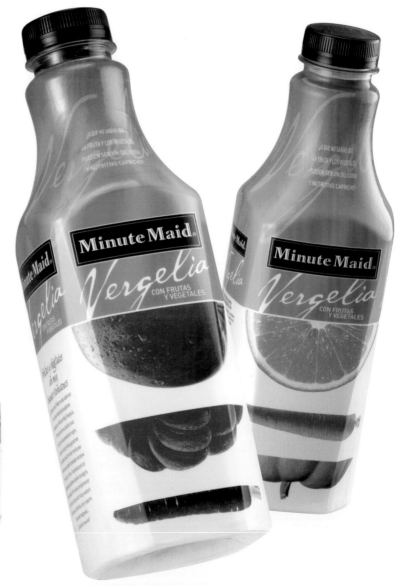

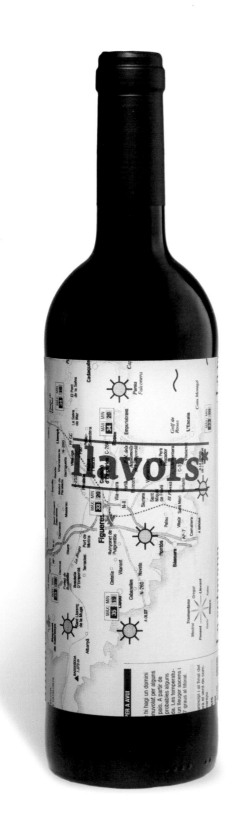

Llavors

client ⌐ La Vinyeta
designer ⌐ Lluís Serra Pla
Girona ⌐ Spain
www.elhombredelalata.com

Buscando un vínculo temporal, el "Llavors" refleja su esencia con una etiqueta que parece un trozo de periódico. El contenido está relacionado con algún momento de la vida del vino. Un evento memorable, un artículo destacado o, como en el del año que fue muy caluroso, un recorte de la previsión meteorológica. De este modo, utilizando la memoria, se realiza un salto temporal que vincula las experiencias personales con las del vino.

Looking for a temporary link, the "Llavors" reflects his essence with a label that seems to be a piece of newspaper. The content is related to some moment of the life of the wine. A memorable event, a prominent article, or —as in that case that the year was so warm— a piece of the wheather forecast. In this way, using the memory, there is a temporary jump that links the personal experiences with those of the wine.

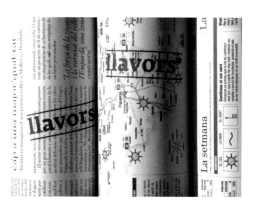

Matsu

>>< p.81

client ⌐ **Vintae**
studio ⌐ **Moruba**
Logroño. La Rioja ⌐ **Spain**
photographers ⌐ Bèla Adler, Salvador Fresneda
www.moruba.es

La solución formal adoptada para la marca y el
packaging de esta bodega ecológica de la DO Toro,
es fiel a la filosofía de Matsu, un moderno proyecto
de viticultura sostenible que reúne una colección
exclusiva de vinos de alta expresión.
Su identidad visual ha sido despojada de todo tipo
de artificios para conectar directamente con la
naturaleza y con las personas que la cuidan día a día.
Así, la trilogía de vinos "El Pícaro", "El Recio" y
"El Viejo" de Matsu está representada por una serie
de retratos a personas de tres generaciones
diferentes que dedican su vida al campo.

La personalidad de cada uno de ellos encarna las
características del vino al que da nombre.

The formal label and packaging solution adopted
for this ecological wine producer from the DO
Toro region is in keeping with the Matsu
philosophy, a modern and sustainable viticulture
project which brings together an exclusive
selection of highly expressive wines.
Visual identity has been stripped of every artificial
aspect in favour of making a direct link with
nature and the people who care for these vines
daily. The set of three Matsu wines, "El Pícaro",
"El Recio" and "El Viejo", are represented by a set of
portraits taken from different generations of
people whose lives were dedicated to the country.

The personalities of these people represent the
qualities of the wines which have been given their
names.

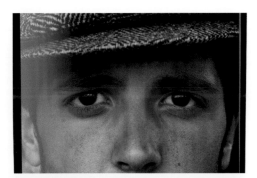

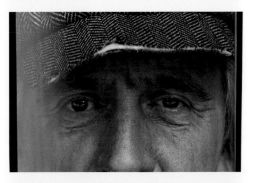

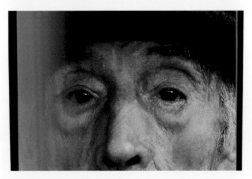

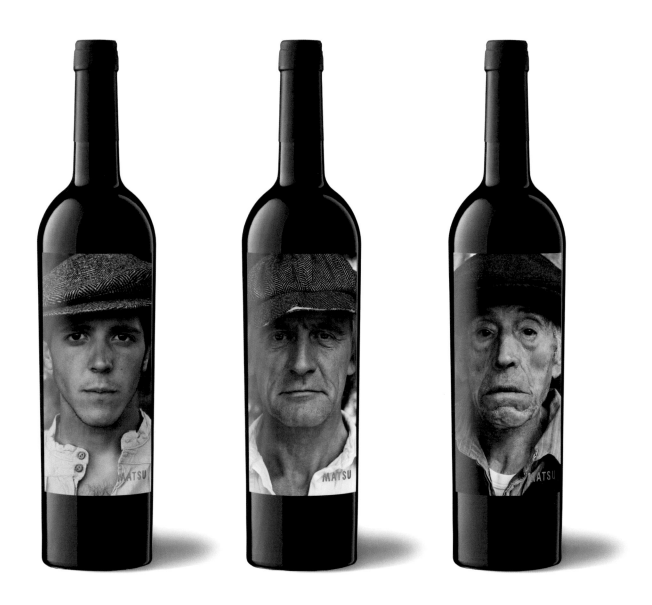

De Bardos

client ˥ Vintae
studio ˥ Moruba
Logroño. La Rioja ˥ Spain
www.moruba.es

De Bardos es un ambicioso proyecto que se sumerge
en la historia y los viñedos de mayor calidad y
singularidad de Ribera del Duero.
Su imagen refleja los valores y personalidad de la
bodega a través de una serie de fotografías de
ángeles con un simbolismo particular. Todo ello
compuesto con gran armonía y delicadeza y con un
especial protagonismo del blanco en todo el
conjunto. En definitiva, un vestido de gala para un
vino de autor destinado a ser una referencia en el
sector.

De Bardos is an ambitious project which has
immersed itself in the history of the finest
vineyards and the wonders of the Ribera del
Duero area.
The winery's values and nature are reflected in the
illustration, effectively a set of photographs of
angels with a particular symbolism. This has all
been composed with a great sense of harmony
and excellent judgment with special importance
given to white throughout the entire composition.
Effectively, full formal dress for a first rate wine
destined to become a point of reference in the
wine industry.

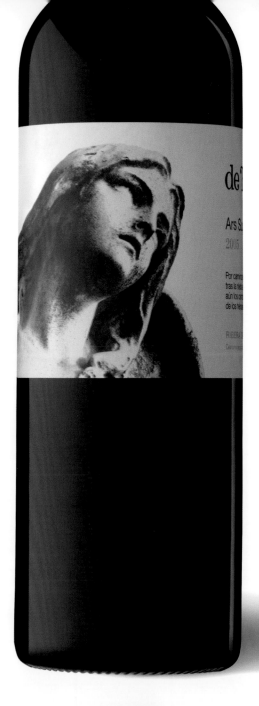

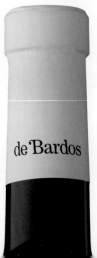

>>< p.81

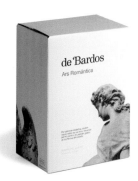

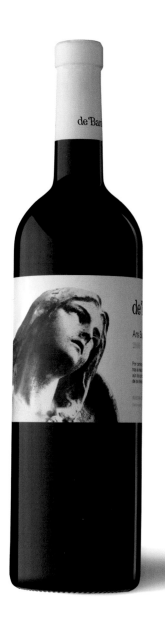

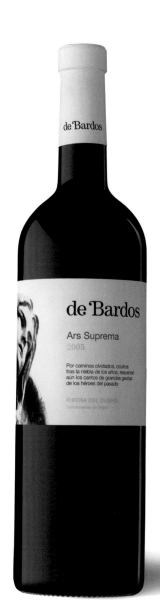

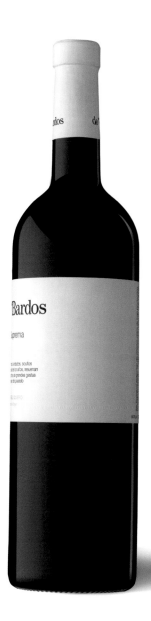

Francis Montesinos

client ⌐ Laboratorios RNB
studio ⌐ Lavernia & Cienfuegos
Valencia ⌐ Spain
www.lavernia.com

Un cilindro de vidrio negro y una envoltura de color fucsia para evocar el mundo creativo de Francis Montesinos en el que se aúnan la tradición y la vanguardia, lo mediterráneo y lo sofisticado.

A black glass cylinder and a fuchsia coloured covering bring to mind the creative world of Francis Montesinos, a world in which tradition is combined with state-of-the-art, the Mediterranean and the sophisticated.

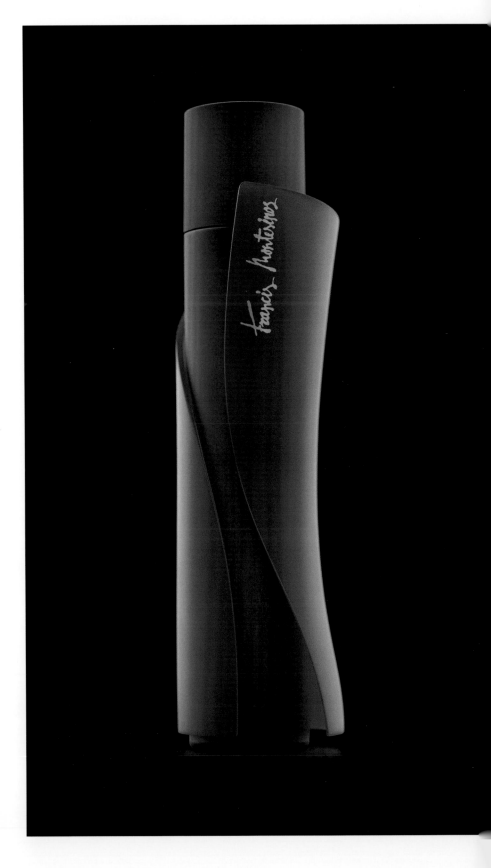

Criterio

client ㄱ **Laboratorios RNB**
studio ㄱ **Lavernia & Cienfuegos**
Valencia ㄱ Spain
www.lavernia.com

CRITERIO es una fragancia para hombres que busca
un producto exclusivo de calidad, pero a un precio
inferior al de los perfumes de lujo.
El frasco hace referencia a la elegancia masculina.
Es un poliedro de cristal transparente cuyos bordes y
planos producen brillos y reflejos, ayudando a crear
una doble sensación de dureza por un lado y de lujo
por el otro.
El envase se resolvió con gráficos que hacen referencia
a la forma con facetas del frasco.

CRITERIO is a fragrance targeted for men searching
for an exclusive product of quality, but at a lower
price than perfumes of luxury range.
The container suggests masculine elegance. It is a
glass transparent polyhedron with edges and
planes producing shines and reflections, helping
to create a double sensation of hardness on one
side and luxury on the other.
The packaging was solved with graphics that
make reference to the faceted shape of the
container.

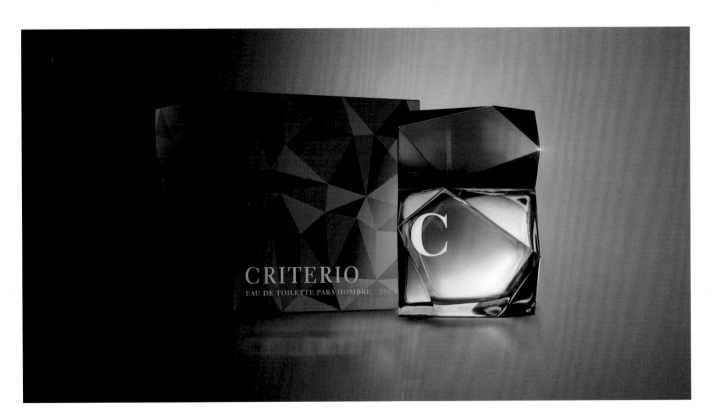

Nau

client ˥ **Naulover**
studio ˥ **Puigdemont Roca design agency**
Barcelona ˥ **Spain**
designer ˥ Albert Puigdemont
www.puigdemontroca.com

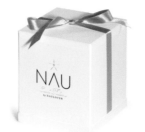

»« p.88

Una nueva fragancia de mujer pensada para transmitir elegancia y prestigio utilizando un frasco de líneas puras y nítidas, con un cristal Swarovski cuyo brillo simboliza el fulgor de la estrella polar, el único punto de orientación de los navegantes de antaño. Todo ello vinculado a la denominación del producto, NAU, que significa "nave".

A new women's fragrance designed to transmit elegance and prestige with a clear and simple glass bottle in Swarovski crystal, a brilliance which symbolises the North Star, the only compass point for navigating sailors in bygone times. All of this is actually linked to the name of the product, NAU, meaning "ship".

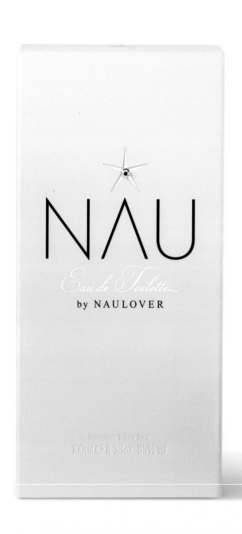

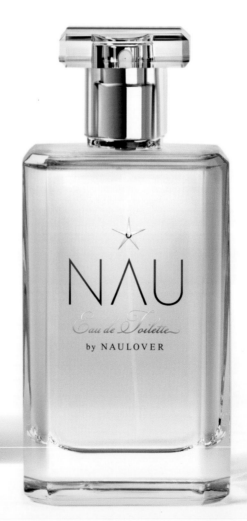

>×< p.118

Mesoestetic Men

client ⌐ Mesoestetic
studio ⌐ Espluga + Associates
Barcelona ⌐ Spain
www.espluga.net

Envase para la línea de Mesoestetic Men. La importancia se da al producto: un aftershave que retrasa el crecimiento del pelo facial, un parche con impulsos eléctricos y una cápsula con un ingrediente activo superconcentrado, etc. Línea gráfica directa y simple. Fondos oscuros, texto blanco. Simple y directo…para hombres.

Packaging for men's mesoestetic line. The relevance is the product itself: a growing hair delay effect aftershave. an electric impulse patch + capsule with an hyperconcentrated active ingredient, etc... Direct and simple graphic line. Dark backgrounds, white text. Simple and direct...for men.

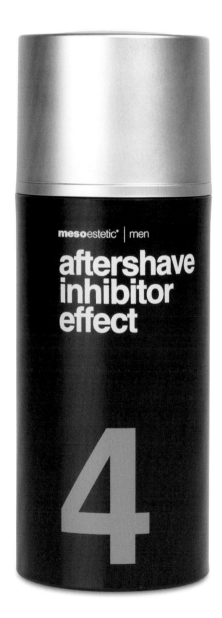

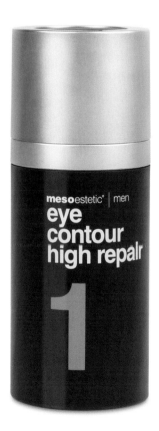

client ⌐ **Davidoff**
studio ⌐ **Karim Rashid.Inc**
New York ⌐ **USA**
designer ⌐ **Karim Rashid**
www.karimrashid.com

Un objeto pequeño y cuadrado que habla de
urbanidad. Las botellas adquieren más importancia
que la fragancia. En resumen, se vende algo
inmaterial que es complejo y abstracto, así que la
botella proporciona una fragancia, una identidad,
una marca y una sensación de interpretación
material.

A small compact square object that speaks of
urbanity. Bottles become more important than
the fragrance. Essentially one is selling something
immaterial that is complex and abstract so the
bottles gives a fragrance, identity, brand, and a
sense of the material interpretation.

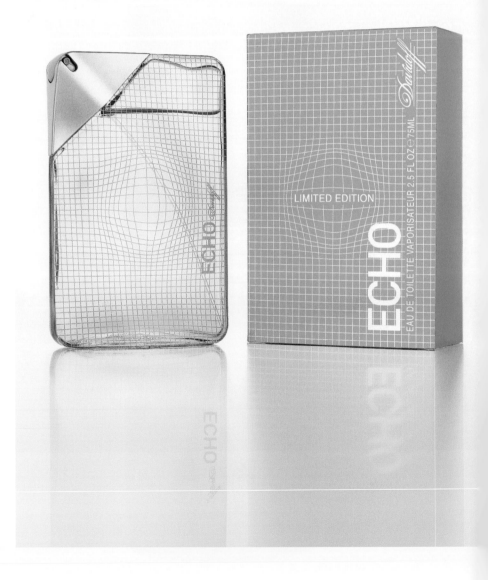

client ¬ **Kenzo**
studio ¬ Karim Rashid.Inc
New York ¬ USA
designer ¬ Karim Rashid
www.karimrashid.com

El perfume femenino Kenzo Summer by Kenzo plasma las notas sensuales y cálidas del verano.
Había que reinventar el frasco original en forma de hoja, y mi intención era desarrollar un lenguaje de diseño holístico para una marca holística. Limpio, simple, cuidado, sobrio y diseñado para adaptarse a la época tecnológica actual.

Kenzo Summer by Kenzo perfume for women embodies warm sensual notes of summer. A re-envisioning of the original leaf packaging, my intention was to develop holistic design language for a holistic brand. Clean, simple, neat, understated, and designed to really perform in our contemporary technological age.

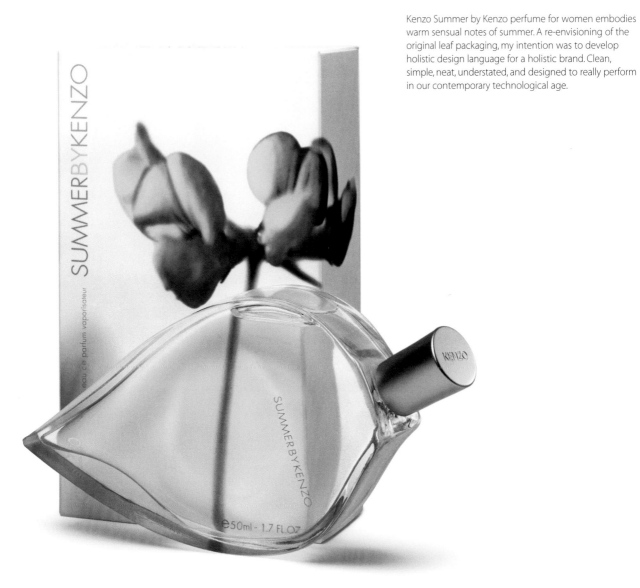

O&M hair care packaging

client ¬ **USPA**
studio ¬ **Container Ltd.**
Sydney ¬ **Australia**
creative directors ¬ **Brenan Liston,**
Jonnie Vigar, Todd Gill
designer ¬ **Mark Evans**
www.containermade.com

Original & Mineral (O&M) es innovador respecto al envase y los ingredientes de sus productos. Investigan nuevos modos de sustituir las agresivas sustancias químicas y añadir los beneficios de las sustancias botánicas y los aceites esenciales. O&M son pioneros en la tecnología de coloración sin amoníaco. La gama de cuidado capilar de O&M incluye frascos de 350 y 250ml de champú y acondicionador, y frascos de 50 y 250ml de productos de modelado. Una gama de formas simples y familiares. El suave acabado mate y la combinación de color recuerdan a una botella de leche. El original tapón en forma de disco aporta una nueva apariencia a un mecanismo familiar existente, que ha evolucionado para convertirse en una forma natural o sello para la marca. Los productos para modelado presentan a propósito una fuerte contradicción, que resalta su naturaleza funcional y respeta al mismo tiempo los valores de O&M.

Original & Mineral (O&M) takes an alternative direction with packaging and ingredients. Researching new ways of substituting harsh chemicals while adding the benefits of botanicals and essential oils. O&M are pioneers of ammonia free colour technology. Launch range of O&M hair care incl des 350 & 250ml shampoo and conditioner bottles, and 50 & 250ml styling products.
A range of simple, familiar forms. The soft matt finish and colour combination are reminiscent of a milk bottle. The unique disc cap is a new look at an existing familiar mechanism, evolved into a si nature shape or stamp for the brand. The styling products are a deliberate bold contradiction; emphasizing their functional nature, while still following the O&M ethos.

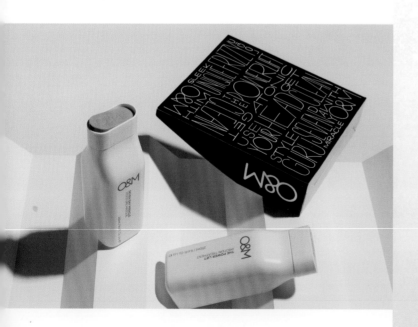

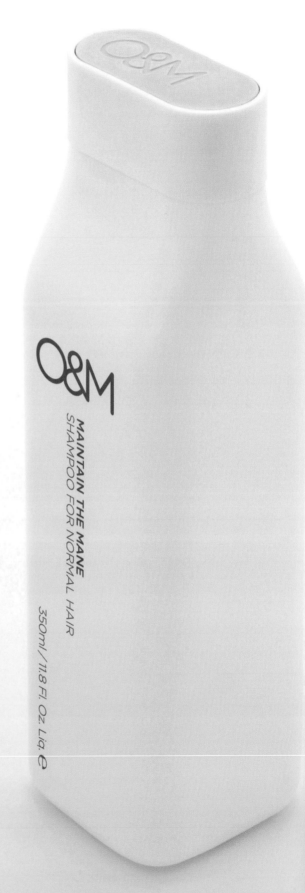

O&M
MAINTAIN THE MANE
SHAMPOO FOR NORMAL HAIR
350ml / 11.8 Fl. Oz. Liq. ℮

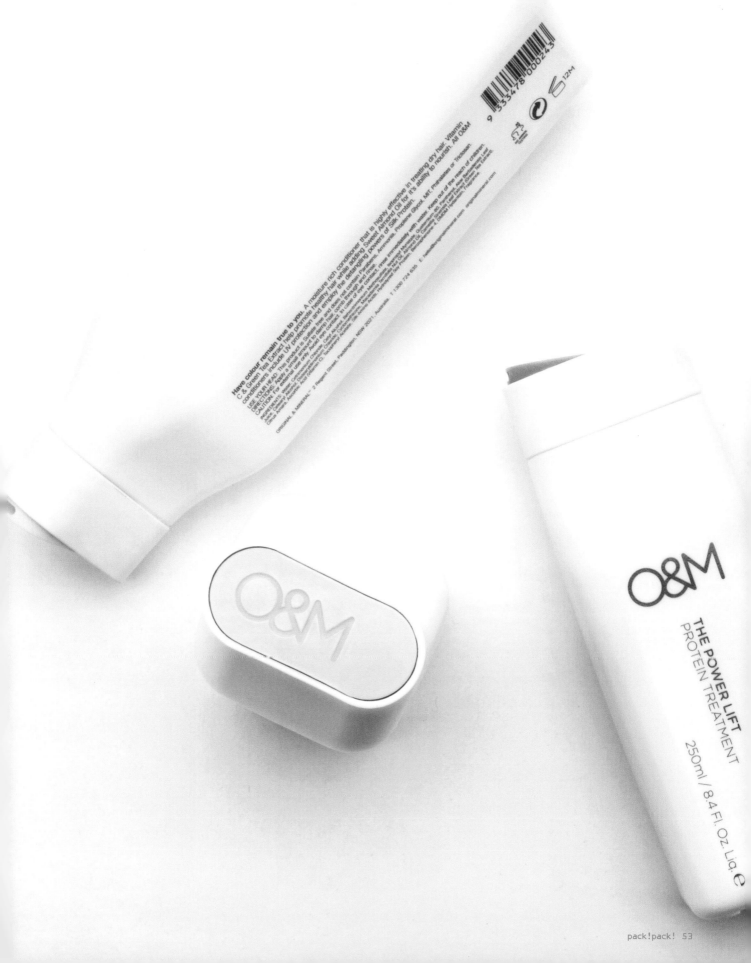

Have colour remain true to you. A moisture rich conditioner that is highly effective in treating dry hair. Vitamin C & Green Tea Extract help promote healthy hair while adding Sweet Almond Oil for it's ability to nourish. All O&M conditioners include UV protection and employ the detangling powers of Silk Protein.

USE YOUR HEAD The product is Sulfate free and does not contain Parabens, Ammonia, Pthalates or Triclosen.

DIRECTIONS: Apply a small amount to damp hair, comb through and rinse.

CAUTION: For external use only Avoid eye contact. In case of eye contact, rinse immediately with water. Keep out of the reach of children.

INGREDIENTS: Water, Cetearyl Alcohol, Behentrimonium Methosulfate, Cetrimonium Chloride, Cetyl Alcohol, Hydrogenated Ethylhexyl Olivate, Olea Europaea (Olive) Fruit Oil, Butyrospermum Parkii (Shea Butter), Prunus Amygdalus Dulcis (Sweet Almond) Oil, Propylene Glycol, Niacinamide, Panthenol, Helianthus Annuus (Sunflower) Seed Oil, Tocopheryl Acetate, Camellia Sinensis (Green Tea) Leaf Extract, Hydrolyzed Silk Protein, Tetrasodium EDTA, Fragrance.

ORIGINAL & MINERAL® 2 Regent Street, Paddington, NSW 2021, Australia. T 1300 724 635. E: retailer@originalmineral.com. originalmineral.com

9 333478 000243

12M

O&M

THE POWER LIFT
PROTEIN TREATMENT

250ml / 8.4 Fl. Oz. Liq. ℮

client ⌐ JRK International
studio ⌐ Adam & Company
Boston ⌐ USA
design / art direction ⌐ Adam Larson at Adam&Co.
www.adamncompany.com

Azul Real (presentado como "Jardim") es un cachaça
de calidad que proviene del corazón de Brasil. Es
elaborado y distribuido por JRK International, en una
destilería situada en un lago en la famosa región de
Minas Gerais, conocida por su buen clima y la calidad
de su tierra. Durante la fase de concepto, Adam&Co.
tomó varios enfoques distintos para crear el envase,
utilizando la época Art Déco, Río De Janeiro, y el color
azul real como principales fuentes de inspiración.
Queríamos plasmar la sensación de producto artesano
y valioso manteniendo al mismo tiempo un perfil limpio
y contemporáneo. El diseño pretendía ser compatible
con el lanzamiento de varias cachaças con sabores, a
medida que la línea del producto fuera evolucionando
con el tiempo.

Azul Real (featured here as "Jardim") is a premium
cachaça that comes from the heart of Brazil. It is
produced and distributed by JRK International, in a
distillery located on a lake in the famous Minas
Gerais region, known for its optimal climate and soil.
During the concept phase, Adam&Co. took several
different approaches to the packaging using the
Art Deco era, Rio De Janeiro, and the color royal
blue, as our main sources of inspriation. We wanted
to capture a precious, hand-crafted feel with the
packaging while keeping a clean and contemporary
profile. The design was intended to support the
rollout of various flavored cachaças as the product
line evolved over time.

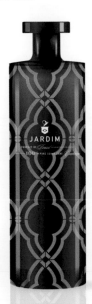

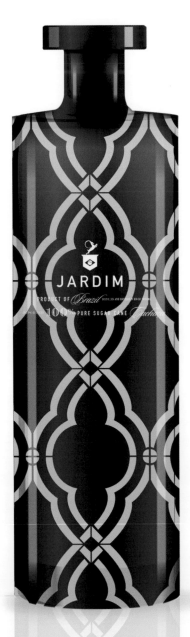

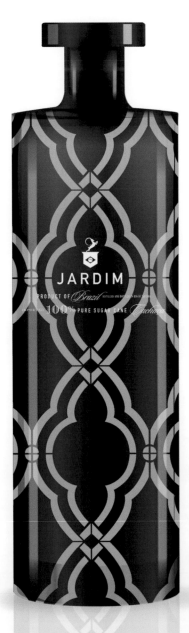

client ˥ Lemonaid GmbH.
studio ˥ BVD
Stockholm ˥ Sweden
www.bvd.se

The ChariTea tea leaf or droplet symbol in pure white floats zen-like above the brand. Elegant, yet eye catching, the products within the series of freshly brewed organic teas are differentiated through the simple descriptive names: ChariTea, black, red and green respectively which refer naturally to the tea types. The flavours are further distinguished by the clear bottle allowing the natural colors of the drink itself to come forward, making for a tasty looking suite of colour. Designed for the heath conscious and socially aware customer, this design solution aims to appeal on a lifestyle basis. A classic standard glass bottle was selected since it feels good in the hand and looks simple and authentic rather than over-designed. The natural aluminum cap is the finishing detail. The use of the typeface New Century Schoolbook gives the logotype a friendly, honest and approachable attitude.

El símbolo de una hoja de té o una gotita de ChariTea en blanco puro flota como haciendo Zen encima de la marca. Elegantes y al mismo tiempo impactantes, los productos de la serie de tés ogánicos recién preparados se diferencian gracias a sus sencillos nombres descriptivos: ChariTea black (negro), red (rojo) y green (verde) respectivamente, hacen referencia a los distintos tipos de té. Los sabores también se distinguen a través de la botella transparente que deja ver los colores naturales de la bebida y muestra su apariencia sabrosa. Diseñado para las personas preocupadas por su salud, esta solución de diseño pretende hacer una llamada al estilo de vida. Se escogió una botella de vidrio estándar clásica porque tiene un buen tacto y tiene una apariencia simple y auténtica. El tapón de aluminio natural es el detalle del acabado. El uso de tipo New Century Schoolbook le da al logotipo una actitud simpática, honesta y cercana.

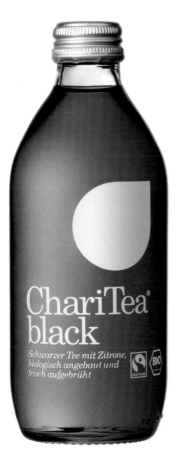

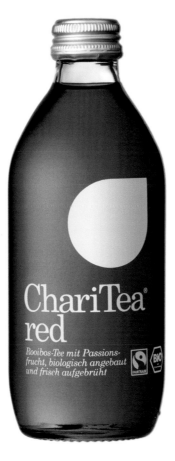

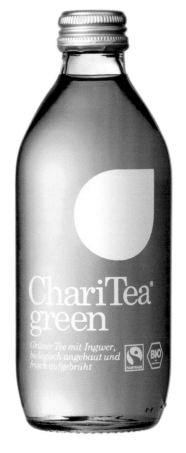

FOI Vodka

client ˥ FOI Club
studio ˥ X-House Design
Shantou ˥ China
designer ˥ Lin Shaobin
www.x-house.cn

Se inspira en el carácter y el estilo de vida de la gente
joven. Se utiliza la ilustración basada en la imaginación
y la forma especial de la botella para crear la imagen
del vodka FOI.

Take the character and life style of young
generation as creativity. The packing makes use of
illustration of imagination and the special bottle
shape to create a Vodka image of FOI.

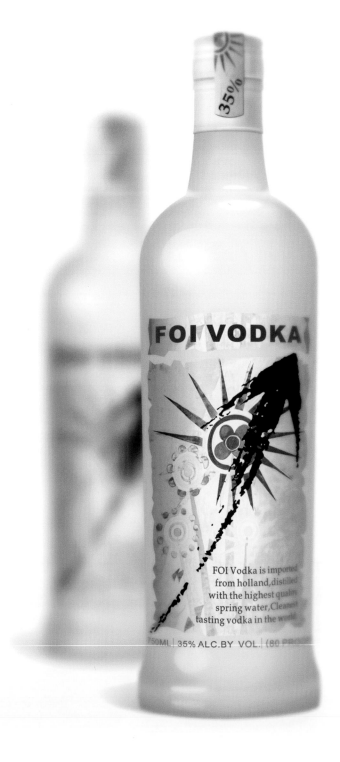

Lemonaid

client ˥ Lemonaid GmbH.
studio ˥ BVD
Stockholm ˥ Sweden
www.bvd.se

A brave statement with an over-dimensioned brand wrapping around the bottle provokes curiosity and celebrates the bottle as a 3-dimensional object rather than having a traditional front and backside. Fitting for this revolutionary product. Clear and eye catching design aims to appeal to a young urban crowd and stand-out in the busy supermarket environment. A classic standard glass bottle was selected since it feels good in the hand and looks simple and authentic rather than over-designed. The natural aluminum cap is the finishing detail. The typography, required logos and bar code are all integrated into a completely holistic design and silkscreened directly on the bottle surface avoiding labels completely. The cross element within the logotype naturally refers to the free trade and charity mission of the product.

Una declaración valiente y el nombre de la marca sobredimensionado alrededor de la botella provocan curiosidad y convierten a la botella en un objeto tridimensional, ideal para este producto revolucionario. El diseño claro e impactante pretende atraer a la gente joven urbana y destacar en el supermercado. Se seleccionó una botella de vidrio clásica estándar porque es agradable al tacto y tiene una apariencia simple y auténtica. El tapón de aluminio natural es el detalle del acabado. La tipografía requería que los logotipos y el código de barras estuvieran integrados en un diseño totalmente holístico y serigrafiados directamente en la superficie de la botella evitando completamente el uso de etiquetas. El elemento transversal del logotipo se refiere naturalmente al comercio libre y a la obra caritativa del producto.

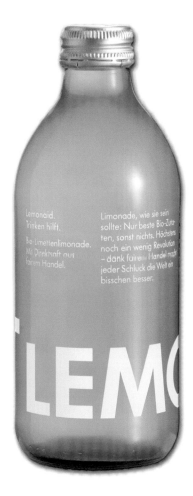
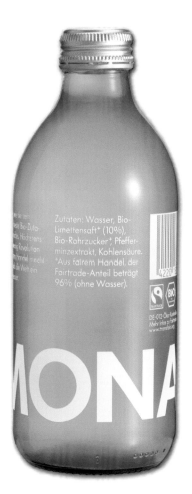
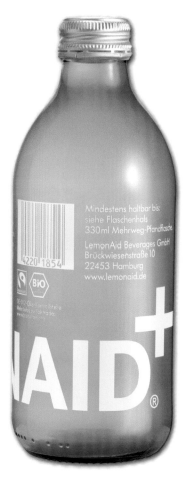

Real McCoy

client ˥ Diageo
studio ˥ The Creative Method
Sydney ˥ Australia
designer ˥ Tony Ibbotson
creative director ˥ Tony Ibbotson
typographer ˥ Tony Ibbotson
www.thecreativemethod.com

≫≪ p.104

El encargo consistía en actualizar la marca, hacer que destaque más, recordar sus características de calidad y reflejar la historia de Bill McCoy. Reducir el tamaño de 'Real' y aumentar el tamaño de 'McCoy' resaltó el nombre y abrió paso en el estante. La calidad de la textura se creó haciendo que aparecieran a propósito los sellos de aduanas y de impuestos. El diseño tenía que ser simple, fuerte y flexible porque también se tenía que aplicar a otros envases.

The brief was to update the brand, increase standout, recall, quality cues and reflect the story of Bill McCoy. Reducing the size of 'Real' and increasing the size of 'McCoy' created more of a focus on the name and more cut-through on shelf. Textural quality was created by deliberately making the mandatories reflect customs and duty stamps. The design had to be simple, strong and flexible as it was applied to a number of other packages.

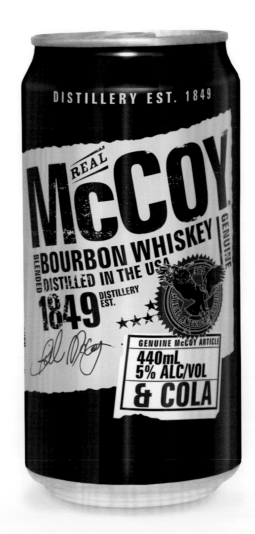

>>> p.104

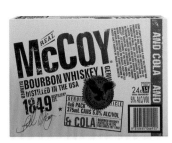

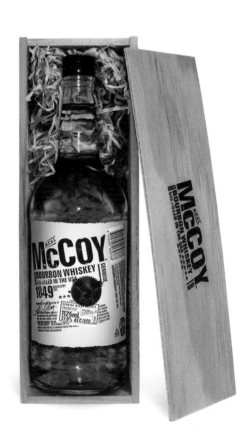

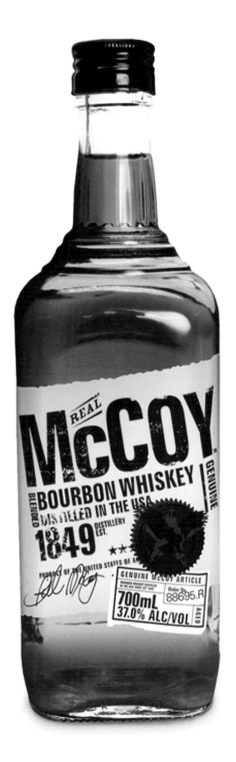

Smirnoff Platinum

>>< p.105

client ¬ Diageo - Smirnoff
studio ¬ The Creative Method
Sydney ¬ Australia
designer ¬ Tony Ibbotson
creative director ¬ Tony Ibbotson
www.thecreativemethod.com

En encargo consistía en diseñar una etiqueta para la botella y una caja para el nuevo producto de Smirnoff. El líquido se ha elaborado a partir del nuevo proceso APRA Smirnoff, mediante el cual el alcohol se elabora y luego se extrae para dar un sabor puro y refrescante.

The brief was to design a bottle label and wrap for a new Smirnoff product. The liquid has been created from a new process for Smirnoff where the alcohol is brewed and then extracted to give a pure and refreshing taste.

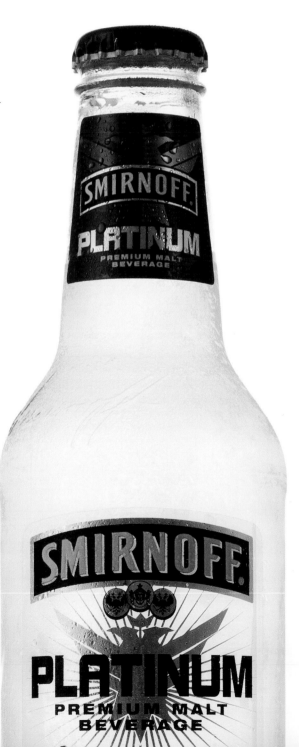

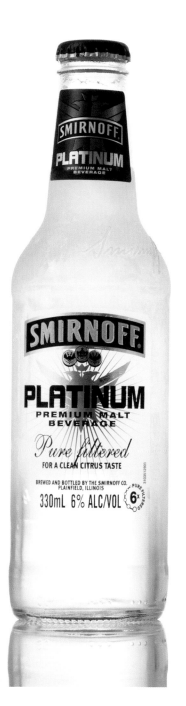
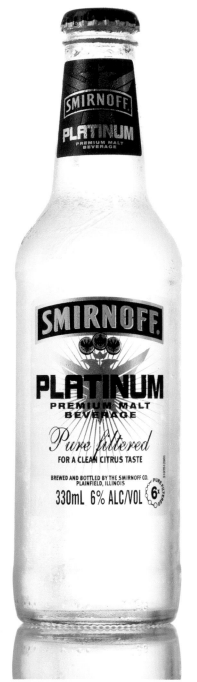
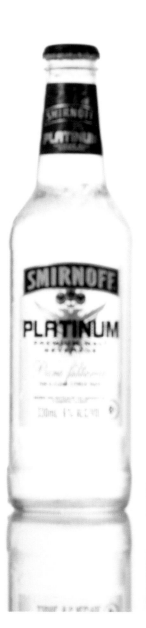
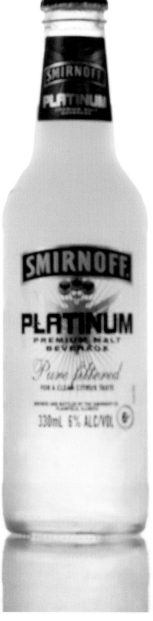

Guzman & Gomez Sauce

client ⌐ Guzman & Gomez
studio ⌐ The Creative Method
Sydney ⌐ Australia
designer ⌐ Tony Ibbotson
creative director ⌐ Tony Ibbotson
typographer ⌐ Tony Ibbotson
www.thecreativemethod.com

El encargo consistía en crear el envase para la gama de salsas mexicanas, utilizando las pautas existentes y los empleados actuales de la marca para resaltar la autenticidad y la personalidad.
La solución consistió en hacer que los empleados de las tiendas probaran las distintas salsas y fotografiar sus reacciones. Las expresiones faciales reflejan la fuerza y la potencia de la salsa, presentan a un miembro de la plantilla, y destacan en el estante. Las imágenes en blanco y negro combinan con la apariencia y la atmósfera de las tiendas y crean una plataforma para utilizar modelos no profesionales.

The brief was to develop packaging for a range of own brand Mexican sauces using existing brand guidelines and current employees to highlight authenticity and personality.
The solution was to capture store employees tasting the various sauces and photograph their reactions. The facial expressions reflect the strength and potency of the sauce while also introducing a member of the staff, and gives great cut-through on shelf. The black and white imagery ties in with the store look and feel whilst creating a better platform for using non-professional models.

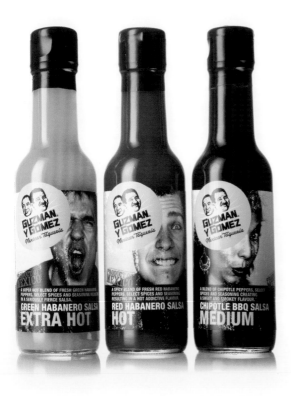

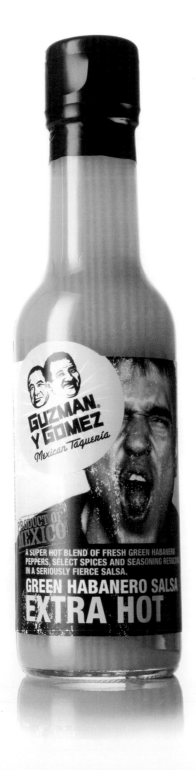

62 pack!pack!

PSI

client ¬ Peter Sisseck
studio ¬ **Pati Núñez Associats**
Barcelona ¬ Spain
designer ¬ Pati Núñez
www.patinunez.com

Psi es más que un vino. Psi es un nuevo proyecto de Peter Sisseck, cuyo primer vino Pingus está entre los veinte mejores del mundo. El agradecimiento que este enólogo danés siente hacia la tierra de la Ribera del Duero, le ha impulsado a diseñar un plan totalmente ecológico y biodinámico que incluye el desarrollo de huertas y la cría de ganado para generar compost orgánico, la construcción de una bodega concebida como escuela-taller donde se vinificará a la antigua usanza, y un perfil de cooperativa del siglo XXI, donde la uva es aportada por viticultores que forman parte del proyecto.

La letra griega Psi es un signo gráficamente duro, parece un tridente y me preocupaba que no transmitiera la condición humana y ecológica que encierra el proyecto.

Se me ocurrió la posibilidad de ilustrar una cepa en forma de Psi. Las viñas de Psi son antiguas, plantadas "en vaso", por lo que no resulta extraño encontrar cepas con esa forma. Y para que quedara implícito el acto de gratitud hacia la tierra, decidí incorporarle raíces, la psique de la planta.

Para realizar la ilustración, Sisseck nos envió la fotografía de una cepa de su propiedad con forma de Psi y nosotros la convertimos en grabado.

Psi is more than a wine. Psi is a new Peter Sisseck project, whose first wine Pingus is now considered to be one of the twenty finest wines in the world. This Danish wine expert's appreciation for Ribera del Duero terrain has led to him designing a totally ecological and biodynamic plan which includes the development of irrigated land and breeding livestock to generate organic compost, the construction of a wine production plant in the form of a apprentice-workshop where traditional wine making practices will be used together with a 21st century cooperative profile whereby the grapes are supplied by viticulturists involved in the project.

The Greek letter Psi is a graphically established sign, with the look of a trident and I was concerned that it would not transmit the ecological and human condition involved in the project.

The possibility of illustrating a vine in the shape of the Psi letter came to me. The Psi vineyards are old, planted in "containers" and it wouldn't be at all unusual to find vines which were actually this shape. Aside from this, for this act of gratitude towards the terrain to remain clear, I decided to incorporate the roots, effectively the plant's psyche.

For the illustration, Sisseck sent us a photograph of one of his Psi shaped vines which we converted into an etching.

Martina

client ⌐ **Massana Noya**
studio ⌐ **Puigdemont Roca design agency**
Barcelona ⌐ **Spain**
designer ⌐ **Albert Puigdemont**
www.puigdemontroca.com

⋙ p.114

La inicial de Martina, quien inculcó a su hijo el amor por la tierra, se reproduce en la etiqueta del producto imitando el aspecto del encaje de bolillos, aportándole personalidad y rindiendo tributo al mismo tiempo a una de las grandes aficiones de la madre.

Martina's initial, the woman who instilled her love of the land into her son, is reproduced on the product label simulating the appearance of bobbin lace, adding a touch of style and at the same time paying tribute to one of this mother's great pastimes.

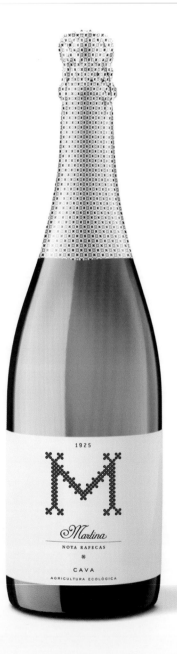

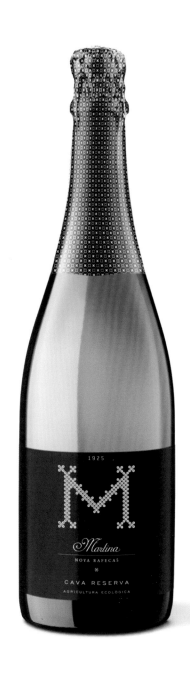

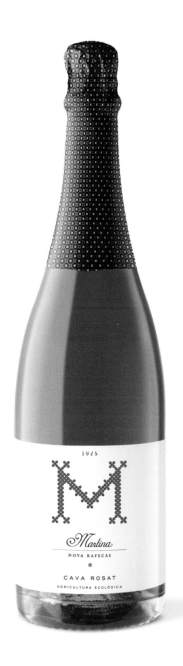

Stoli DA

client ⌐ **Stolichnaya**
studio ⌐ **SVIDesign**
London ⌐ United Kingdom
creative director ⌐ Sasha Vidakovic
designer ⌐ Sasha Vidakovic
www.svidesign.com

El famoso vodka Stolichnaya quería crear combinados
listos para beber suaves para gente joven y dinámica.
El enfoque tipográfico sugiere una fuerte conexión
con la famosa historia de la vanguardia rusa, y resalta
la calidad del producto.
La composición vertical de las letras creó una
composición visual fresca y rápidamente reconocible.

Famous Stolichnaya Vodka wanted to create
lighter, ready-to-drink mix for young and dynamic
people. Typographic approach suggested strong
connection with famous russian avangarde
history as well as underlining no-nonsense quality
of the product. Vertical composition of letters
created fresh and instantly recogniseble visual
composition.

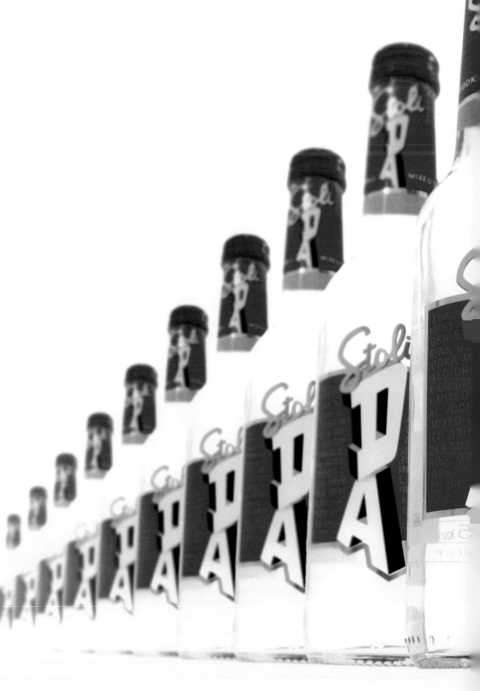

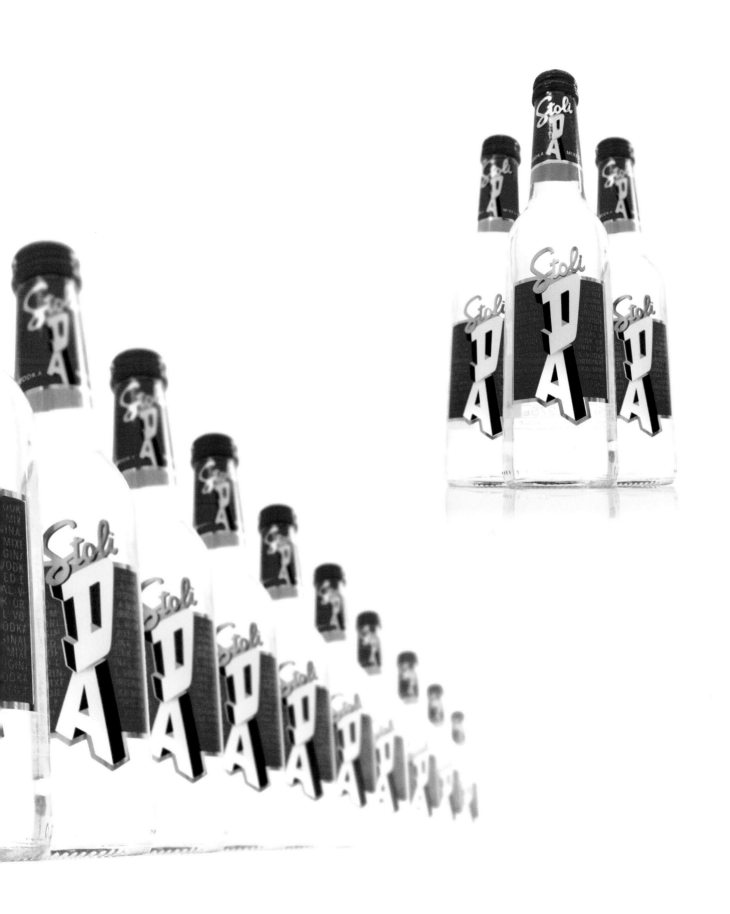

Limon & Nada

client ⌐ Coca-Cola España
agency ⌐ **Salvatore Adduci**
Barcelona ⌐ Spain
designer ⌐ Salvatore Adduci
www.salvatore-adduci.com

La Marca hace honor a la fórmula: limón y nada. Es decir, una sencilla formula a base de Agua, Puro Limón y Azúcar en las proporciones adecuadas para obtener una limonada muy próxima a la casera: Limón & Nada.
Desde este principio tan simple surgió un Pack tan simple. El Limón hace de ducha y piscina. Las ilustraciones, (ingenuas), al combinarlas con las fotos nos aproximan al consumidor a través del humor de la escena espontánea. El blanco nos da pureza y frescura.
Y nada más.

La Marca lives up to the formula: lemon and nothing. That is to say, a simple formula based on Water, Pure Lemon and Sugar in the appropriate percentages to obtain lemonade just like the home-made: Limón & Nada. Naturally, from such a simple principle as this, there arose an equally simple Pack. The Lemon serves as shower and swimming pool. The illustrations (ingenious), together with the photos, draw us closer to the consumer through the vibes in the spontaneous scene. The white gives us purity and freshness. Nothing more.

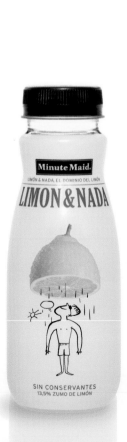
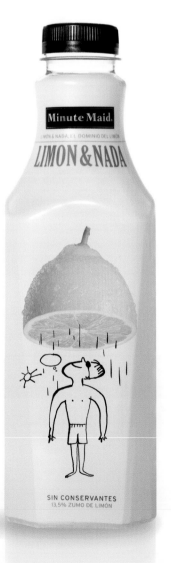
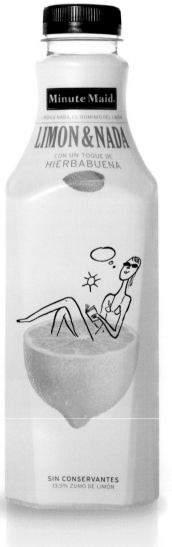
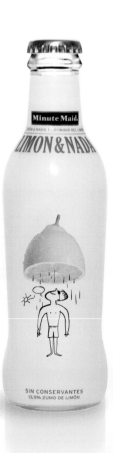

Un tercio - A third

client ˥ Estrella Dam
studio ˥ Insignia Creativa
Murcia ˥ Spain
designer ˥ Rafael Fernández Moratinos,
Jose Antonio Rosa, Nacho Rodriguez
www.insigniacreativa.com

El briefing era muy claro: Diseño para un botellín de 1/3 de cerveza de aluminio, con presencia de la marca, de fácil identificación, dirigido a un público joven y de consumo en locales nocturnos.
Es muy importante decir, que en gran parte de España el botellín de cerveza se pide dependiendo de su capacidad: un tercio de... o un quinto de... y luego se dice la marca (igual que Inglaterra se pide una pinta). Y como el consumo es exclusivamente nocturno, se invita a una reflexión que enlaza con la capacidad del botellín: "Un tercio de nuestra vida sucede de noche".

The briefing was quite clear: Design a small 1/3 aluminium beer bottle displaying the brand name, making it easy to identify, aimed at young people and suitable for serving in night spots.
It's very important to point out that in a large part of Spain the small beer bottle is requested according to its capacity: a third of... or a fifth of... followed by the brand name (just as a pint is ordered in England). And since this is based entirely on night-time consumption, consumers are invited to reflect on something linked to the capacity of this small bottle: "A third of our life happens at night".

Rustad Water

client ⌐ **Pure Norwegian**
studio ⌐ **Strømme Throndsen Design**
Oslo ⌐ **Norway**
art director ⌐ **Morten Throndsen**
designer ⌐ **Eia Grødal**
www.stdesign.no

Agua pura de manantial noruega embotellada en botellas de PET, de vidrio, cartón y latas.

La empresa Pure Norwegian quería crear una nueva marca de agua con la intención de exportar agua mineral noruega de calidad principalmente a los EE.UU. Con esta intención compró el manantial Rustad, situado en el corazón de la Noruega rural.

Las líneas limpias y suaves de la botella azul hacen referencia a la naturaleza virgen y al frescor. El uso de los colores de la bandera noruega hace referencia al origen noruego del producto. Impresión: 100% agua fresca noruega de primera calidad.

Norwegian pure spring water in PET, glass bottles, cartons and cans.

The company Pure Norwegian wanted to develop a new water brand with the aim of exporting premium Norwegian spring water primarily to the USA. The natural water source Rustad in the heart of rural Norway was acquired.

The clean and soft lines of the blue bottle reveal associations to pure unspoilt nature and ultimate freshness. The distinct use of the Norwegian flag colours, give clear associations to the Norwegian origin. Impression: 100% fresh Norwegian high quality water.

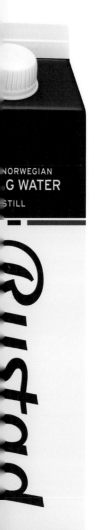
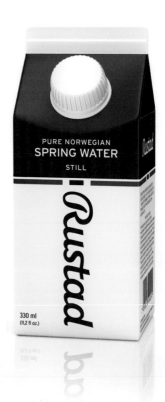
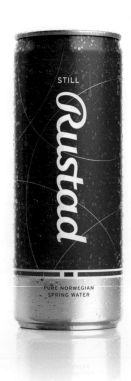
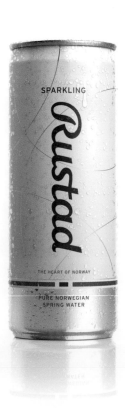

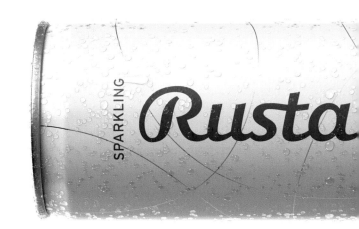

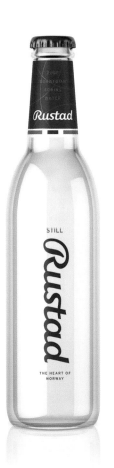

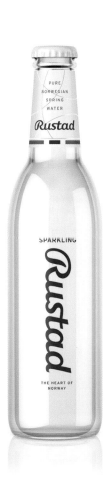

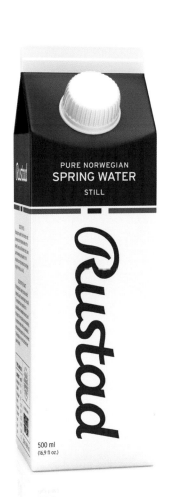

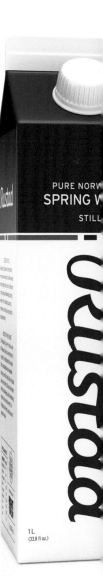

client ⌐ Niagara
studio ⌐ Hattomonkey
Novosibirsk ⌐ Russia
designer ⌐ Alexey Kurchin
www: hattomonkey.ru

Hattomonkey ha creado el diseño del envase del
agua mineral "Niagara". El isotipo de la marca parece
una cascada, una corriente inagotable de agua.
La solución es simple y lacónica, para resaltar la
naturalidad del producto.

Hattomonkey has created packaging design of
mineral water "Niagara". Brand mark is looks like
waterfall - inexhaustible stream of pure water.
The solution is simple and laconic, which is to
underline naturality of product.

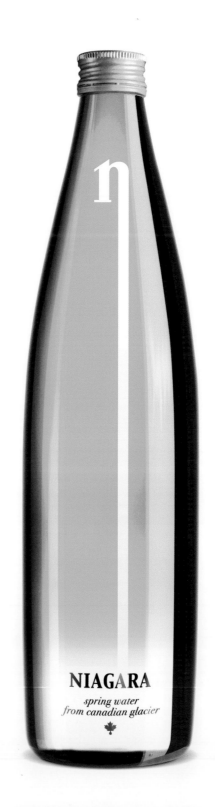

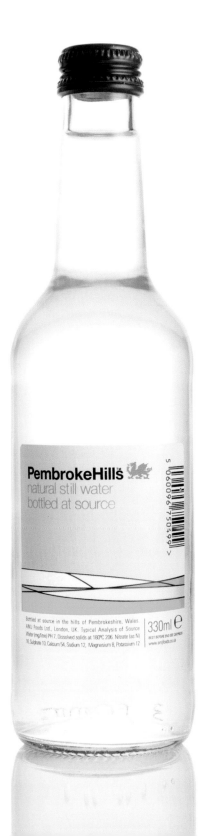

Pembroke Hills Water

client ↴ AMJ foods
studio ↴ Davies Hall
London ↴ United Kingdom (UK)
designer ↴ Rob Hall
www.davieshall.co.uk

Creación de marca para una empresa de agua mineral galesa.
Una solución elegante al reto que suponía disponer de una
sola etiqueta que tenía que incluir el código de barras y la
marca. La tinta translúcida distingue el motivo de la colina
sobre el blanco opaco.

Brand creation for a Welsh mineral water company.
An elegant solution to the challenge of a single label
that has to include a barcode as well as the branding.
Translucent ink picks out the hill side motif against opaque
white.

boxes, bags, papers

Violet

client ˥ Violet
studio ˥ Raymond Interactive,
a Saguez & Partners subsidiary
Paris ˥ France
art director ˥ Bruno Auret
www.raymond-interactive.com

Línea visual VIOLET, productos inteligentes interactivos.
Transmite sencillez con su tipografia y su visual
marcada con un potente espacio de blancos que
permite potenciar su cromática corporativa,
generando un conjunto único, lo cual facilita una
mayor percepción de cada línea de producto.

The VIOLET visual line is comprised of intelligent
interactive products. Simplicity is transmitted
through the typography and the visual marked
with strong white spaces reinforcing the corporate
chromatics, generating a unique collection which
facilitates improved perception of every product
line.

Le Miroir qui donne des pouvoirs à vos objets

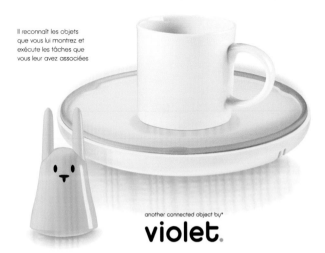

Il reconnaît les objets
que vous lui montrez et
exécute les tâches que
vous leur avez associées

another connected object by*
violet.

Le Miroir qui donne des pouvoirs à vos objets

Contient trois Ztamps RFID à
poser sur vos objets, deux Lapins
Nano:ztag à programmer
et bien sûr un Mir:ror

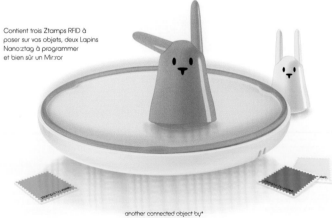

another connected object by*
violet.

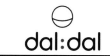

dal:dal

La Lámpara maravillosa que transforma Internet en luz

Animando con sus miles de colores, presenta de manera permanente las informaciones fundamentales

another connected object by*
violet.

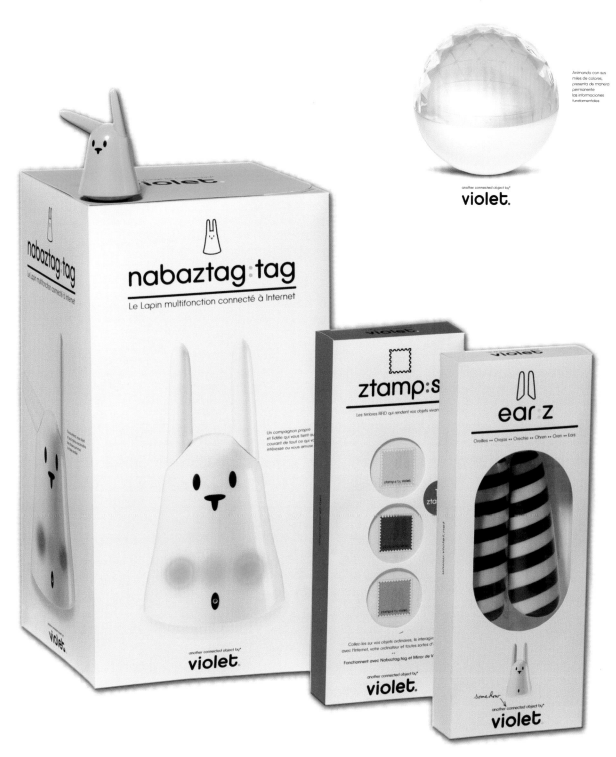

Chroma paint

client ㄱ The FreshAire Choice
studio ㄱ Stephanie Kuga
Los Angeles ㄱ U.S.A
designer ㄱ Stephanie Kuga
special thanks ㄱ Ania Boriesywicz
www.stephaniekuga.com

La línea de pintura actual se ha ampliado para incluir pintura para un aire limpio y pintura solar concentrada, así como pinceles y muestras para aumentar la presencia de Chroma en el mercado. Esta nueva forma resuelve los problemas de ergonomía y de uso que había con las latas de pintura tradicionales. Al mismo tiempo actualizamos la tipografía con una jerarquía y unas instrucciones de uso más claras. El contenedor se puede aplastar y reciclar. El tapón a presión también está hecho de plástico reciclable, y asocia el envase con el producto que contiene.

The current paint line has been expanded to include concentrated, clean air, and solar paint, as well as brushes and samples to increase Chroma's presence in the market. This new shape resolves current ergonomic and use issues encountered with the traditional paint can, while updating typography with clear hierarchy and instructions for use. The container can be collapsed and recycled in the corrugate chain. The snap on lid is also made of recyclable plastic, relating the packaging to the product it contains.

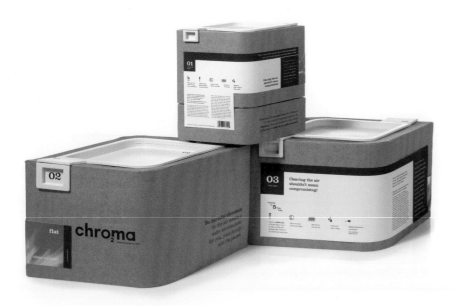

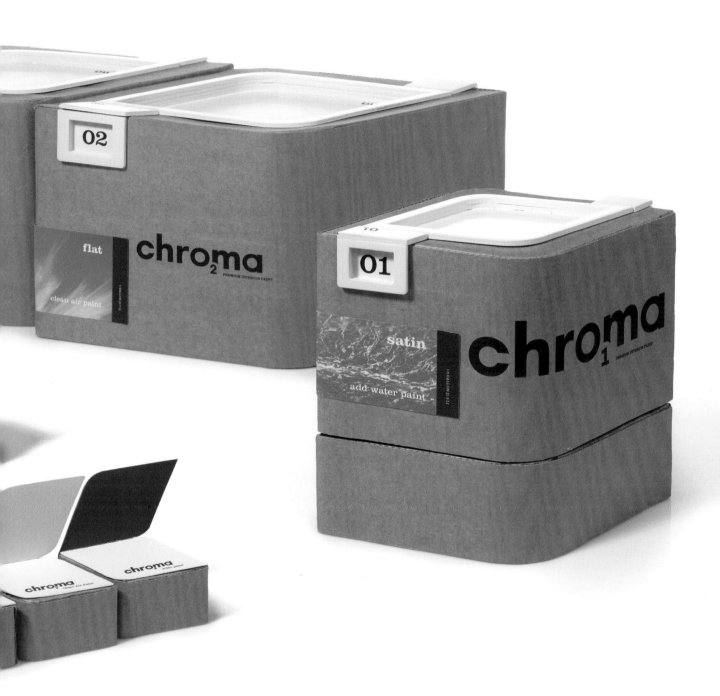

Martin Berasategui

client � Martín Berasategui
studio � Enric Aguilera Asociados
Barcelona � Spain
art director � Enric Aguilera
designer � Gaizka Ruiz
www.enricaguilera.com

Proyecto para crear la línea de envases con la que el Chef Martín Berasategui comercializa algunas de sus creaciones.

A project aimed at designing suitable packaging for Chef Martín Berasategui to market some of his creations.

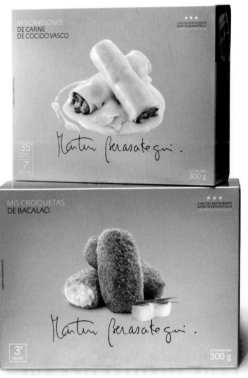

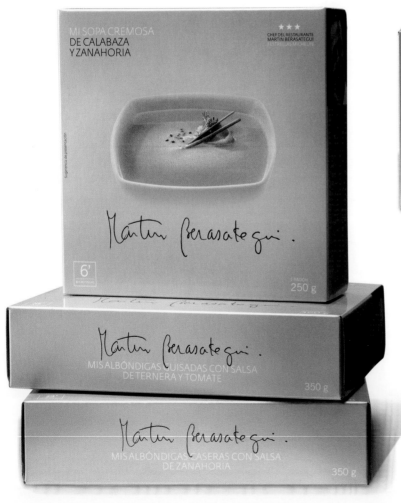

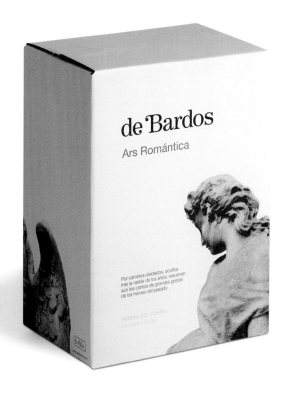

client ¬ **Vintae**
studio ¬ **Moruba**
Logroño. La Rioja ¬ Spain
www.moruba.es

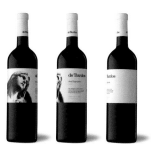

>>« p.44

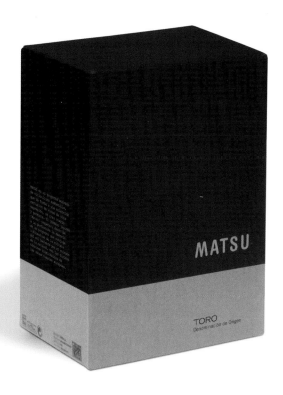

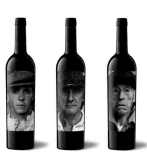

>>« p.42

Jaqk Cellars Wine

client ꞌ **Jaqk Cellars**
studio ꞌ **Hatch Design**
San Francisco, Ca. ꞌ USA
art director ꞌ Katie Jain & Joel Templin
designer ꞌ Katie Jain, Joel Templin, Ryan Meis, Eszter T. Clark
illustrator ꞌ Paul Hoffman, Eszter T. Clark, Ryan Meis
www.hatchsf.com

»« p.18

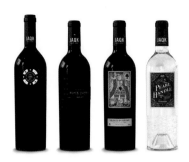

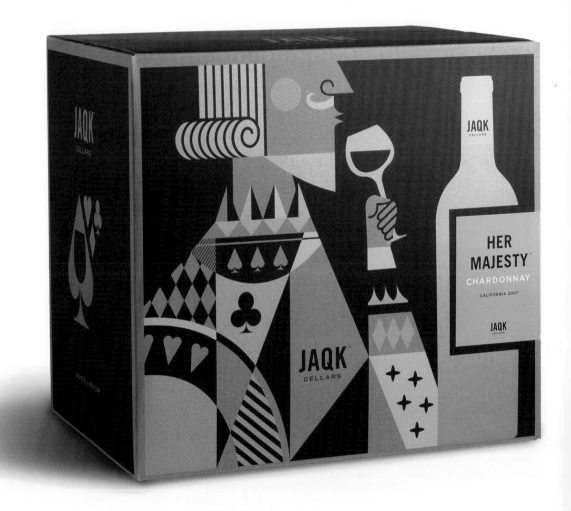

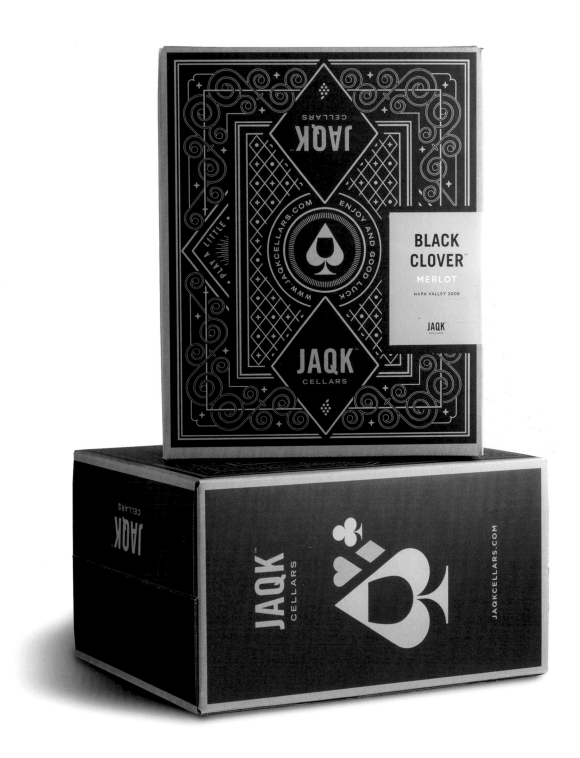

Domaine de Canton

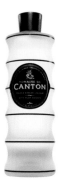

»« p.12

client ꓶ **Domaine de Canton**
studio ꓶ **Mucca Design**
New York ꓶ USA
creative director ꓶ **Matteo Bologna**
art director ꓶ **Andrea Brown**
designers ꓶ **Andrea Brown, Ariana Dilibero**
www.muccadesign.com

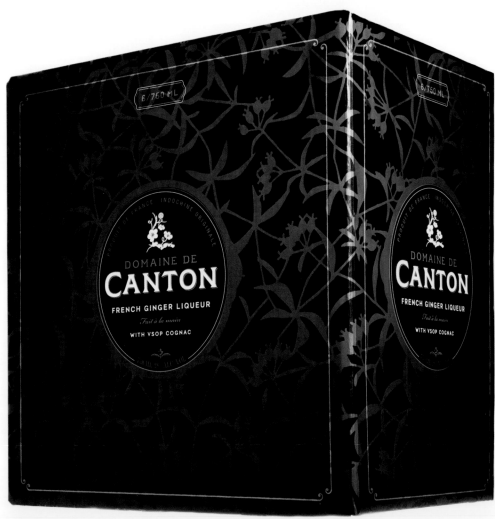

LGE

client ⌐ Le Bon Marché
studio ⌐ Lewis Moberly
London ⌐ United Kingdom
designer ⌐ Bryan Clark
www.lewismoberly.com

To create a new identity for La Grande Epicerie de Paris, the leading Parisian food hall.
Tonality to be modern, Stylish and simple
– allowing products and fresh produce to be the hero. To make the long name more edited a brand mark and focus the Parisian provenance. Black lettering on an ivory ground aims to reflect the stores confidence as the food specialist.

Crear una nueva identidad para La Grande Epicerie de Paris, la tienda de comida de París líder del mercado.
La tonalidad debía ser moderna, estilosa y simple, sin eclipsar a los productos y la comida fresca. Para acortar el largo nombre editamos un isotipo y nos centramos en el origen parisino.
Las letras negras sobre un fondo marfil intentan reflejar la confianza de la tienda como especialista en comida.

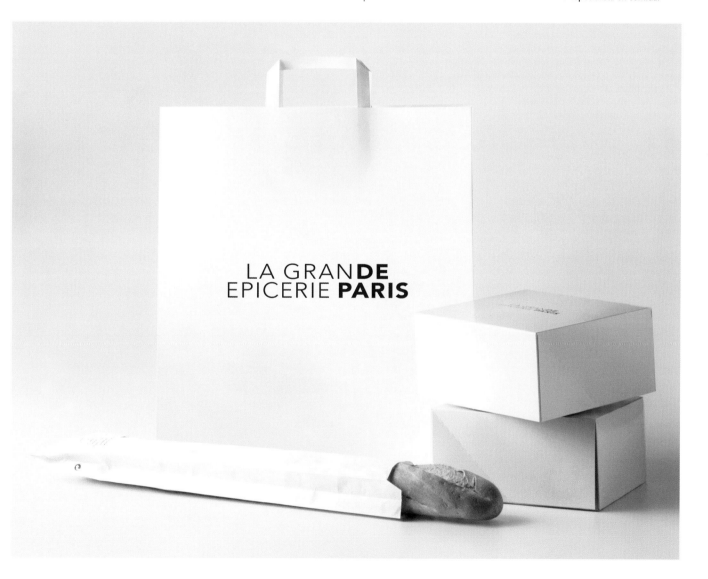

Taste Please

client ˥ TastePlease
studio ˥ **Homework**
Copenhagen ˥ Denmark
designer ˥ Jack Dahl
www.homework.dk

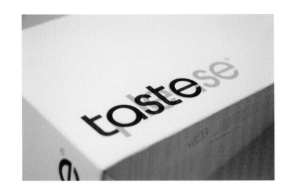

TastePlease® es un mercado de comida orgánica
para todos aquellos que quieran disfrutar de la
buena comida cada día. Se puede encontrar desde
pan orgánico de nuestra propia panadería a
exquisiteces para llevar, pasteles creativos, refrescos
caseros, comida fácil y especialidades de todo el
mundo. En TastePlease puedes probar comida de
Ecuador, saborear la fragancia de la sofisticada
cocina italiana o disfrutar del sabor natural de las
patatas fritas caseras del fabricante de patatas fritas
más pequeño de Inglaterra. TastePlease también te
puede tentar con especialidades locales como
galletas de ortiga o quesos de pequeñas lecherías
danesas. Taste Please se creó a partir de la pasión por
la buena comida y el respeto por el medio ambiente,
motivo por el cual sólo utilizamos envases
biodegradables para nuestra comida.

TastePlease® is an organic food market for everyone
who wants to enjoy good food everyday. From
organic bread from our own bakery, to take away
delicacies, creative cakes, home made soft drinks,
easy food and specialities from all over the world.
At TastePlease you can try a bite of Ecuador,
savour the fragrance of Italy's sophisticated
cuisine or enjoy the natural taste of home made
crisps from England's smallest crisp manufacturer.
TastePlease can also tempt you with local
specialities such as home made nettle biscuits or
cheeses from small dairies around Denmark. Taste
Please has been developed out of a passion for
good food based on respect for the environment,
which is why we only use biodegradable
packaging for our food.

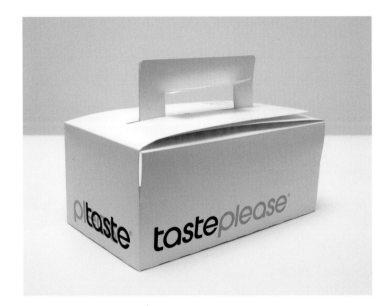

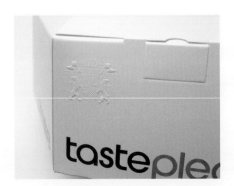

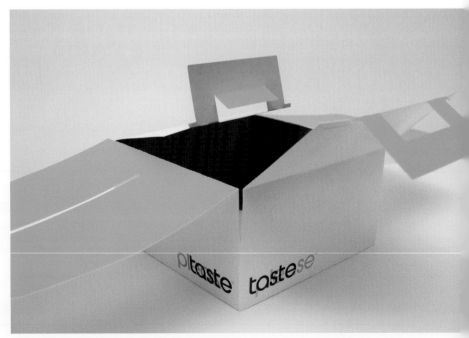

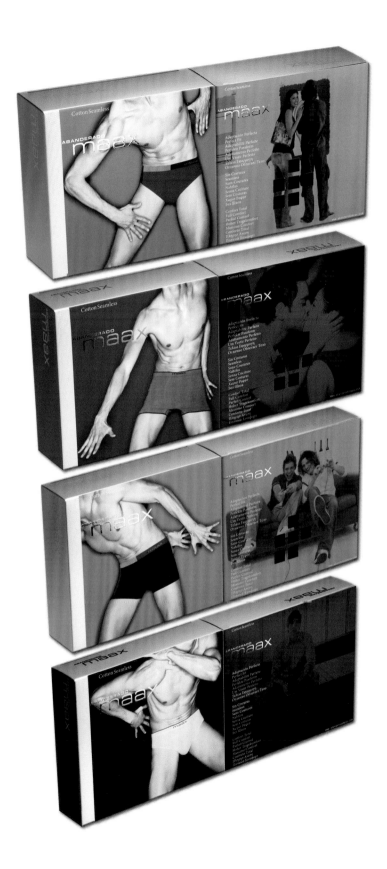

Maax

client ┐ Sans Branded Appareil
agency ┐ Salvatore Adduci
Barcelona ┐ Spain
designer ┐ Salvatore Adduci
www.salvatore-adduci.com

El primer lanzamiento de la gama de Packaging de ropa
interior masculina bajo la marca Maax, anterior a ésta,
se hizo atendiendo a las premisas y objetivos en donde
se debía potenciar la naturalidad del algodón y la
técnica del tejido sin costuras. Ambas soluciones daban
un confort y un fit perfecto. Debido a investigaciones
posteriores se descubrió que el diseño resultaba en
exceso serio, que el consumo se dirigía hacia una franja
de usuarios adulta-adulta, en el que la franja 20-30 años
no se veia identificada.
Se hizo un nuevo brief que cambiaba radicalmente
de dirección, buscando una participación por parte
del grupo de consumidores más joven y actual.
El movimiento del actor es exagerado y a la vez
desenfadado y flexible, dando prueba con ello de la
comodidad de la ropa. En los dorsos de cada pack
aparecen personajes distintos cada vez. Para identificar
el color de la prenda, se abrieron 6 ventanillas en los
dorsos con una solución gráfica afín. La configuración
final del Pack se asemeja a un estuche de CD.

Prior to this, the first Packaging designed for the
launch of men's underwear from Maax, focussed on
the premises and objectives behind promoting the
natural cotton and seam-free fabric. Both were
contributory factors in providing comfort and a
perfect fit. Subsequent research revealed that the
design was in fact rather too restrained and sales
were restricted to a group of mature adults, a sector
the 20 to 30 age group were not going to be
identified with.
A new brief was designed which brought about a
radical change of direction, in search of a younger
and more fashion conscious group of consumers.
The actor's movement is exaggerated as well as
being relaxed and supple, effectively demonstrating
the comfort of the garment. Different celebrities are
shown on the back of every pack. To identify the
colour of the garment 6 small windows open on the
back of the pack with a similar graphic effect. The final
result for the shape of the Pack is similar to that of a
CD case.

Nau

client ꓶ Naulover
studio ꓶ Puigdemont Roca design agency
Barcelona ꓶ Spain
designer ꓶ Albert Puigdemont
www.puigdemontroca.com

≫≪ p.48

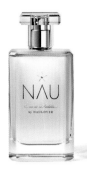

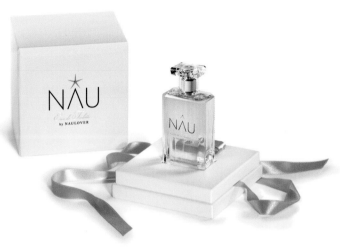

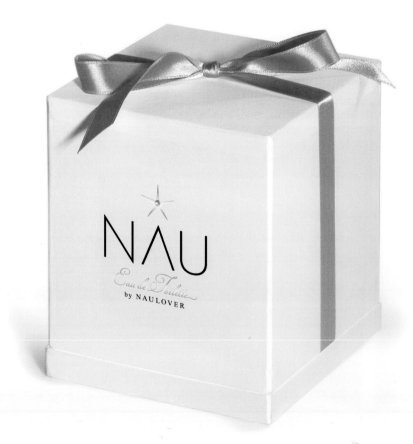

Super Cima

client ⌐ Super Cima
studio ⌐ Puigdemont Roca design agency
Barcelona ⌐ Spain
designer ⌐ Albert Puigdemont
www.puigdemontroca.com

Development for the full line of packaging for thermometers sold in pharmacies. The objective was to differentiate the four different product ranges through different colours.

Desarrollo de la línea completa de packaging para termómetros de venta en farmacias. La finalidad era encontrar una estética atractiva y rompedora diferenciando las cuatro gamas de producto mediante color.

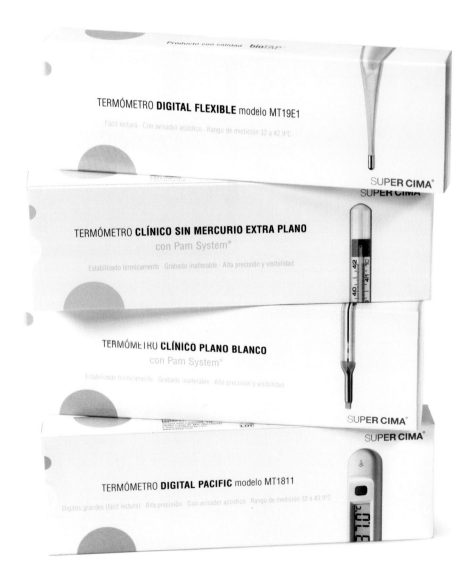

Fleur Tang

client ˥ Fleur Tang
studio ˥ Homework
Copenhagen ˥ Denmark
designer ˥ Jack Dahl
photography ˥ Nicky de Silva
www.homework.dk

La ropa y el embalaje de Fleur Tang están hechos de
materiales orgánicos 100%.
Desde el algodón a la fábrica y la fabricación, todos
los procesos tienen en cuenta el medio ambiente, y
no utilizan sustancias químicas nocivas. Una prenda
de ropa que podemos adquirir con la conciencia
tranquila.

Fleur Tang garment and packaging is made with
100% organic materials.
From the cotton to the mills to the manufacturing,
every process is done with the environment in
mind – and without harmful chemicals. A piece of
clothing with peace of mind.

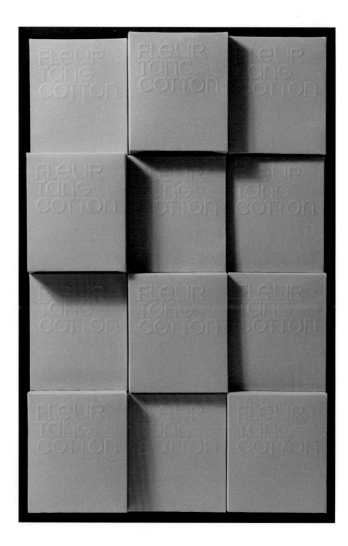

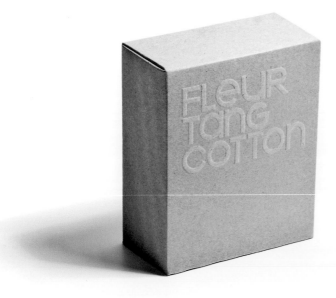

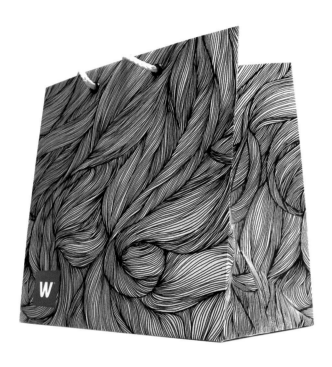

Woman-hairstyle

client ¬ Hairstyle Studio - Woman
studio ¬ Peter Gregson Studio
Novi Sad ¬ Serbia
art direction & illustration ¬ Marijana Zaric
www.petergregson.com

Ilustración hecha a mano de cabello, para bolsas de papel y pósters. Las bolsas se utilizan como embalaje para los productos capilares adquiridos.

Handmade pattern illustration of hair, for paper bags and posters. Bags are being used as packaging for purchased hair products.

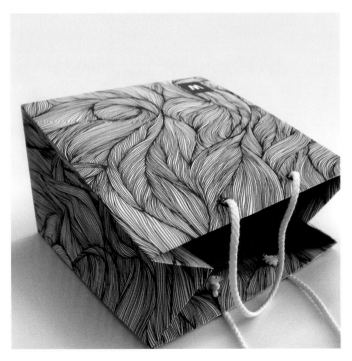

Como tu

client ⌐ **RNB**
studio ⌐ **Pepe Gimeno Proyecto Gráfico**
Godella, Valencia ⌐ Spain
designer ⌐ **Pepe Gimeno, Julio Alonso**
www.pepegimeno.com

Estuche contenedor para la colección de fragancias
"COMOTÚ" en miniatura.
RNB ha hecho una edición especial de COMOTÚ en
formato miniatura y encargó un estuche contenedor
para regalar la colección completa de las fragancias
masculinas y femeninas.
Una solución sencilla para un problema de cantidades.

A gift box for the "COMOTÚ" miniature fragrance
collection.
RNB has created a special miniature edition of
COMOTÚ fragrances and commissioned a specially
made gift box for the full collection of both men's
and women's fragrances.
A simple solution for a matter of quantity.

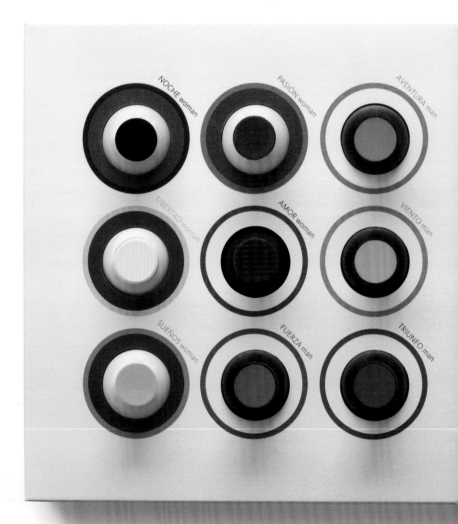

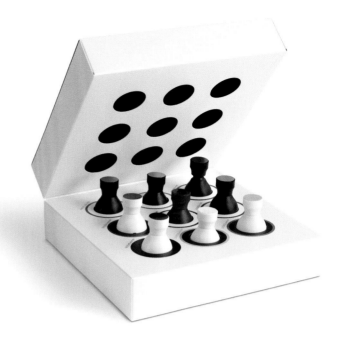

Drink coasters set

client ⌐ Chiga-biga
studio ⌐ **Artel Artyomovyh graphic design bureau**
Kyiv ⌐ **Ukraine**
designers ⌐ Katerina Voytko, Oleksii Chernikov
art directors ⌐ Gera Artyomova, Sergey Artyomov
www.designartel.com.ua

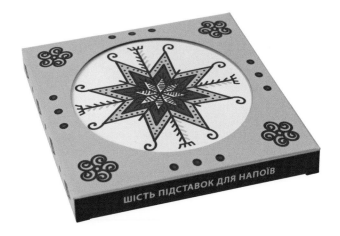

El embalaje y los posavasos están decorados con adornos ucranianos tradicionales. Todos los símbolos (Árbol de la Vida, Sol, Pez, Pájaro, Ciervo) tienen un significado antiguo.

The package and coasters are decorated with traditional ukrainian ornaments. All symbols (Tree of Life, Sun, Fish, Bird, Deer) have ancient meaning.

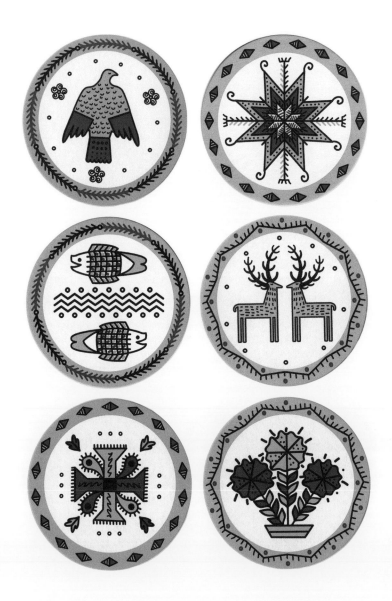

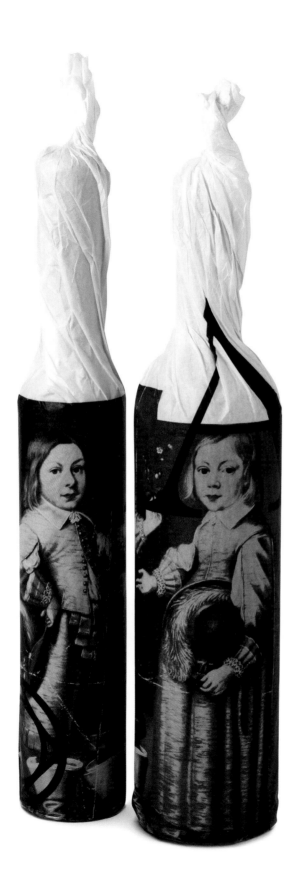

client ꞁ **Adelina**
studio ꞁ **Mash**
Adelaide ꞁ **Australia**
art direction ꞁ **Dom Roberts, James Brown**
designer ꞁ **Dom Roberts**
www.mashdesign.com.au

Se trata de una marca fundada por dos vinicultores jóvenes con mucho talento y altamente cualificados. "The young will master the old" (Los jóvenes dominarán lo antiguo), en referencia a los jóvenes vinicultores que dominan el arte de la vinicultura (metodología con siglos de antiguedad). Se escogieron unos cuadros renacentistas, que representan un niño y una niña de unos 5 o 6 años y que parecen tener una madurez y una sabiduría muy por encima de su edad). Estas dos figuras representan a Colin y Jen, los fundadores de Adelina.
El diseño combina lo nuevo con lo antiguo. La impresión en 4 colores en papel de seda, que cubre toda la botella, es muy atractiva en el estante, al lado de la mayoría de etiquetas de papel. Las botellas se bañaron en cera para añadir romanticismo y hacer referencia a la manera en que se envasaba el vino antiguamente. Las etiquetas son muy simples a propósito para contrastar con el envoltorio. La tipografía une estos dos elementos de forma armoniosa.

A brand created by 2 young, talented and highly educated wine makers. "The young will master the old", relating to the young wine makers mastering the art of wine making (methodology that dates back centuries). Mash sourced renaissance paintings, depicting two young children who appear to have maturity and wisdom beyond their age; the girl and boy in the chosen image are only 5 to 6 years old. These 2 figures representing Colin and Jen, the founders of Adelina. The design combines the new with the old. 4 colour printing on tissue paper, covering the entire bottle, to provide maximum shelf appeal, next to the majority of paper labels. The bottles were wax dipped to add to the romance and to reflect the old ways of wine packaging. The labels are purposefully understated and simple to create contrast with the tissue wrap; typography bringing these two elements into harmony with each other.

Organ Donation

client ⌐ Organ Donation
studio ⌐ Stephanie Kuga
Los Angeles ⌐ U.S.A
designer ⌐ Stephanie Kuga
special thanks ⌐ Sean Donahue
www.stephaniekuga.com

Esta caja "regalo" se da a los donantes potenciales, y el
órgano de peluche del interior significa que un órgano es
el "regalo de la vida". El acto de sacar el órgano de la caja
es parecido al acto de sacar el órgano de un cuerpo.
Al sacar el órgano, encontramos una pegatina de donante
en el fondo de la caja.

This "gift" packaging is given to potential donors, with
the plush organ inside symbolizing an organ as the
"gift of life." The act of removing the organ from the
box is similar to the act of taking an organ out of a
body, and reveals the donor sticker in the back of the
box.

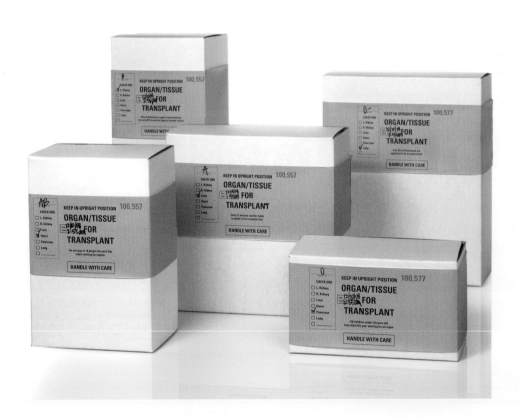

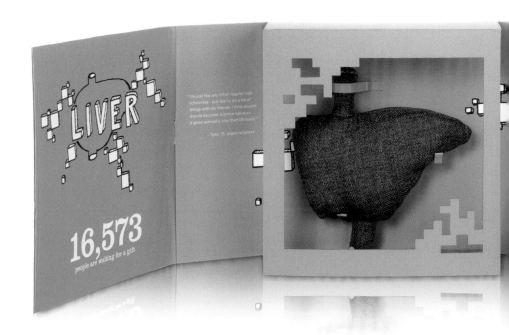

LIVER

"I'm just like any other regular high school kid - just like to do a lot of things with my friends. I think people should become a donor because it gives someone else their life back."

- Tyler, 15, organ recipient

16,573
people are waiting for a gift

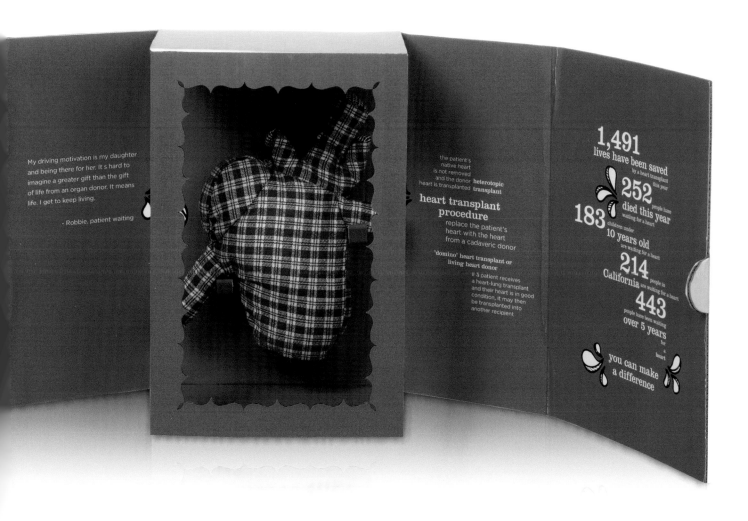

My driving motivation is my daughter and being there for her. It's hard to imagine a greater gift than the gift of life from an organ donor. It means life. I get to keep living.

- Robbie, patient waiting

the patient's native heart is not removed and the donor heart is transplanted **heterotopic transplant**

heart transplant procedure

replace the patient's heart with the heart from a cadaveric donor

"domino" heart transplant or living heart donor

if a patient receives a heart-lung transplant and their heart is in good condition, it may then be transplanted into another recipient

1,491
lives have been saved by a heart transplant this year

252 people have died this year waiting for a heart

183 children under 10 years old are waiting for a heart

214 people in California are waiting for a heart

443 people have been waiting over 5 years for a heart

you can make a difference

kidney

"I'm 9 years old. I love to read, play, and I really love to dance and just be a kid. My kidney transplant let me do that."

- Roma, 9, kidney recipient

In most cases only one kidney is transplanted, but two can be used if a donor is not ideal

kidney tran procedu

only one k needed fre donor for

splitting (experin

it b
sp
tr
is
a

82,897

people are waiting for a gift

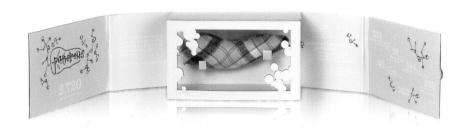

Greek Coffee

client ⌐ Draculi Coffee
studio ⌐ Mouse Graphics
Athens ⌐ Greece
creative director ⌐ Gregory Tsaknakis
art director ⌐ Gregory Tsaknakis
illustrator ⌐ Ioanna Papaioannou
www.mousegraphics.gr

El uso de letras griegas hace referencia al origen
griego del producto. Los colores primarios, las vistas
de planos para el enfoque fotográfico y los tipos de
letras tradicionales le proporcionan seguridad y
familiaridad al comprador. No se utilizan efectos y las
formas simples implican que el producto tiene una
gran calidad y estabilidad.

The use of Greek letters relates to the Greek origin
of the product. Primary colours, plan views for the
photographic approach and traditional typefaces
provide security and familiarity to the buyer.
No use of effects and simple forms imply perfect
product quality and stability.

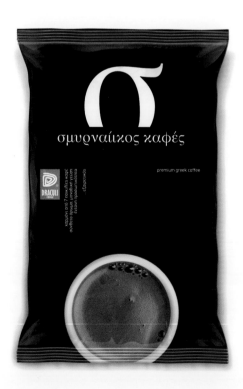

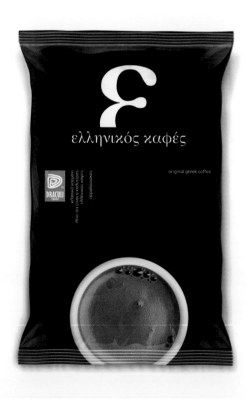

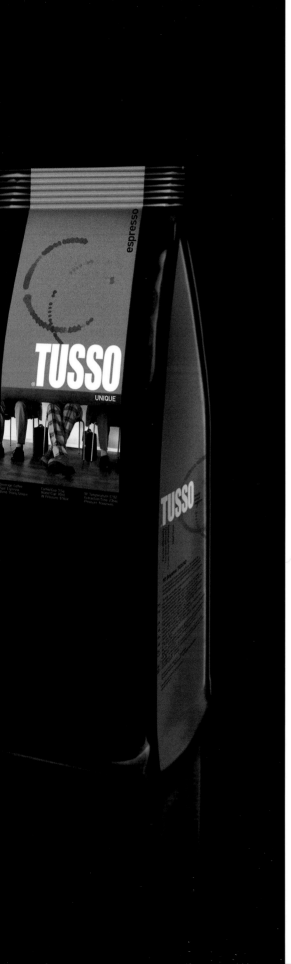

client ￢ Draculi Coffee
studio ￢ Mouse Graphics
Athens ￢ Greece
creative director ￢ Gregory Tsaknakis
art director ￢ Gregory Tsaknakis
illustrator ￢ Ioanna Papaioannou
www.mousegraphics.gr

Los valores principales de los productos Tusso son la
simplicidad, la estética y la calidad, y queremos que todos
nuestros clientes sean conscientes de ello.
Las fotos en blanco y negro de personas únicas, todas ellas
escogidas para un producto concreto lleno de color,
corresponden a la personalidad de cada producto.
Las formas simples, la tipografía clara y el uso del negro
como color de fondo, implican estabilidad y confianza en la
calidad del producto.

Unique simplicity, premium aesthetics and product
quality are the main principles of Tusso products and we
want this to be obvious to our customers.
The black&white photos of unique people, each chosen
for a particular product filled with solid colour, matches
the personality of each product. Simple forms, clear
typography and the use of black for background colour,
imply stability and confidence to the products' quality.

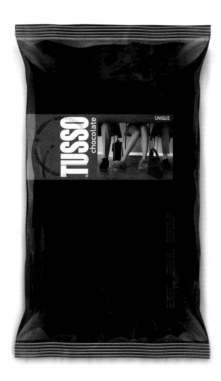

Castillo de Maetierra

client ⌐ **Vintae**
studio ⌐ **Moruba**
Logroño. La Rioja ⌐ Spain
www.moruba.es

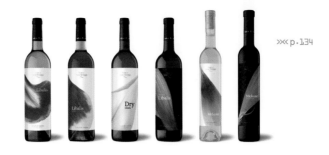

≫≪ p.134

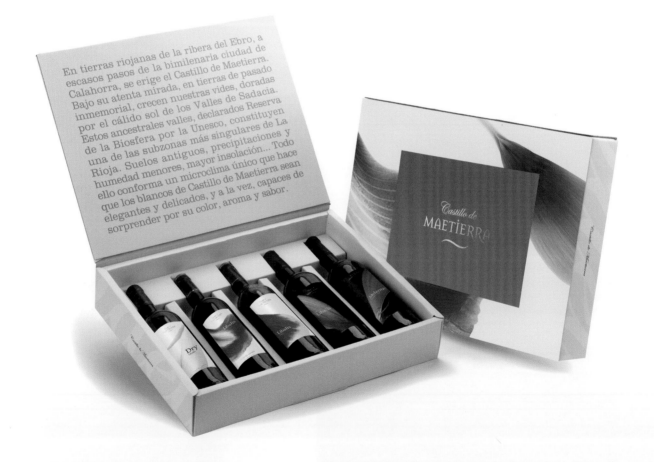

En tierras riojanas de la ribera del Ebro, a escasos pasos de la bimilenaria ciudad de Calahorra, se erige el Castillo de Maetierra. Bajo su atenta mirada, en tierras de pasado inmemorial, crecen nuestras vides, doradas por el cálido sol de los Valles de Sadacia. Estos ancestrales valles, declarados Reserva de la Biosfera por la Unesco, constituyen una de las subzonas más singulares de La Rioja. Suelos antiguos, precipitaciones y humedad menores, mayor insolación... Todo ello conforma un microclima único que hace que los blancos de Castillo de Maetierra sean elegantes y delicados, y a la vez, capaces de sorprender por su color, aroma y sabor.

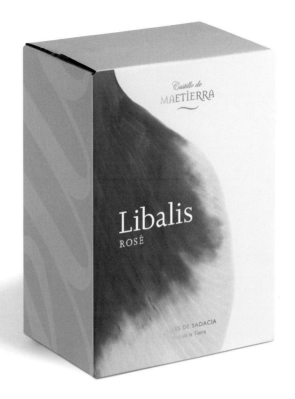

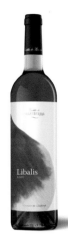

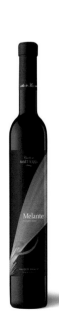

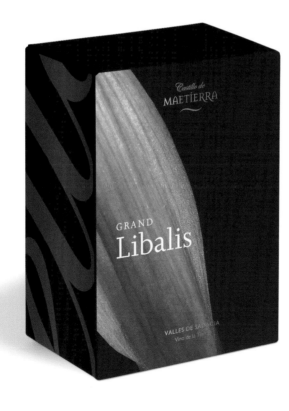

Real McCoy

>>> p. 58

>>> p. 59

client ┑ Diageo
studio ┑ The Creative Method
Sydney ┑ Australia
designer ┑ Tony Ibbotson
creative director ┑ Tony Ibbotson
typographer ┑ Tony Ibbotson
www.thecreativemethod.com

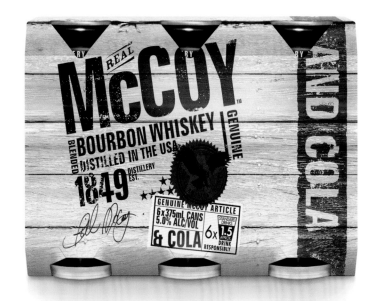

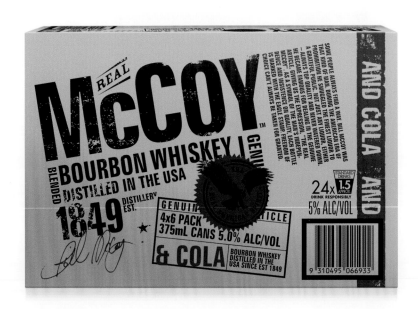

≫ p.60

Smirnoff Platinum

client ⌐ Diageo - Smirnoff
studio ⌐ The Creative Method
Sydney ⌐ Australia
designer ⌐ Tony Ibbotson
creative director ⌐ Tony Ibbotson
www.thecreativemethod.com

El envase tenía que reflejar pureza, simplicidad y actualizar el envase actual de Smirnoff.
El objetivo principal del envoltorio era mostrar frescor, reflejar el nombre de la marca y hacer referencia a la precisión utilizada en el proceso de filtración.

The packaging needed to reflect purity, simplicity and contemporise the current Smirnoff packaging.
The core objective of the wrap was to show refreshment, reflect the brand name and to allude to the precision used in the filtration process.

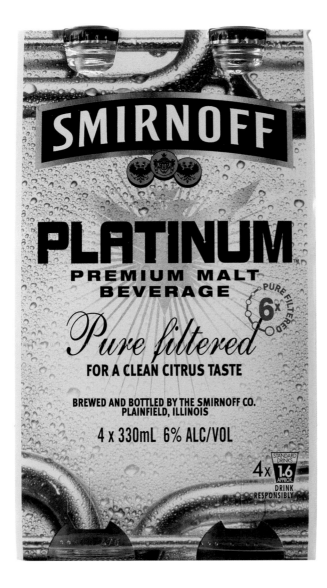

T'ang teahouse

client ㄱ T'ang teahouse
designer ㄱ Lin Shaobin
Shantou ㄱ China

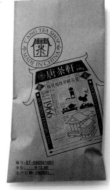
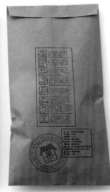

Este envase utiliza material ecológico reciclable, que además es ventajoso para el fabricante porque reduce el coste y permite controlar el precio de venta. El diseño gráfico del envase que se ha aplicado es el formato de los envases de té tradicionales chinos, con una técnica de ilustración moderna para crear la nueva imagen. El conjunto mantiene el sabor de los envases de té tradicionales, y la innovación en los detalles hace que sea simple, fino y elegante, valores que se transmiten a la marca Tang Chaxuan. Este envase causa muy buena impresión, y se diferencia de los otros envases que tienden a ser excesivos. La imagen visual simple y fina atrae al consumidor.

This packing used the material of green environmental protection, and the recycles use the Kraft paper, its serviceability, usable, was advantageous of producer to fall lowly in the cost, could be very good to control retail price.
The graphic designed of the packing has applied the Chinese tradition tea package format, with the modern illustration technique to design the new packing image. The whole retained the traditional tea packing flavor, and the mentality which innovation in the details to increase the overall packing to be simple, to be fine and elegant, transmits brand of Tang Chaxuan the localization and the connotation.
The whole impression of this packing to be prominent, which is different with other similar excessive packing, by simple, the fine visual image let the consumer to establish the good brand emotion.

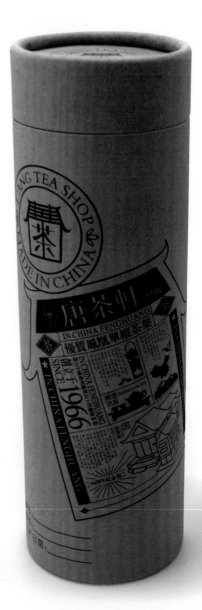

Puer tea

client ˥ Gumachadao Puer tea
designer ˥ Lin Shaobin
Shantou ˥ China

El té, el caballo y la nube prometedora constituyen el cuerpo principal del diseño, con asociaciones a la fábula de la caravana de caballos de la antigua Ruta del Té y los Caballos y a la gloriosa historia del té Puer. El diseño incorpora el rojo rubí como tono principal, que simboliza la noble calidad del té Puer.

The tea, the horse and the auspicious cloud constituted the main body of design, caucusing the human to associate to the horse caravan fable on the Ancient Tea Horse Road, and associates to glorious history of the Puer tea. The design took the ruby red as the host tone, symbolizing the noble unique quality tea soup of the Puer tea.

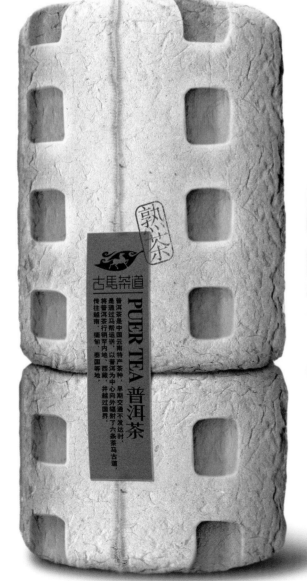

The Manual Co. Boxes

client ˥ **The Manual Co.**
studio ˥ **Peter Gregson Studio**
Novi Sad ˥ **Serbia**
art direction ˥ **Jovan Trkulja**
illustration ˥ **Filip Bojovic, Vladimir Mirkovic**
www.petergregson.com

Había que rediseñar las cajas de cartón de las botas, bolsos y accesorios de The Manual Company, una moderna franquicia que se dedica a la fabricación de artículos de lujo de piel de calidad, y accesorios y bolsos hechos a mano. Puesto que la empresa fabrica todos sus productos manualmente, decidimos crear las cajas con el mismo espíritu. Todos los dibujos de estas piezas se hicieron a mano.

Redesign for existing cardboard packaging design for boots, bags and accessories for The Manual Company, a modern franchise based on high quality luxury leather, handmade accessories and bags. Since the company produces everything manually, the idea behind was to create packaging in the same spirit. Everything on these pieces was drawn by hand.

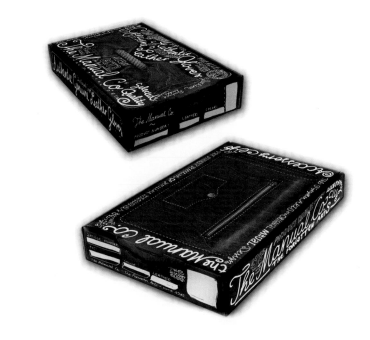

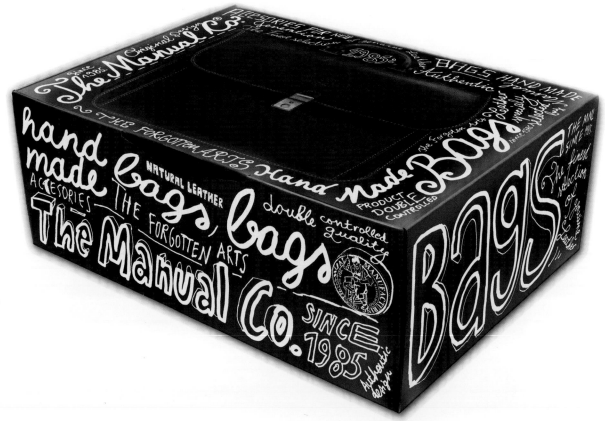

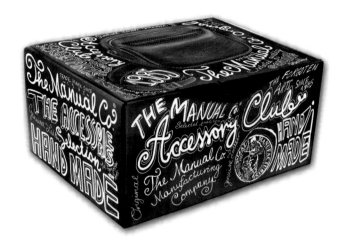

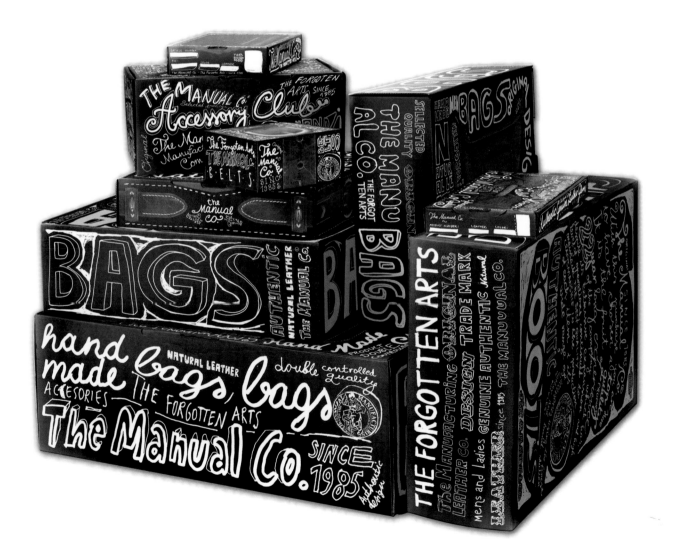

Special edition boxes for Pasion for Fashion

client ˥ **Pasión for Fashion**
studio ˥ **Narrow House**
Madrid ˥ **Spain**
www.narrow-house.com

Passion for Fashion es una tienda de moda online especializada en ropa y accesorios. En un primer momento, se dirigieron a nosotros para que diseñáramos su identidad de marca y les ayudáramos con el diseño de su página web. Acababan de abrir el negocio y su presupuesto era muy pequeño. De hecho, aceptamos bolsos, zapatos y joias como pago.

A medida que nuestra relación y su negocio fueron creciendo, sugerimos que empezaran a "jugar" con la marca y, a modo de experimento, creamos una gama de packaging de edición especial. Ese primer año, creamos 3 cajas de edición especial que tuvieron un gran éxito, crearon un gran revuelo y les hicieron ganar publicidad gratuita en varios periódicos y revistas de moda.

De ahí, la idea ha ido creciendo y ahora creamos de 5 a 10 cajas de edición especial a lo largo del año. Basamos los diseños de cada caja en un tema de moda/belleza, pero a veces podemos irnos por las ramas y ser bastante abstractos. Es muy divertido hacer estos diseños, y tenemos suerte de que a nuestro cliente le encanta lo que hacemos y nos da toda la libertad para hacerlo.

Pasión for Fashion is an online fashion store specialising in clothes and accessories. They first came to us to design their brand identity and to help them with the design of their website. At that time they had just started their business and their budget was particularly small, in fact we accepted bags, shoes and jewellery as payment. As our relationship and their business grew, we suggested that they should begin to "play" with their brand and as an experiment we created a range of special edition packaging. In that first year we created 3 special edition boxes that proved to be an enormous success, creating a buzz and gaining free publicity in many newspapers and fashion magazines. From there, the idea has grown and now we create between 5 to 10 different special edition boxes throughout the year. We base the designs for each box on the fashion/beauty theme, but they can easily go off on a tangent, often becoming quite abstract. They are great fun to design and we are lucky that our client loves what we do and gives us freedom to do it.

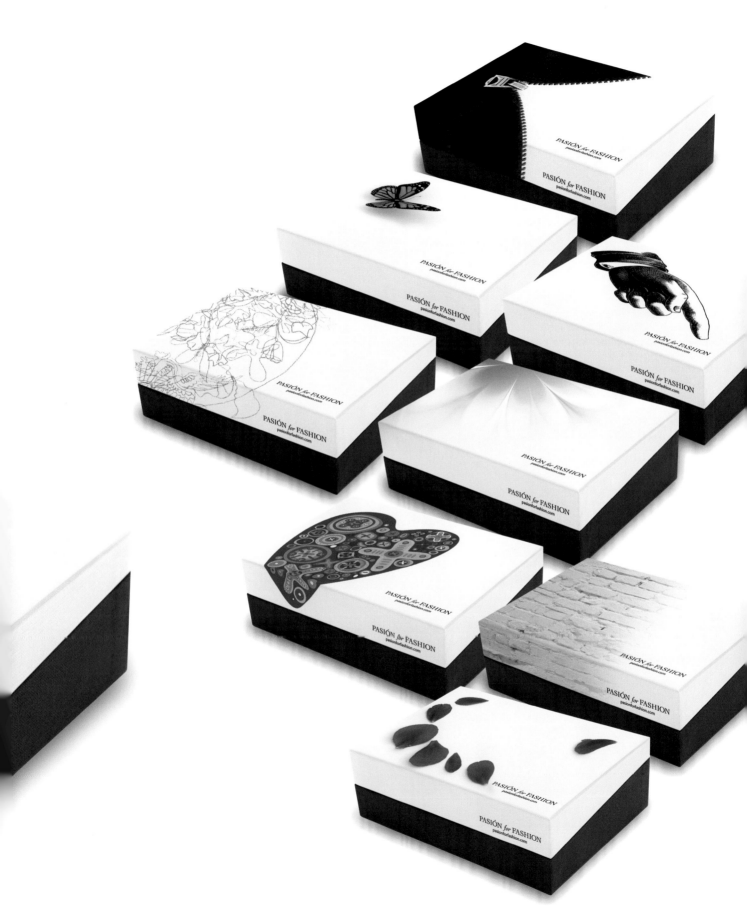

Packaging concept

client ⌐ Warner Brothers Records
studio ⌐ **Adam&Company**
Boston ⌐ USA
designer / art direction ⌐ Adam Larson at Adam&Co.
illustration ⌐ Adam Larson
www.adamncompany.com

Cuando se terminó el contrato de 25 años que tenía con Warner Brothers, Madonna iba a lanzar un disco de grandes éxitos definitivo que repasaría toda su carrera hasta el momento, titulado simplemente "Hits". Adam&Co. recibió el encargo de desarrollar los conceptos de packaging para el lanzamiento. Este concepto ilustra un digipack de 6 paneles con una envoltura de plástico transparente y 1 estuche serigrafiado de color. El digipack se pliega y revela a Madonna posando en la señal de cruz.
El librillo que acompaña el paquete se diseñó de modo que pareciera una Biblia. Cada capítulo contiene texto sobre cada uno de los álbumes de su carrera, acompañado por una ilustración única que hace referencia a su estilo en esa época.

As her 25 year contract with Warner Brothers came to an end, Madonna was to release a definitive greatest hits record that would catalogue her career to date, simply titled "Hits". Adam&Co. was commissioned to develop packaging concepts for the release. This concept illustrates a 6-panel digi-pak enclosed in a clear plastic, 1 color silk-screened sleeve. The digi-pak folds out to reveal Madonna posed in the sign of the cross.
The booklet that accompanied the package was designed to resemble a bible. Each chapter contains text around each album of her career, accompanied by a unique illustration that references her stylings from that era.

Martina

client ᛨ Massana Noya
studio ᛨ Puigdemont Roca design agency
Barcelona ᛨ Spain
designer ᛨ Albert Puigdemont
www.puigdemontroca.com

»« p.64

TCHO

client ˧ Tcho
studio ˧ Edenspiekermann
Berlin ˧ Germany
creative director ˧ Susanna Dulkinys
typographer ˧ Erik Spiekermann
photography ˧ Mark Leet
www.edenspiekermann.com

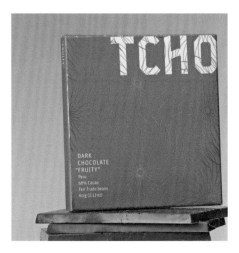

Para los aztecas, el grano de cacao era tan valioso que lo utilizaban como moneda. Una barrita de cholocate TCHO, con sus patrones quilloché algorítmicos, parece una moneda moderna. La palabra "moderna" apareció en el encargo de identidad de marca desde el primer momento. No querían falsos tradicionalismos, sino mirar hacia delante para una nueva generación de apasionados del chocolate.
Los colores y los productos de las barritas TCHO se sacan de la Rueda del Sabor de TCHO y representan la filosofía de la empresa basada en los sabores: chocolatoso, terroso, a frutos secos, floral, afrutado y cítrico. La barrita de chocolate más pequeña de TCHO tiene una forma cuadrada. Este cuadrado es la base de medida de la cuadrícula utilizada en todos los embalajes, folletos y comunicaciones. El logotipo deriva de una fuente icónica del sector industrial pero con los trazos transversales y las esquinas modificadas. El sistema de composición se basa proporcinalmente en múltiples de los cuadrados, definiendo las medidas de las columnas y la escala de la imagen.

The Aztecs prized the cacao bean so highly that it was their form of currency. A TCHO Chocolate bar, with its algorithmic guilloche patterns, looks like a modern form of currency. 'Modern' was always part of the brand identity brief - no faux traditionalism, but resolutely forward-looking for a new generation of chocolate enthusiasts.
The colors on TCHO's bars and products are drawn from the TCHO Flavor Wheel and represent the company's unique flavor-driven philosophy, based on the inherent flavors present in cacao: chocolatey, earthy, nutty, floral, fruity, and citrus. TCHO's smallest chocolate bar has a square shape. This square is the basis of measure for the grid underlying all packaging, literature, and communications. The logotype is derived from an iconic letterform from the industrial sector but with modified cross-strokes and corners. The layout system is proportional based on multiples of squares, defining column measures and image scale.

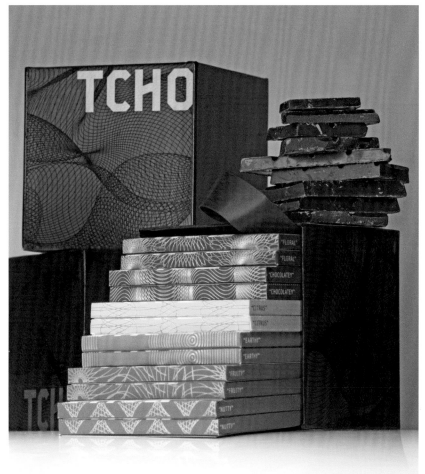

Dom Ruinart

client � Dom Ruinart
studio ꓐ Partisan du Sens
Paris ꓐ France
art direction ꓐ Gérald Galdini, François Takounseun
photography ꓐ Thomas Duval
www.partisandusens.com

Para celebrar el cincuenta aniversario de la marca, Partisan du sens creyó que era necesario diseñar una caja de presentación excepcional en negro mate iluminada por una tapa de acero inoxidable a modo de espejo, que evoca el brillo del gran chardonnay.

Un solo gesto y la tapa se despliega y proporciona una preciosa superficie que sirve de bandeja.

El metal fundido plateado se adapta perfectamente a los contornos de las copas y la botella.

Esta puesta en escena decorosa sacraliza la unión del Dom Ruinart 1998 con la botella y las flautas, que van a tener un papel muy importante en la cata de vinos, y sella su alianza a lo largo de más de cincuenta años de excelencia.

To make the golden jubilee of the brand, Partisan du sens felt it would be suitable to design an exceptionnal presentation box sheated in matt black lit up by a stainless steel mirror-light lid evocative of the great chardonnay brilliance.

One single gesture and the lid strepches out and expectedly provides a surface serving as a precious tray. Its silvery skin like molten metal closely fits the contours of the glasses and bottle.

This decorous staging will sacralize the conjunction of the Dom Ruinart 1998 with the bottle and flutes which are to play an imminent part in the coming wine-tasting thus setting the seal on their alliance over fifty years of excellence.

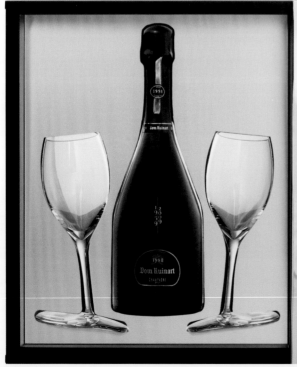

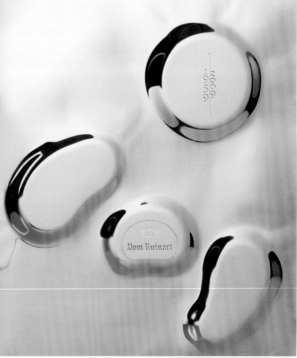

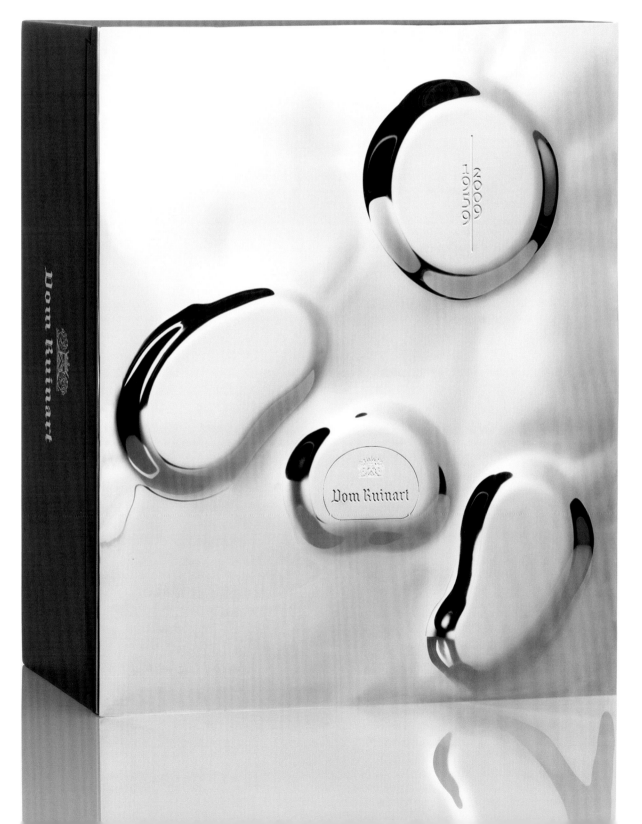

Mesoestetic Men

client ˥ Mesoestetic
studio ˥ Espluga + Associates
Barcelona ˥ Spain
www.espluga.net

≫≪ p.49

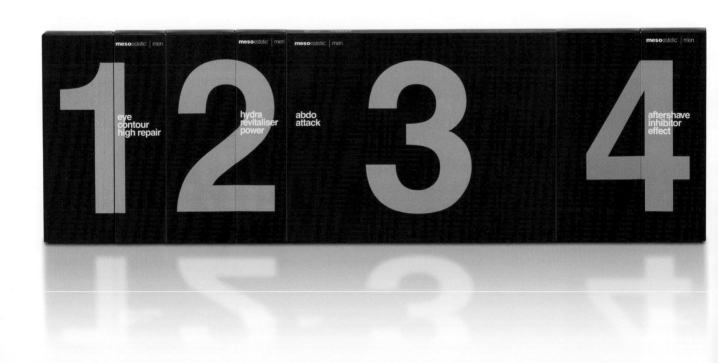

>>< p.14

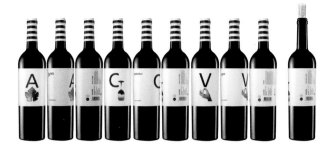

Carchelo

client ˥ Carchelo
studio ˥ Eduardo del Fraile
Murcia ˥ Spain
www.eduardodelfraile.com

Far Foods

studio ˥ James Reynolds
London ˥ England, UK
designer ˥ James Reynolds
www.jwgreynolds.co.uk

El autor estaba maravillado por lo fácil que era comprar comida de lugares tan lejanos como África, Sudamérica o el Caribe, y lo poco que se pensaba en cómo había llegado hasta aquí, o en los daños causados durante el transporte al supermercado de Inglaterra o Europa. El proyecto se creó para informar a los clientes del supermercado sobre el origen de la comida, la distancia viajada y el dióxido de carbono emitido, de un modo claro y fácil de entender. La etiqueta simbólica de la maleta es el símbolo reconocido internacionalmente del viaje, y pensé que era la manera más fácil de comunicar la idea. Esperemos que el embalaje haga que los clientes se paren a pensar en el origen de su comida, y quizás escojan un producto local en vez de un producto de un lugar exótico.

The author was amazed at how easy it was to buy an item of food from somewhere as far away as Africa, South America or the Caribbean, but without giving a thought as to how they got there or the damage caused by transporting the food to a supermarket in England or Europe. The project was created to hopefully inform supermarket customers where the food comes from, the distance travelled and the carbon dioxide emitted, in a clear and easy way to understand. The iconic luggage label is an internationally recognised symbol of travel, which I thought was the easiest way of communicating the idea.
Hopefully the packaging will make customers stop and think about the origin of their food, with them perhaps choosing a locally-sourced product instead of one from an exotic location.

THESE TOMATOES HAVE TRAVELLED 6866 MILES BY AIRFREIGHT AND HGV
THIS JOURNEY RELEASED 5100G OF CARBON DIOXIDE INTO THE AIR

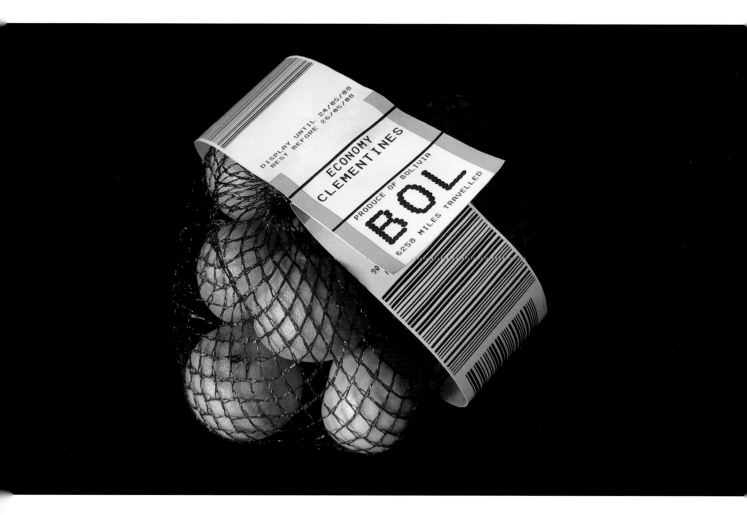

Help Remedies
OTC Medication

client ⌐ **Help Remedies**
studio ⌐ **ChappsMalina**
New York ⌐ **USA**
structural and product design ⌐ **ChappsMalina**
identity and graphics ⌐ **Little fury**
www.chappsmalina.com

Help Remedies es una línea de medicamentos OTC que pretende simplificar los temas de salud simples. La línea consiste en 6 productos diseñados para ayudar a guiar al consumidor por los pasillos de medicinas con facilidad y comodidad. El enfoque del producto era sencillo, limpio y minimalista, con suficientes códigos e indicaciones para articular claramente el síntoma del modo más directo posible. Para reforzar el mensaje de responsabilidad de Help Remedies, el empaque se diseñó y se fabricó utilizando una innovadora combinación de pulpa de papel y plástico a base de maíz, de modo que es totalmente compostable. Los elementos clave como los nuevos materiales, la codificación por color y una narrativa ingeniosa han logrado crear una presencia en la estantería única y que se reconsiderara el modo de entender la medicación de libre venta.

Help Remedies is a line of OTC medication aimed at making simple health issues simple. The line consists of 6 products that are designed to Help guide the consumer through the medicine aisles with ease and comfort. The product approach was simple; it's clean and minimal with enough coding and approachable cues to clearly articulate the symptom as directly as possible. To reinforce the Help Remedies message of responsibility the packaging was designed and manufactured using a highly innovative combination of paper pulp and co-molded corn-based plastic making it completely compostable and a first of it's kind. Key elements such as new materials, color coding and clever narrative have culminated to create a purely unique shelf presence and re-thinking of the OTC medication experience.

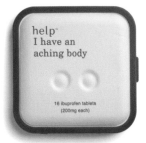
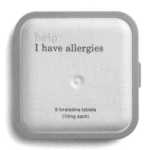
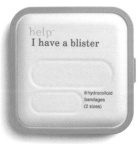
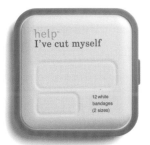
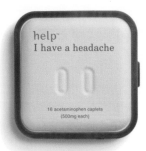
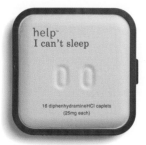

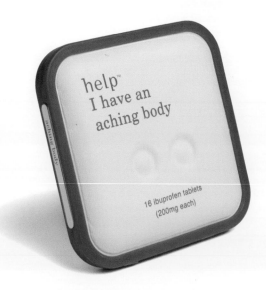

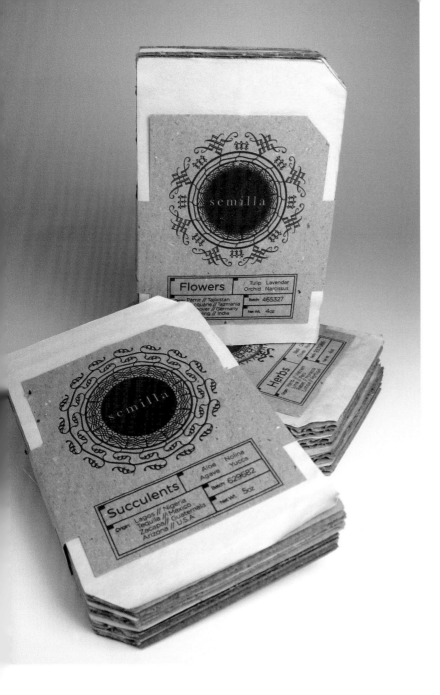

Semilla

client ⌐ **Semilla**
studio ⌐ **Erick Fletes**
San Francisco ⌐ **USA**
designer ⌐ **Erick Fletes**
www.oherick.com

Semilla abarca los valores fundamentales del reciclaje. En estos tiempos de sostenibilidad y suave apisonamiento de nuestro palenta, nos encontramos delante de un nuevo reto: el reto de crear sabiamente respetando el planeta en el que vivimos. Estos paquetes con semillas de jardín están dirigidos a la población que vive en una gran ciudad y no tiene un gran terreno. Hay 6 vainas individuales en cada paquete, lo justo para cultivar las verduras suficientes. Se han utilizado tintas de soja para no dañar el planeta de ningún modo.

Semilla encompasses the fundamental values of recycling. In this time of sustainability and light treading of our planet we have come to face a new challenge, a challenge to create wisely with proper respect to the planet we live on. These garden seed packages are aimed at the demographic who live in a busy city and do not have a large plot, the individual pods come six to a package, just enough to grow the right amount of veggies. Soy based inks were also used as to not harm the planet in any way.

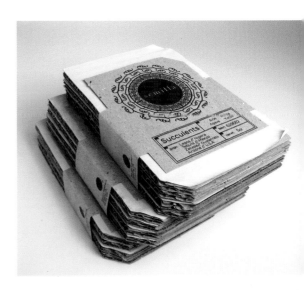

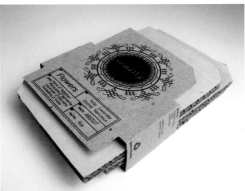

T-Shirt design kit

client ⌐ **Born To Create**
studio ⌐ **GT Design International Co.Ltd.**
Tokyo ⌐ Japan
designer ⌐ Henry Ho
www.gtdi.co.jp

Nuestro reto era crear un producto que cumpliera el concepto de la marca, "Nacido para crear". Queríamos productos que animaran a los niños a participar en el proceso de diseño, y que se divirtieran haciéndolo. La camiseta tiene una zona de color a la que se le ha dado forma para estimular las ideas de los niños y que sepan que el proceso de diseño siempre tiene unos límites. El embalaje exterior utiliza el material del cartón de huevos para concienciar sobre la ecología. Además, la forma es fácil de exponer y es fácil de llevar para los niños.

Our challenge was to create product that pursue the brand concept, 'Born to Create'. We wanted products that encourage children to participate in the design process, and find joy in that process. The shirt has a color area that is shaped to stimulate children's idea and also be aware of the design process which always has limits. The outer packaging uses egg carton material for awareness of ecology and the shape is easy to display, as well as easy for children to carry.

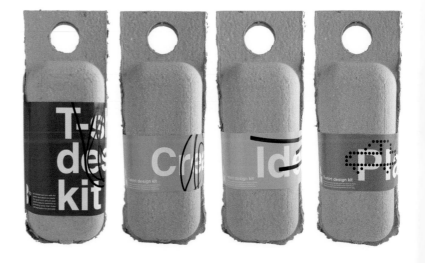

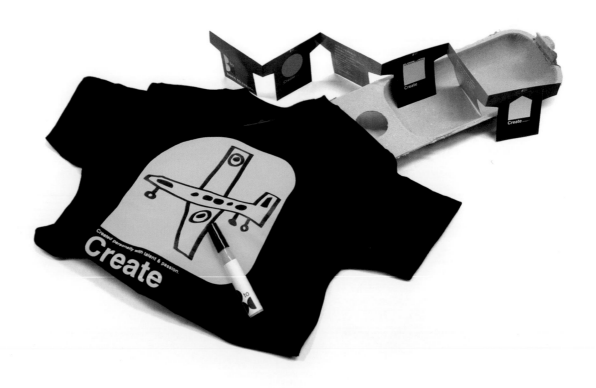

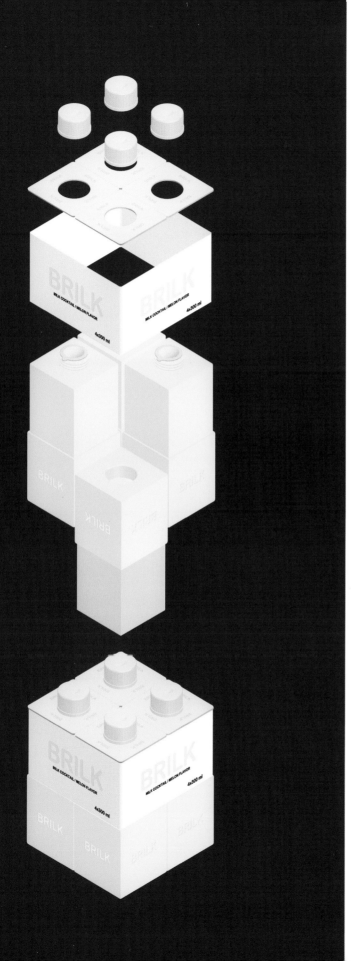

Brilk

client ⌐ **Brilk**
studio ⌐ **Hattomonkey**
Novosibirsk ⌐ **Russia**
designer ⌐ Alexey Kurchin
www: hattomonkey.ru

Nuestra tarea consistía en crear un packaging inususal para promover las ventas.
No importa lo bonito que sea un embalaje, siempre acabará en la basura, ¿Y si prolongáramos su vida? Se nos acudió crear un embalaje modular que pudiera utilizarse como juguete.
BRILK es un concepto de embalaje modular para bebidas o zumos de niños. La unidad consiste en 4 envases y un soporte. La unidad es un elemento de construcción como Lego. El soporte es el elemento de unión. Se puede doblar y dividir. BRILK es una buena manera de utilizar la imaginación.
¡Cuantas más unidades, más interesante!

The task was to create the unusual package, which is to promote sales.
No matter how the package is beautiful, the only place is waiting it is scrap basket. How about prolonging its life? So the idea came to the mind to create the modular package, that can be used as a toy.
BRILK is a concept of modular package for children's cocktails or juices. The unit consists of 4 packages and holder. So the unit is the element of construction set like Lego. Holder is the locking element. It can bend and be divided. BRILK is a good way to use imagination.
More units – more interest!

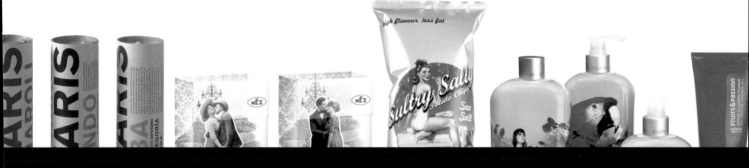

range

Spatula Pputty

client ⌐ **Petrocoll**
studio ⌐ **Mouse Graphics**
Athens ⌐ Greece
creative director ⌐ Gregory Tsaknakis
art director ⌐ Aris Pasouris
www.mousegraphics.gr

Pensamos en el producto como bien de consumo dinámico. Teniendo en mente la creación de un paquete para vender masilla, creamos un diseño que distinguiera a la marca (Petrocoll) de sus competidores. Utilizamos el elemento femenino como plartaforma de comunicación; una figura femenina estaría bastante fuera de lugar en una obra de construcción y confiamos en que crearía un gran revuelo entre los profesionales del sector. Todas las figuras femeninas llevan ropa con varios niveles de transparencia. La idea no era ser provocativo, sino asociar las características del producto (grado de superposición de la masilla), con la prenda respectiva.

We thought of the product as any fast moving consumer good; with our mind towards the creation of a pack that would in fact sell putty, we created a design that could differentiate the brand (Petrocoll) from its competition.
We employed the female element as our communication platform; a female figure would seem quite out of place within a construction site and would -we hoped- create a buzz among people in the business. Every female figure was dressed up with clothing of various degrees of transparency - the idea being not to be provocative, but to relate the product characteristics (degree of putty overlap), with the respective garment.

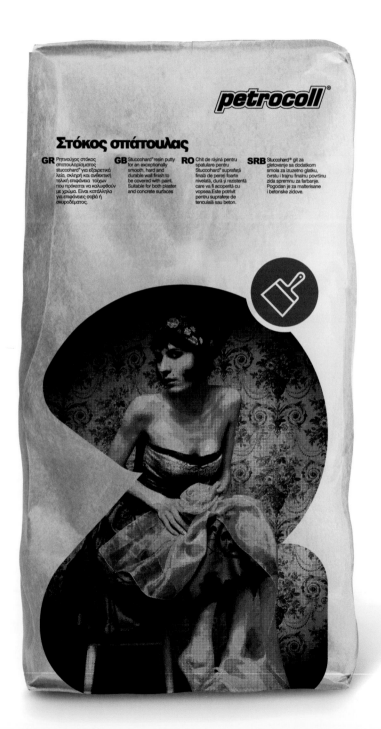

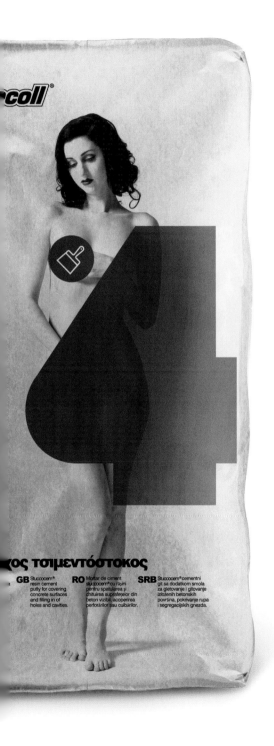

coll®

ΚΟΣ ΤΣΙΜΕΝΤΟΣΤΟΚΟΣ

GB Stuccocem®
resin cement
putty for covering
concrete surfaces
and filling in of
holes and cavities.

RO Mortar de ciment
stuccocem® cu rășini
pentru spatularea și
chituirea suprafeelor din
beton vizibil, acoperirea
perforărilor sau cuibărilor.

SRB Stuccocem® cementni
git sa dodatkom smola
za gletovanje i gitovanje
izloženih betonskih
površina, pokrivanje rupa
i segregacijskih gnezda.

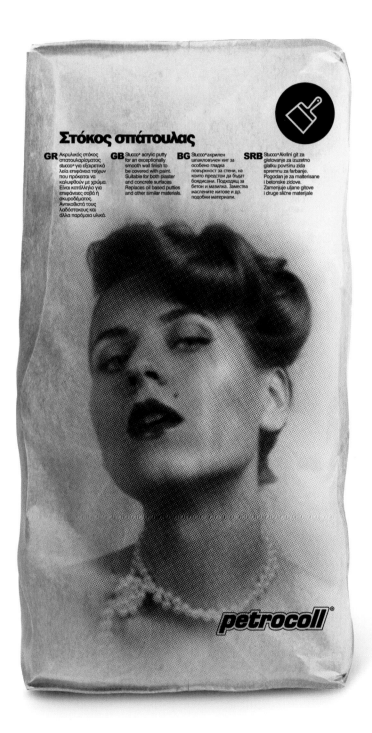

Στόκος σπάτουλας

GR Ακρυλικός στόκος
σπατουλαρίσματος
stucco® για εξαιρετικά
λεία επιφάνεια τοίχων
που πρόκειται να
καλυφθούν με χρώμα.
Είναι κατάλληλο για
επιφάνειες σοβά ή
σκυροδέματος.
Αντικαθιστά τους
λαδόστοκους και
άλλα παρόμοια υλικά.

GB Stucco® acrylic putty
for an exceptionally
smooth wall finish to
be covered with paint.
Suitable for both plaster
and concrete surfaces.
Replaces oil based putties
and other similar materials.

BG Stucco® акрилен
шпакловъчен кит за
особено гладка
повърхност за стени, на
които предстои да бъдат
боядисани. Подходящ за
бетон и мазилка. Заменя
маслените китове и др.
подобни материали.

SRB Stucco® Akrilni git za
gletovanje za izuzetno
glatku površinu zida
spremnu za farbanje.
Pogodan je za malterisane
i betonske zidove.
Zamenjuje uljane gitove
i druge slične materijale.

petrocoll®

Sultry Sally

client ⌐ Potato Magic
studio ⌐ **The Creative Method**
Sydney ⌐ Australia
designer ⌐ Tony Ibbotson
creative director ⌐ Tony Ibbotson
typographer ⌐ Tony Ibbotson
www.thecreativemethod.com

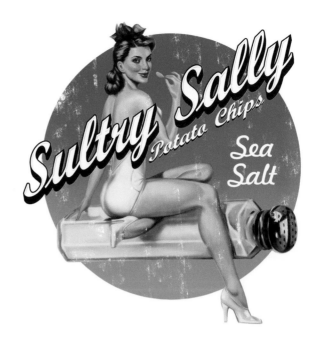

Una gama de originales bolsas de patatas para Sultry Sally, para su línea internacional de patatas bajas en grasas y con todo el sabor.
Se crearon ilustraciones tipo "Vargas Girls" de los años 40 como el centro y la idea principal de los paquetes, ya que le dieron a Sally personalidad, actitud y diferenciación de los productos existentes en el mercado. El punto de precio del producto estaba al máximo, de modo que la calidad, la atención al detalle y el estilo clásico eran necesarios para reflejarlo. Sally se ilustró interactuando con cada sabor de un modo distinto, así se diferencian bien los sabores, y la figura de Sally es un gran vínculo entre todas las bolsas de la gama.

A range of unique chip packages for Sultry Sally, a new to world range of low fat, high flavour potato chips.
Vargas Girl style illustrations of the 1940's were created as the focus and core idea for the packs as they gave Sally immediate personality, attitude and standout from existing products in the market. The product price point was at a premium so quality, attention to detail and classic style was required to reflect that. Sally is illustrated interacting with each flavour in a different way, this gives good flavour differentiation, while Sally herself is a great link between all the packs in the range.

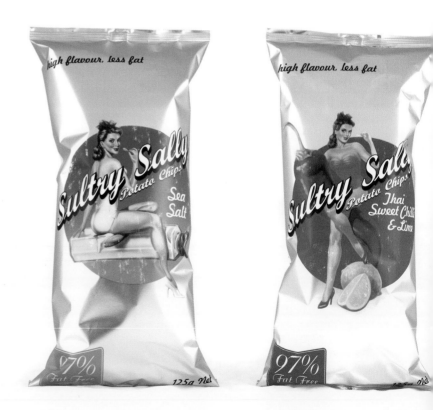

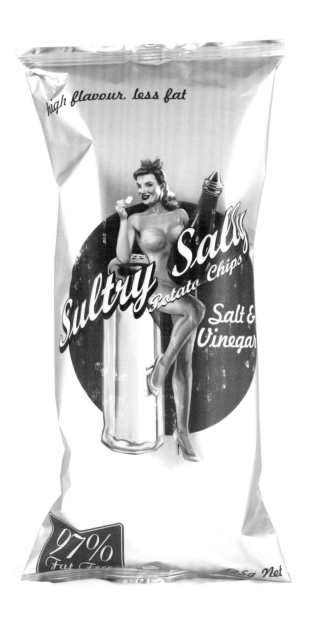

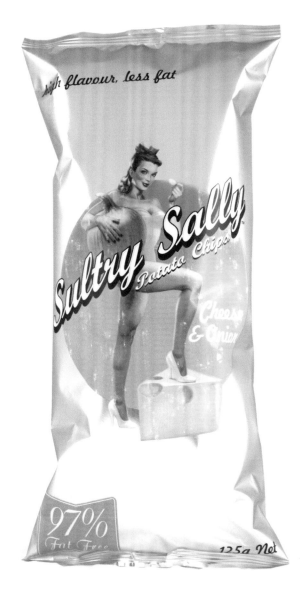

G&B Wine

client ⌐ G&B Restaurant
studio ⌐ Narrow House
Madrid ⌐ Spain
www.narrow-house.com

El G&B es un restaurante y bar de la costa este (Reino Unido).
Estas botellas de vino se crearon en un principio para un proyecto de diseño interior. Los propietarios del restaurante se dirigieron a nosotros para ver si podíamos hacer algo para darle más sabor a la decoración del restaurante, pensando que podíamos crear algunos murales o tapices.
En Narrow House nos esforzamos por sorprender a nuestros clientes, así que decidimos que en vez de hacer lo típico, decoraríamos su restaurante utilizando centenares de botellas de vino. Para este proyecto diseñamos 25 etiquetas de vino ilustrativas distintas.
Al cliente le gustó la idea y seguimos adelante. Muy pronto, los clientes del restaurante empezaron a pedir si podían probar el vino, así que los propietarios decidieron utilizar las etiquetas en su vino de la casa. Las etiquetas se iban cambiando periódicamente, y para las ocasiones especiales hacemos etiquetas nuevas (Navidad, Pascua, la Copa del Mundo, etc.).

The G&B restaurant and lounge, restaurant on the east coast (United Kingdom).
These wine bottles actually began life as an interior design project. The owners of the restaurant approached us to see if we could do something to spice up the decoration of their restaurant thinking that we would create some murals or wall hangings.
In Narrow House we try very hard to surprise our clients so we decided that instead of the doing the usual we would decorate their restaurant with hundreds of wine bottles. For this project we designed 25 different illustrative wine labels.
The client thought it was great and the idea went ahead. Very soon their customers began asking to sample the wine so the owners decided that they would use the labels for their house wine.
The labels change occasionally and we produce new labels for special occasions (Christmas, Easter, the world cup etc.).

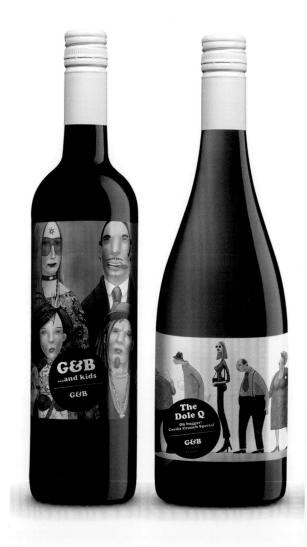

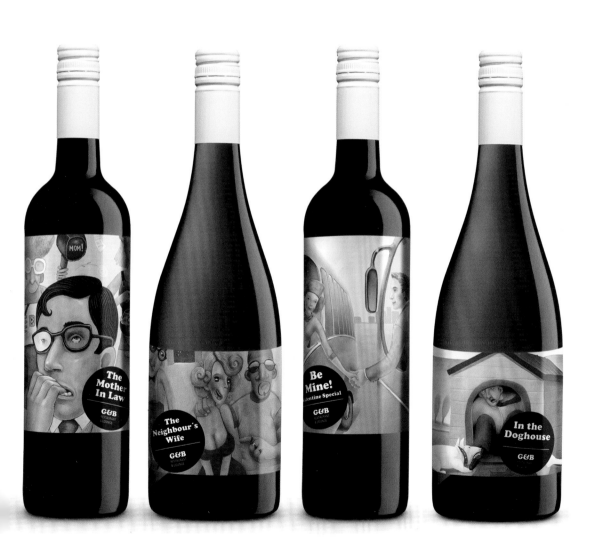

Castillo de Maetierra

client ˥ **Vintae**
studio ˥ **Moruba**
Logroño. La Rioja ˥ Spain
www.moruba.es

≫≪ p.102

Castillo de Maetierra es la única bodega de La Rioja especializada en blancos. El concepto e imagen gráfica de la colección debía de reflejar las características de unos vinos elegantes y delicados pero, a la vez, capaces de sorprender al igual que su diseño.
La linea de packaging, de inconfundible personalidad transmite, a través de una serie de imágenes de pétalos, propiedades como el aroma, el color y el frescor que hacen de estos vinos blancos de alta expresión un producto singular y diferente.

Castillo de Maetierra is the only wine producer in the La Rioja region specializing in white wines. The concept and the graphic image reflect the qualities of a collection of elegant and delicate wines which, just like the design, also display an element of surprise.
The unmistakable packaging, based on a series of images featuring petals, transmits the sort of properties, aroma, colour and freshness, which make these exquisite white wines a distinctive and exceptional product.

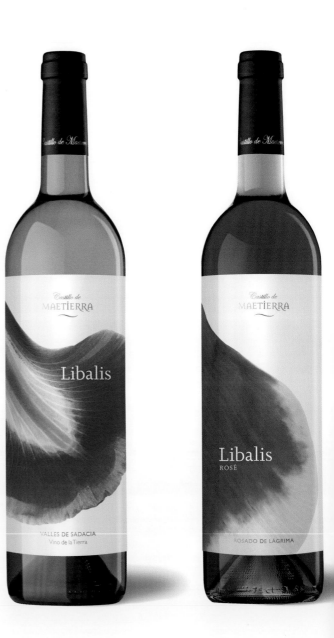

Dry
Libalis

VALLES DE SADACIA
Vino de la Tierra

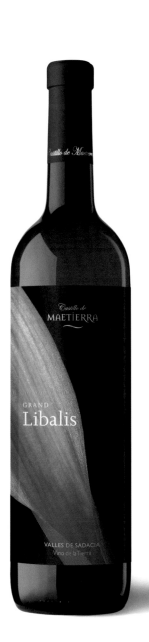

Castillo de
MAETIERRA

GRAND
Libalis

VALLES DE SADACIA
Vino de la Tierra

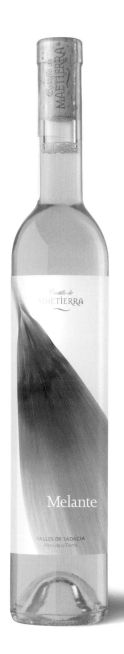

Castillo de
MAETIERRA

Melante

VALLES DE SADACIA
Vino de la Tierra

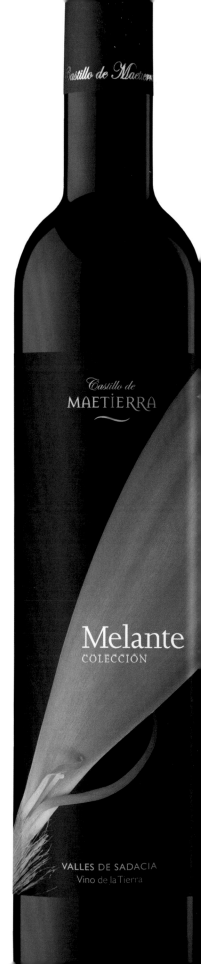

Castillo de
MAETIERRA

Melante
COLECCIÓN

VALLES DE SADACIA
Vino de la Tierra

Mermeladas Museo de la Confitura

client ˥ **Museu de la Confitura de l'Empordà**
studio ˥ **Petit Comité**
Barcelona ˥ Spain
www.petitcomite.net

Una mermelada con muchos números para estar en un museo.
Una colección tan amplia de mermeladas, más de cien, sólo se podía ordenar mediante números. Bajo este concepto se combinaron las tipografías Clarendon para la numeración y Helvética para la definición del sabor. Para ilustrar las etiquetas, fotografías en blanco y negro del entorno donde se encuentra el museo. El conjunto potencia la idea de fusión entre tradición y contemporaneidad.

A great number of Jams to be in a museum. With such a wide selection of jams, more than one hundred, they can only be listed by numbers. With this in mind, a combination of two separate typographies have been used, Clarendon for the numbers and Helvética for the flavour description. Black and white photographs showing the museum setting are used to illustrate the labels. The collection endorses the idea of merging the traditional with the contemporary.

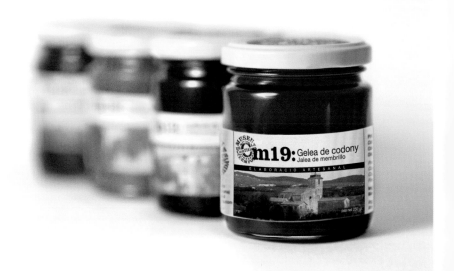

So Biotic yogurt drinks

client ˥ So Biotic
studio ˥ Davies Leslie-Smith
Buckinghamshire ˥ UK
designer ˥ Steve Davies
art director ˥ Tim Leslie-Smith
www.daviesleslie-smith.co.uk

Un delicioso yougur líquido bajo en grasa, donde el diseño tenía que manifestar claramente los sabores frescos y afrutados del producto.

A delicious low fat drinking yogurt where the design needed to clearly convey the fresh and fruity flavours.

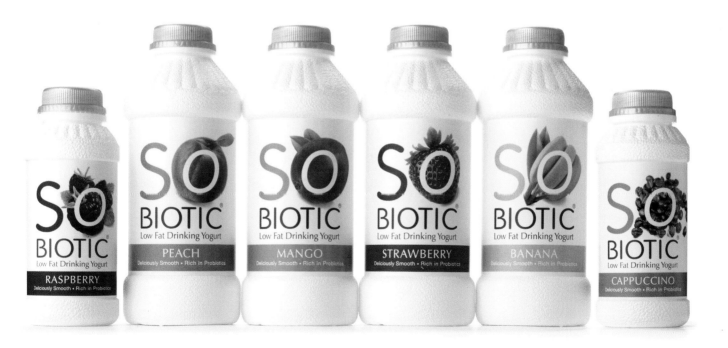

Atugusto - La Sirena

client ￢ **La Sirena**
studio ￢ **Marnich Associates**
Barcelona ￢ Spain
designers ￢ **Wladimir Marnich** , **Griselda Martí.**
Marnich Associates
www.marnich.com

Las tiendas La Sirena son los especialistas en
congelados del mercado español. El cliente nos pidió
que desarrolláramos su propio diseño de marca
familiar para su nueva gama de productos no
congelados para acompañar y realzar el sabor de sus
productos.
En esta gama podemos encontrar varios tipos de
salsas, harina, mayonesa, etc.

La Sirena stores are a frozen food specialist wihtin
the Spanish market. We were asked by our client
to develop an own brand family design for a new
range of non-frozen products to accompany and
make tastier their regular products.
Within this range we can find many type of
sauces, flour, mayonnaise, etc.

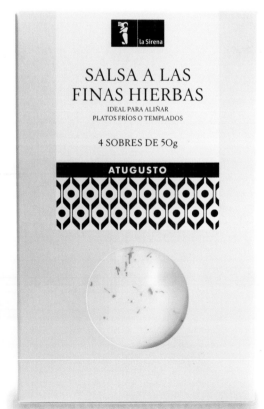
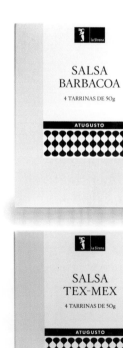

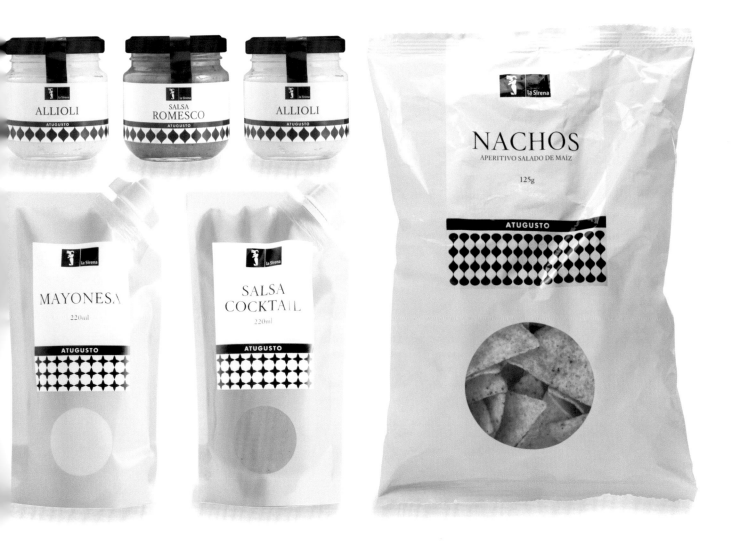

ALLIOLI
ATUGUSTO

SALSA
ROMESCO
ATUGUSTO

ALLIOLI
ATUGUSTO

la Sirena

MAYONESA
220ml
ATUGUSTO

SALSA
COCKTAIL
220ml
ATUGUSTO

la Sirena

NACHOS
APERITIVO SALADO DE MAÍZ

125g

ATUGUSTO

Treo

client ⌐ **McNeal**
studio ⌐ **BVD**
Stockholm ⌐ Sweden
www.bvd.se

Treo es un clásico sueco de los años 50 y 60, y tiene
un diseño muy conocido. El packaging tenía que
hacerse más explícito y moderno sin perder su fuerza
icónica. Solución: pequeños ajustes en la tipografía y
el color. Una imagen que muestra un comprimido
disolviéndose de forma fácil y rápida en el agua.

Treo is a Swedish classic of the 50s and 60s, and
has a very well known design. The packaging
needed to become more explicit and modern
without losing its iconic power.
Solution: small adjustments of typography and
colour. An image that gives the impression of a
tablet quickly and easily dissolving in water.

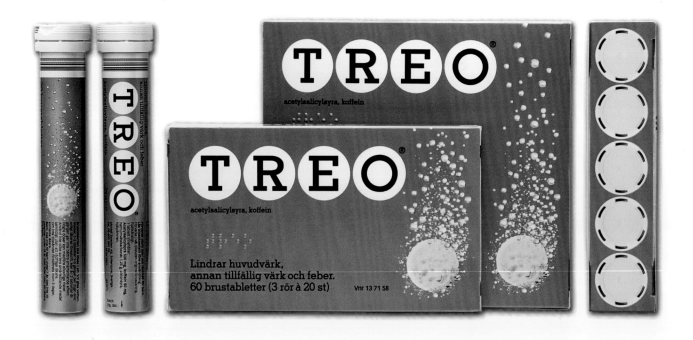

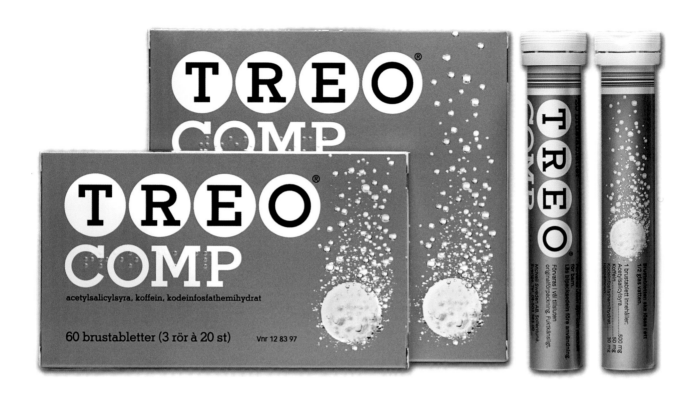

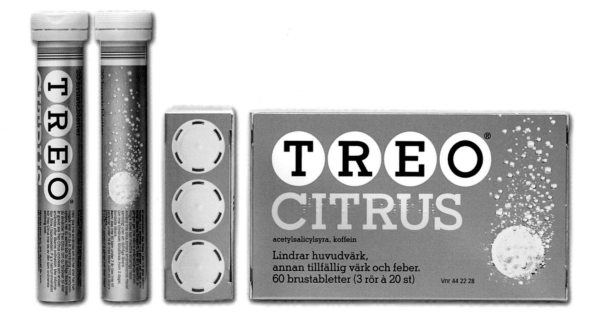

Helps

client ⌐ Pharmadus
studio ⌐ Zapping/M&CSaatchi
Madrid ⌐ Spain
design ⌐ Kiko Argomaniz
creative director ⌐ Uschi Henkes, Urs Frick, Manolo Moreno
www.zappingmcsaatchi.com

Gama de infusiones medicinales de venta en farmacias. Qué mejor que HELPS para una gama de productos que ayudan a personas de cualquier edad y condición física. Debido a su carácter natural y a los más altos estándares de calidad utilizados en Pharmadus, la gama abarcaría desde adultos con problemas de salud (HELPS), adultos que desean la máxima calidad (HELPS INTENSE), hasta niños con problemas cotidianos (HELPS KIDS). De la misma manera se pensó en los niños, con el mismo caracter informativo, pero más lúdico en su aspecto, para no provocar rechazo. El enfoque varía ligeramente con la línea HELPS INTENSE, dado su posicionamiento premium.

Selection of medicinal herbal infusions sold in pharmacies. What better than HELPS for a range of products to help people whatever their age and whatever their state of health. Due to the natural ingredients and the excellent standards of quality at Pharmadus, the range covers everyone from adults with health problems (HELPS), adults seeking the utmost quality (HELPS INTENSE), to children with everyday problems (HELPS KIDS). Children have been thought of in the same informative way but with a more encouraging aspect to prevent any rejection. The HELPS INTENSE range is slightly different to the others, effectively top of the range.

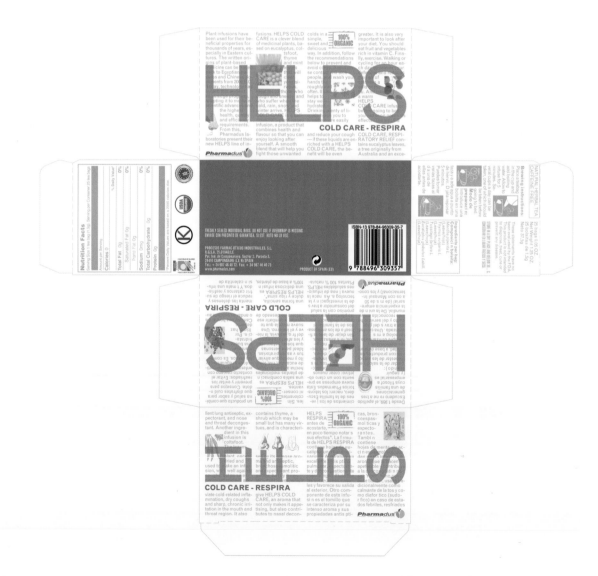

ANTIAGING - REJUVENECEDOR

FOR DIABETICS - PARA DIABÉTICOS

JUST FOR HER - SOLO PARA ELLAS

FOR EASY DIGESTION - DIGESTIVO

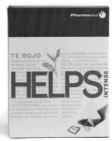

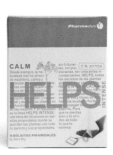

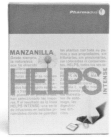

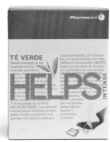

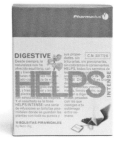

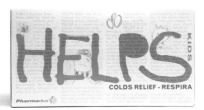

COLDS RELIEF - RESPIRA

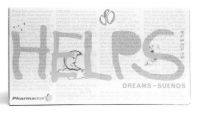

DREAMS - SUEÑOS

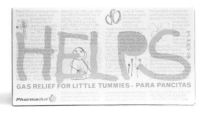

GAS RELIEF FOR LITTLE TUMMIES - PARA PANCITAS

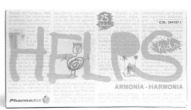

ARMONÍA - HARMONIA

Mel de Cal Milio

client ⌐ Cal Milio
studio ⌐ **Puigdemont Roca design agency**
Barcelona ⌐ Spain
designer ⌐ Albert Puigdemont
www.puigdemontroca.com

Para un producto natural de elaboración artesanal, nada
mejor que trabajar sobre la base de una asociación directa
entre la imagen del producto y la de su origen, en este caso
las abejas.

For a natural traditionally made product, in this case
honey, what better than to work on the basis of a direct
link between the appearance of the product and that if
its source, in this case, bees.

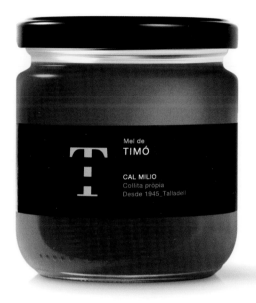

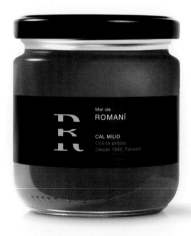

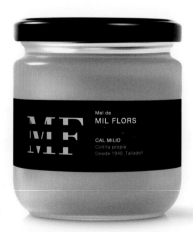

Peace Cereal

client ⌐ Peace Cereal
studio ⌐ Hatch Design
San Francisco, Ca. ⌐ USA
art director ⌐ Katie Jain & Joel Templin
designer ⌐ Katie Jain
illustrator ⌐ Si Scott
www.hatchsf.com

Peaceful packaging? In a nutshell that was the challenge when Golden Temple, the third largest private label granola maker, came to us with their Peace cereal brand. They had reformulated the product with the addition of a whole new flavor lineup and were looking for a way to grab shelf attention. But how do you garner attention on crowded grocery shelves with dozens of screaming competitors. For one thing, you quit screaming. We created a peaceful, joyful, gift-like packaging campaign in a smaller format box. The svelte packages not only reduced their carbon footprint and shipping costs, but also allowed more Peace Cereal to be displayed on store shelves. The back of the box featured stories on the company's Peace Grant recipients. We were inspired by Golden Temple to make their simple granola a daily gift and inspiration.

¿Un packaging pacífico? En pocas palabras, esto es lo que nos pidió Golden Temple, el tercer fabricante privado más importante de muesli, para su marca Peace Cereal. Habían reformulado el producto, añadiéndole una nueva línea de sabores, y buscaban un modo de llamar la atención en la estantería. Pero, ¿Cómo podemos captar la atención en las atiborradas estanterías de los supermercados, con docenas de competidores gritando? Para empezar, dejando de gritar. Creamos una campaña de diseño de packaging pacífica, alegre, como si fuera un regalo, en una caja más pequeña. Las esbeltas cajas no solo reducían el impacto de carbono y los costes de transporte, sino que también permitían exponer más cajas de Peace Cereal en las estanterías de las tiendas. La parte posterior de las cajas muestra historias sobre los receptores del Peace Grant (Subvenciones a proyectos solidarios) de la empresa. Nos inspiramos en Golden Temple para hacer que su sencillo muesli se convirtiera en un regalo y una inspiración diarios.

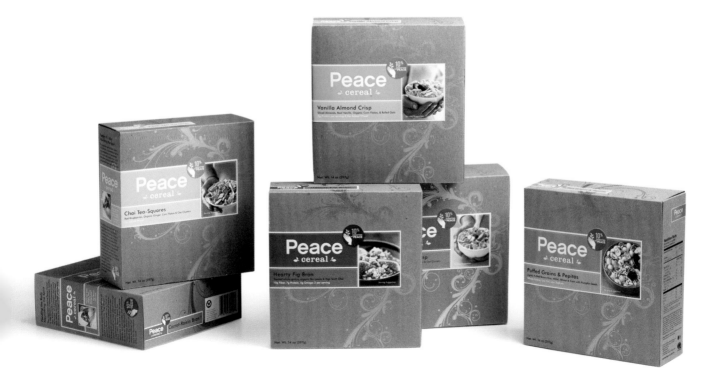

Holli Mølle

client ⌐ **Holli Mølle**
studio ⌐ **Strømme Throndsen Design**
Oslo ⌐ Norway
art director ⌐ Morten Throndsen
designer ⌐ Eia Grødal, Linda Gundersen
www.stdesign.no

Diseño de Packaging para Holli Mølle, que
produce harina orgánica a partir de tipos de
grano antiguos.
Holli Mølle es una fábrica de harina orgánica, que
utiliza tipos de grano antiguos y nutritivos en la
producción de su harina. Hemos creado una
fuerte identidad basada en valores como la
tradición, la producción orgánica, la ecología y la
autenticidad.
El empaque destaca en las estanterías y es
funcional, flexible y eficiente en la producción, con
etiquetas de distinto color como único elemento
diferenciador entre las 5 variedades.
El diseño se comunica bien con el público
objetivo: las mujeres dispuestas a pagar más por
la seguridad y el sabor de la harina orgánica.
El diseño ayuda a dar la sensación de que la harina
está realmente "molida con amor", tal como se
indica en el mensaje personal del propietario,
Trygve Nesje.

Packaging design for Holli Mølle, producing
organic flour made from ancient grain types.
Holli Mølle is an organic mill, using ancient and
nutritious grain types in its production of flour.
We have created a strong identity based on
values such as tradition, organic production,
environment friendly, and authenticity.
The packaging stands out in the shelves and is
both functional, flexible and efficient in
production, with different colored labels as the
only differentiator between the 5 varieties.
The design communicates well with the target
audience, women willing to pay extra for the
safety and taste of organic flour, giving them a
feeling that the flour really is "ground with love",
as stated in the personal message from the
owner, Trygve Nesje.

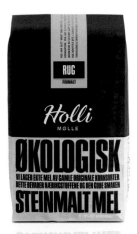
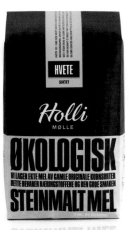
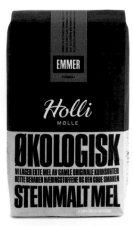
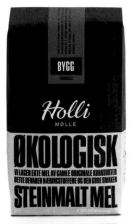
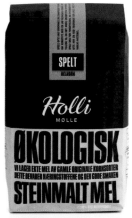

Sivaris

client ˥ NM Arrossos
studio ˥ **Pepe Gimeno Proyecto Gráfico**
Godella, Valencia ˥ Spain
designers ˥ Pepe Gimeno, Baptiste Pons
www.pepegimeno.com

Línea de Packaging para Sivaris. El proyecto tiene
dos claros objetivos: crear notoriedad y una fuerte
presencia del producto y hacerlo desde una gran
economía de medios. Para ello se ha adoptado una
gráfica que se apoya en la tipografía como único
elemento y en el color para distinguir las distintas
variedades de arroz. En la fabricación de estos pack
se han utilizado tubos y tapas existentes en el
mercado y la gráfica se ha aplicado con una
impresora láser sobre el papel kraft, posteriormente
pegado sobre el tubo.

A Packaging line for Sivaris. This project came
along with two clearly defined objectives: to create
product recognition and profile and to do so
making optimum use of the resources. To do this
an illustration has been adopted which relies on
typography as the only element with the
appropriate colour to distinguish the different
types of rice. Manufacturing these packs has been
done with the aid of tubes and tops currently
available on the market and the graphics have
been applied with a laser printer on kraft paper,
subsequently stuck onto the tube.

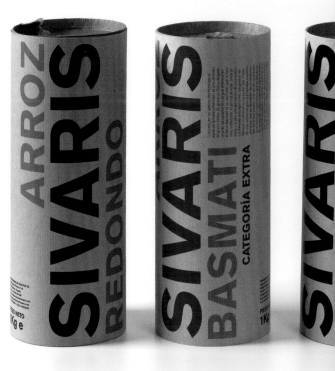

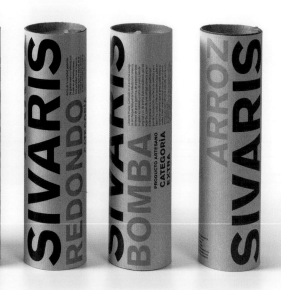

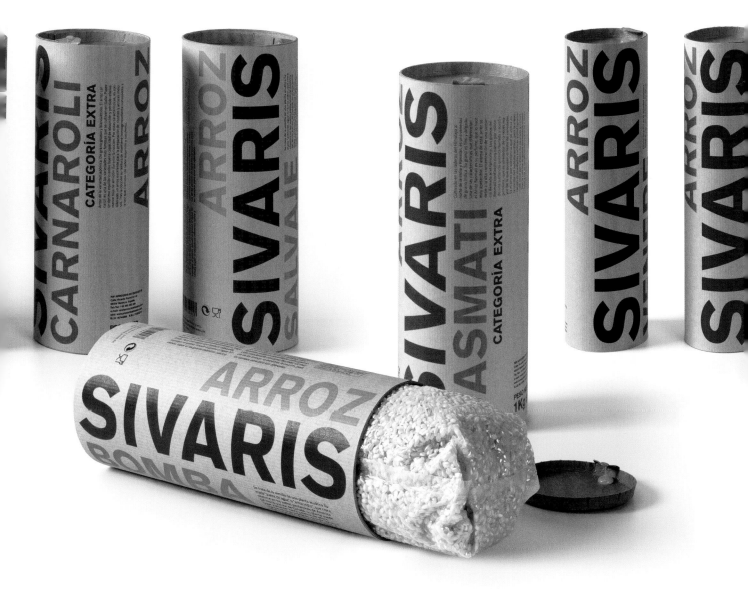

client ⌐ Milk coctail from Joe
studio ⌐ **Hattomonkey**
Novosibirsk ⌐ Russia
designer ⌐ Alexey Kurchin
www: hattomonkey.ru

Nuestra tarea consistía en crear un envase para el producto que fuera pegadizo y fácil de recordar. Hattomonkey ha creado un diseño de packaging para el batido de leche "From Joe". Se parece a un conocido héroe, ya que es fácil de recrear las orejas de Batman. Hattomonkey ha creado una nueva forma de envase. Tiene una apariencia familiar que conocemos desde la infancia.

The task was to create product package, which is catchy and easy to remember.
Hattomonkey has created a packaging design of milk cocktail "From Joe". It looks like well-known hero. It is easy to create Batman's ears.
Hattomonkey designers has created a brand new package form. It looks familiar and well-known since childhood.

Cowmilk - Crestmilk

client ㄱ **Milkcollection**
studio ㄱ **Hattomonkey**
Novosibirsk ㄱ Russia
designer ㄱ Alexey Kurchin
www: hattomonkey.ru

La gente está acostumbrada a ver bordados en tejidos, no en papel. Por este motivo, un envase con punto de cruz llama la atención. Como puedes ver, la construcción del envase reproduce unas orejas de vaca. Esto hace que el envase se distinga entre todos los otros.
Creamos un concepto de packaging simple y destacado, que introduce graciosamente el producto en la estantería.
..........
Hattomonkey design studio ha creado un nuevo concepto de envase para bebida láctea.
A los diseñadores se les pidió que inventaran un envase que resaltara la naturalidad para acercarse más al consumidor de productos lácteos. La idea nació de forma inesperada, queríamos estilizar el producto por medio del punto de cruz.

People used to mention embroidery on material not on paper. That's why such a cross stitch package attracts attention. As you may see the peculiarities of package construction let to create cow ears. That makes a new package become notable among others.
We made simple and highlighted package concept, which gratefully introduce your product on a shelf.
..........
Hattomonkey design studio has created a brand new dairy beverage product package concept.
So the task which has been set before designers is to invent a package, which is to underline naturality, thereby to get closer to the consumer of diary products. The idea was born unexpectedly – to stylize package by a cross stitch.

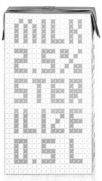
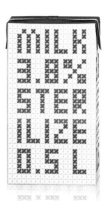

Pa Serra

client ┐ **Pa Serra**
studio ┐ **Batllegroup**
Barcelona ┐ **Spain**
art director ┐ **Enric Batlle**
photographer ┐ **Alexis Taulé**
www.batllegroup.com

Pa Serra es un ejercicio de modernidad y sencillez
en el diseño, con el objetivo de comunicar tradición
y el "buen hacer" de los auténticos horneros.
Un pack tipográfico que mediante códigos cromáticos
diferencia las variedades de producto en el punto de
venta. Las variedades existentes són las siguientes:
Auténtico Pan Artesanal: KORNACKER, FIT BERRY y
PA D'ESPELTA .

Pa Serra is an exercise involving a modern look
with simplicity in the design, the objective being
to communicate tradition and the "good working
practices" of authentic bakers.
A printed colour coded pack is used to distinguish
the different products at the point of sale.
The following products currently available: Real
Traditionally Baked Bread: KORNACKER, FIT BERRY
and PA D'ESPELTA.

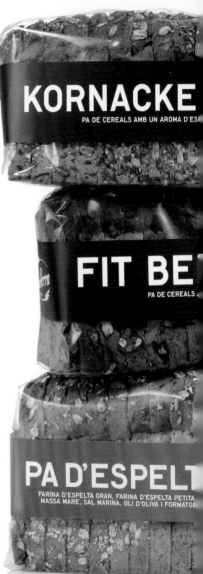

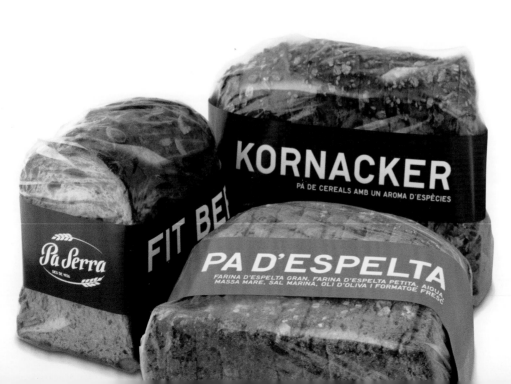

client ˥ **Waitrose Ltd**
studio ˥ Lewis Moberly
London ˥ United Kingdom
designer ˥ Mary Lewis
www.lewismoberly.com

Teníamos que crear la identidad para una gama de mostazas esencial para la despensa, pero que también tenía que ser elegante en la mesa.
Cada una de las etiquetas presenta un sencillo troquelado centrado en el producto. Cada uno de ellos muestra su color y textura.

To create the identity for a range of mustards which are larder essentials, but also have to be table setting smart. Each label features a simple die cut focusing the product. Each shows off its own colour and texture.

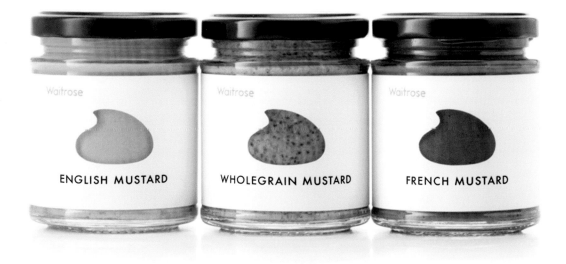

Frozen Herbs · Uncle-Statis

client ˥ Vivartia SA. Frozen food division
studio ˥ **Mouse Graphics**
Athens ˥ **Greece**
creative director ˥ **Gregory Tsaknakis**
art director ˥ **Gregory Tsaknakis**
illustrator ˥ **Ioanna Papaioannou**
photographer ˥ **George Drakopoulos**
food styling ˥ **Tina Webb**
www.mousegraphics.gr

Sinceridad, honestidad, franqueza. Estos son los
principales valores del producto que se comunican
de forma clara y directa en el envase. Acercarse al
cliente con honestidad a través de un diseño directo
para un producto funcional.

Sincerety, honesty, directness. These are the main
product values clearly and directly communicated
on pack. Approaching the customer in honesty
through a simply straightforward design for a
simply functional product.

Mez Pastilles

client ‚ Lavdas
studio ‚ Mouse Graphics
Athens ‚ Greece
creative director ‚ Gregory Tsaknakis
art director ‚ Gina Zafiraki
www.mousegraphics.gr

Había que redefinir la imagen y la proposición de una marca griega tradicional de caramelos blandos, que originalmente se llamaba Kiss or Date. El producto atrae tanto a generaciones pasadas como futuras con el replanteamiento de su tradicionalidad. El paquete evoca una sensación de nostalgia; los espectadores se ven atraídos hacia él por medio de la composición retrorromántica, y subliminalmente son conscientes del pasado de la marca.

Redefining the image and proposition of a very traditional Greek soft candy, originally named Kiss or Date. The product captures both past and future generations with its revisited traditionality. The pack evokes a feel of nostalgia; viewers are drown to it through a retro romantic set-up, almost subliminally aware of the brand's past.

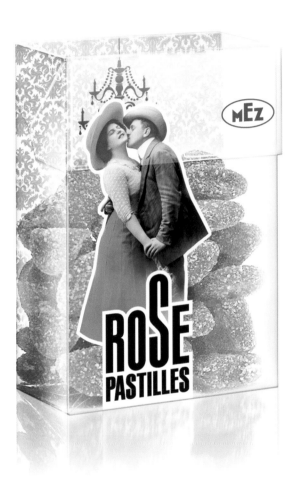

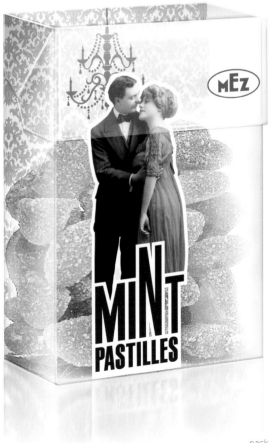

Lakeland freezer accessories

client ⌐ **Lakeland**
studio ⌐ **Davies Leslie-Smith**
Buckinghamshire ⌐ UK
designer ⌐ **Steve Davies**
art director ⌐ **Tim Leslie-Smith**
photography ⌐ The Original Packshot Co.
Illustration ⌐ Peter Ruane
www.daviesleslie-smith.co.uk

Debíamos crear el diseño para una gama de
productos para el almacenaje de comida que debía
explicar claramente el producto y su uso, pero sin
dejar de ser atractivo. El diseño versátil se aplicó a
35 productos y a una gama de distintos formatos de
envase.

A design for a range of food storage products that
needed to clearly explain the product and its
usage but still retain a foodie appeal. The versatile
design was taken across 35 products and a range
of different pack formats.

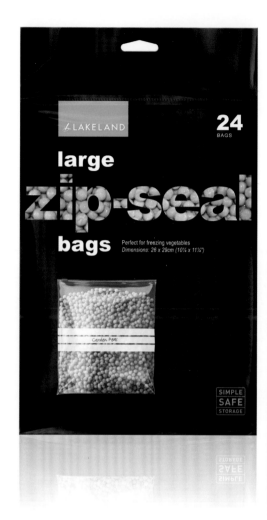

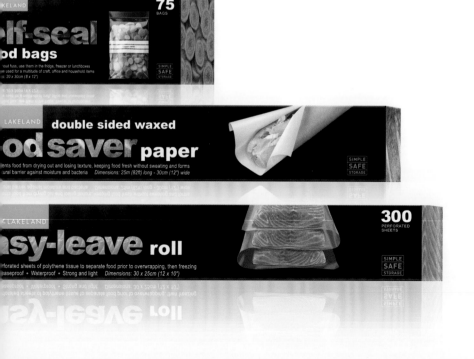

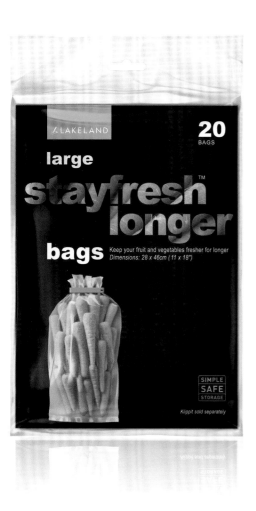

LAKELAND

20 BAGS

large

stayfresh™ longer

bags

Keep your fruit and vegetables fresher for longer
Dimensions: 28 x 46cm (11 x 18")

SIMPLE SAFE STORAGE

Klippit sold separately

20 BAGS

uce

Microwave, fridge and freezer safe
Easy to fill, perfect for storing
home-made soups and sauces
Dimensions: 22.5 x 23cm (8¾ x 9")

SIMPLE SAFE STORAGE

LAKELAND

50 SACHETS + 24 CUBES

ice cube bags

Easy release
Can also be used for freezing fruit juices

SIMPLE SAFE STORAGE

LAKELAND

20 BAGS

small

stayfresh™ longer

bags

Keep your fruit and vegetables fresher for longer
Dimensions: 20 x 23cm (8 x 9")

SIMPLE SAFE STORAGE

Klippit sold separately

LAKELAND

20 BAGS

medium

stayfresh™ longer

bags

Keep your fruit and vegetables fresher for longer
Dimensions: 25 x 36cm (10 x 18")

SIMPLE SAFE STORAGE

Klippit sold separately

LAKELAND

20 BAGS

large

stayfresh™ longer

bags

Keep your fruit and vegetables fresher for longer
Dimensions: 28 x 46cm (11 x 18")

SIMPLE SAFE STORAGE

Klippit sold separately

Kookie Karma

client ⌐ Juli Novotny / Kookie Karma
studio ⌐ Kelley Lilien Design
San Diego ⌐ California
designer ⌐ Kelley Lilien
packaging images ⌐ www.dajuse.com
www.kelleylilien.com

Diseño del logotipo y el envase para una empresa de alimentos gourmet que se especializa en galletas orgánicas sin refinar que además de ser nutritivas y deliciosas son puras y limpias. Cada uno de los sabores sale juguetonamente por debajo de la flor del logotipo describiendo sus ingredientes. Los envoltorios totalmente blancos y el fuerte uso del color ayudan a que el producto destaque entre la gran cantidad de productos de las estanterías de las tiendas de comida sana.

Logo and package design for a gourmet company specializing in raw, organic cookies that are not only nutritious and delicious but pure and clean too. Each flavor playfully pokes out beneath the signature flower logo portraying it's contents. The all white wrappers and bold use of color were to aide in the product's ability to stand out amongst the sea of products on an otherwise boring health food store shelf.

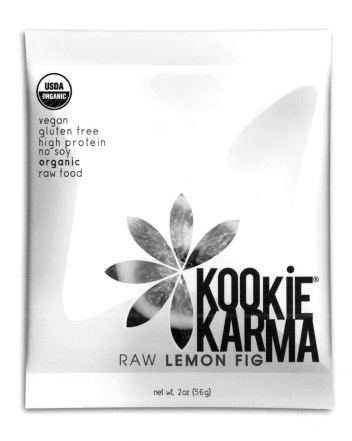

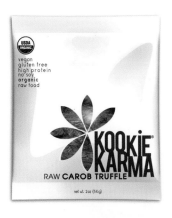
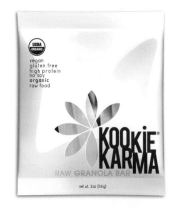
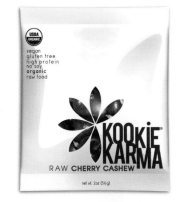
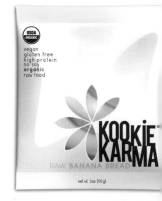

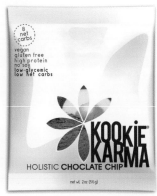
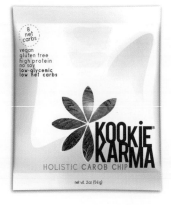
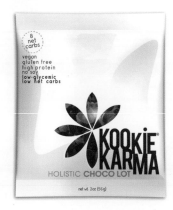

ISST. Organic Tea

client ¬ ISST
studio ¬ Artentiko
Poznan ¬ Poland
designer ¬ Marcin Kaczmarek
www.artentiko.com

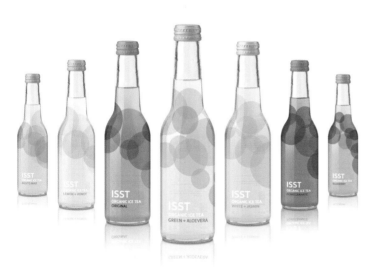

Crear una solución de branding integral (que incluía el nombre de la marca, arquitectura de la marca, identidad visual, packaging, campaña publicitaria para varios países, página web) para una nueva bebida orgánica en 7 sorprendentes sabores. Construir una marca fresca y minimalista que pueda convertirse en un elemento de "estilo de vida". La imagen de la marca debe corresponderse con el carácter orgánico del té y los originales sabores. Los sabores deben distinguirse fácilmente, pero también tienen que ser homogéneos y representar el mismo estilo de diseño. Un diseño fresco, vigorizante y limpio. La forma orgánica más simple conocida (círculo) es el principal elemento de identidad visual.
La forma de la botella es intemporal y neutra.
Los colores utilizados para comunicar los distintos sabores son característicos, ligeros, transparentes y no muy intensos.
El nombre de la marca es corto y sencillo, y se basa en la siguiente idea:
ICE TEA >> ICE = I+S >> MORE ICE = I+S+S >> TEA = T
I + S + S + T = ISST

Create a complete branding solution (including brand name, brand architecture, visual identity, packaging, advertising campaign for various countries, website) for new organic drink in 7 surprising flavors. Build a fresh and minimalistic brand that could become a 'lifestyle' element.
Brand image should correspond with organic tea character and original flavors.
Flavors should be easily distinguished but should also strongly correspond with each other and represent the same design style.
Fresh, crisp and clean design. The simplest known organic shape (circle) as the main visual identity element.
Timeless and neutral bottle shape. Characteristic, light, transparent and not too vibrant colors which communicate different flavors.
Short and simple brand name based on the idea:
ICE TEA >> ICE = I+S >> MORE ICE = I+S+S >> TEA = T
I + S + S + T = ISST

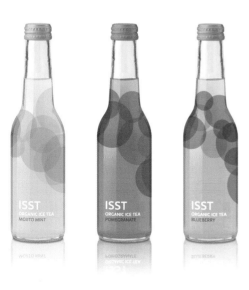

Sula

client ⌐ Susanne Lang Perfumerie
studio ⌐ Concrete Design Communications, Inc.
Toronto ⌐ Canada
art directors ⌐ Diti Katona, John Pylypczak
designers ⌐ Natalie Do, Agnes Wong,
Megan Hunt
www.concrete.ca

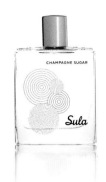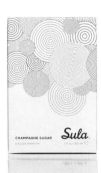

Sula es una nueva línea de perfume/cosmética de Susanne Lang Parfumerie. Sula se dirige a un público objetivo más joven que el de la marca senior de la empresa, y les permite a los clientes expresar su personalidad y estilo combinando juguetonamente distintas fragancias.
Concrete desarrolló la identidad de marca y el packaging para varias esencias y productos cosméticos. La línea se distribuye internacionalmente a través de los principales establecimientos.

Sula is a new perfume/cosmetics line from Susanne Lang Parfumerie. Targeted at a younger audience than the company's senior brand, Sula allows customers to express their personal character and style by playfully layering different fragrances. Concrete developed the brand identity and packaging for various scents and cosmetics products. The line is distributed internationally through leading retailers.

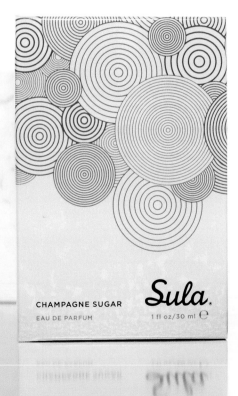

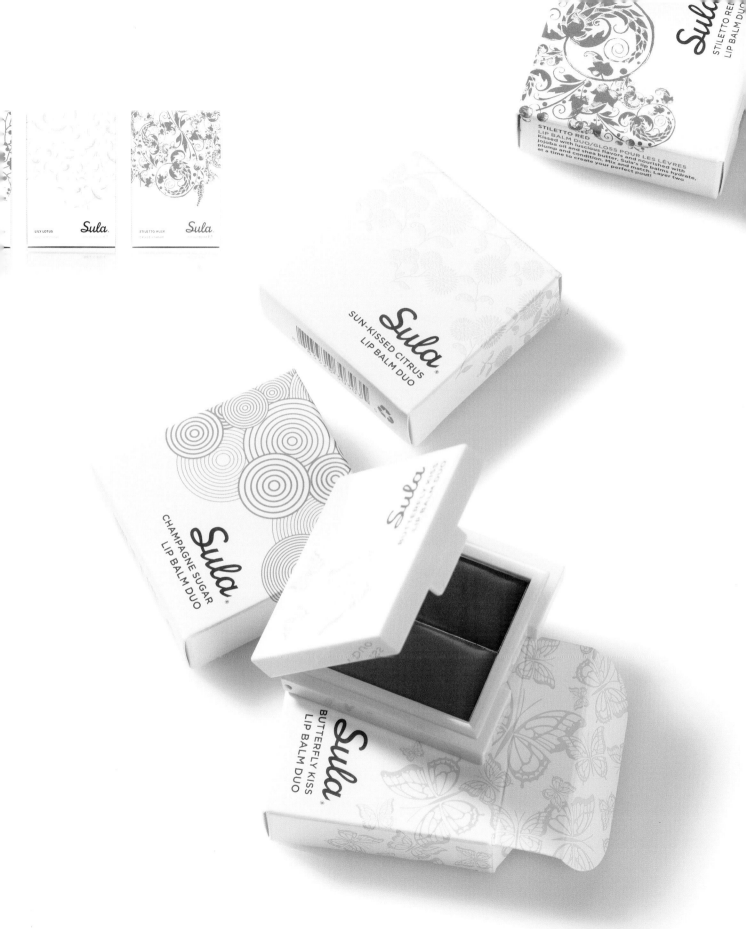

LILY LOTUS

Sula.

STILETTO MUSK

Sula

STILETTO RED
LIP BALM DUO

Sula

STILETTO RED
LIP BALM DUO/GLOSS POUR LES LÈVRES
Kissed with luscious flavors and nourished with
jojoba oil and shea butter, Sula's lip balms hydrate,
plump and condition. Mix and match! Layer two
at a time to create your perfect pout!

SUN-KISSED CITRUS
LIP BALM DUO

Sula®

CHAMPAGNE SUGAR
LIP BALM DUO

Sula®

BUTTERFLY KISS
LIP BALM DUO

Sula®

Evo

client ⌐ **Evo**
studio ⌐ **Mash**
Adelaide ⌐ **Australia**
designer ⌐ **James Brown, Dom Roberts**
Art Direction ⌐ **James Brown**
www.mashdesign.com.au

Evo es una marca de cuidado capilar que tiene su propia personalidad y cultura, en contraste con la mayoría de empresas del sector que tienen un enfoque muy parecido. Evo es atrevido, divertido y un poco retorcido.
La redacción de textos publicitarios de David Kalucy y Mash supo resumir la personalidad de la marca tan bien que decidimos utilizarla como base del packaging, manteniéndolo lo más simple posible y dejando que fuera el texto el que hablara.

Evo is a hair care brand that has its own unique personality and culture, in stark contrast to an industry filled with 'more of the same' type approaches. Evo is cheeky, humorous and slightly twisted.
The copywriting developed by David Kalucy and Mash seemed to sum up the brand personality so well that we decided to use this as the basis for the packaging, keeping it raw simple and letting the copy do all the talking.

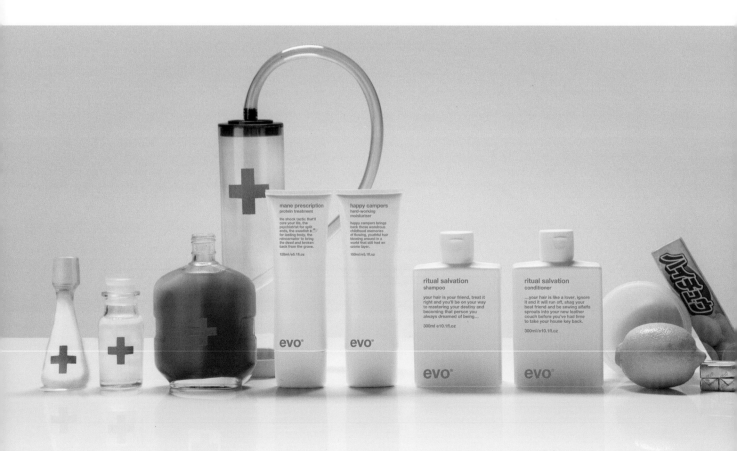

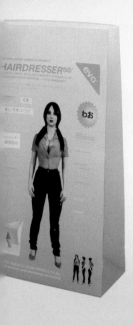

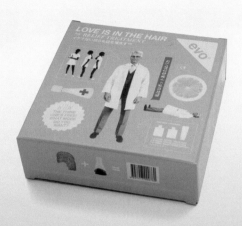

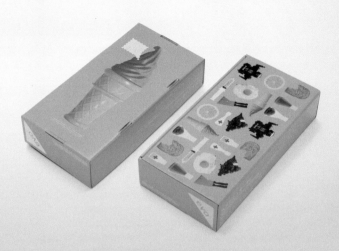

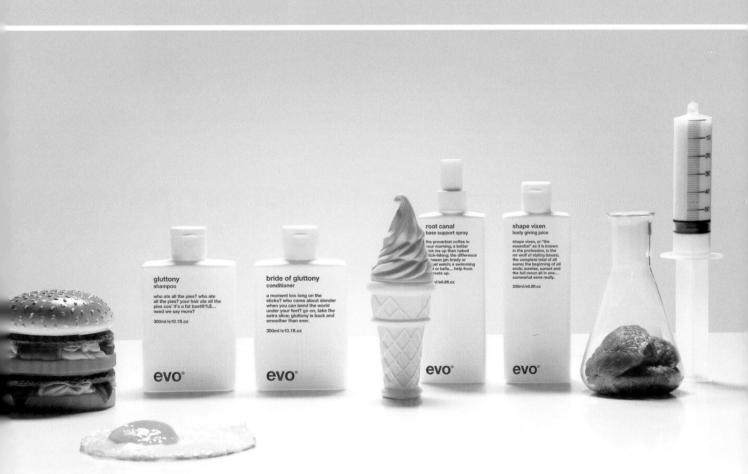

gluttony
shampoo

who ate all the pies? who ate
all the pies? your hair ate all the
pies cos' it's a fat bast@!%$...
need we say more?

300ml/e10.1fl.oz

bride of gluttony
conditioner

a moment too long on the
sticks? who cares about slender
when you can bend the world
under your feet? go on, take the
extra slice; gluttony is back and
smoother than ever.

300ml/e10.1fl.oz

root canal
base support spray

the proverbial coffee in
your morning; a better
kick me up than naked
hitch-hiking; the difference
tween jan brady or
uel welch; a swimming
l or bells... help from
roots up.

ml/e6.8fl.oz

shape vixen
body giving juice

shape vixen, or "the
essential" as it is known
in the profession, is the
mr wolf of styling issues;
the complete total of all
sums; the beginning of all
ends; sunrise, sunset and
the full moon all in one...
somewhat eerie really.

200ml/e6.8fl.oz

Ivancic & Sinovi

client ˥ **Ivancic & Sinovi**
studio ˥ **SVIDesign**
London ˥ **United Kingdom**
creative director ˥ **Sasha Vidakovic**
designers ˥ **Sasha Vidakovic, Ian Mizon**
illustration ˥ **Sasha Vidakovic, Ian Mizon, Sarah Bates**
www.svidesign.com

Diseño de packaging para la empresa farmacéutica que fabrica suplementos dietéticos y alimentarios de alta calidad.
El concepto de diseño hizo salir ideas como los valores familiares, las recetas tradicionales y la sensación de confort que conllevan. Los diseños inspirados en el bordado y el tipo de letra personalizado aportaron una apariencia distintiva/única a la familia de envases. Además de unas formas fuertes y reconocibles, se introdujeron unos colores intensos para realzar la personalidad de cada uno de los productos así como la línea de productos en general.
El resultado es un lenguaje de diseño fresco y energético.

Packaging design system for pharmaceutical company producing high quality diet and food supplements.
The design concept drew on notions of family values, traditional recipes and the sense of comfort they provide. Embroidery-inspired patterns and custom made type-face brought a distinctive/unique look and feel to the packaging family. Beyond these strong and recognizable forms, bright colours are also introduced to enhance the personality of each product as well as the product line in general. Fresh and energetic design language.

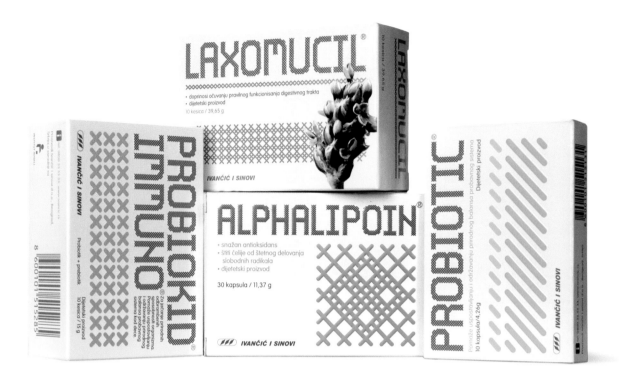

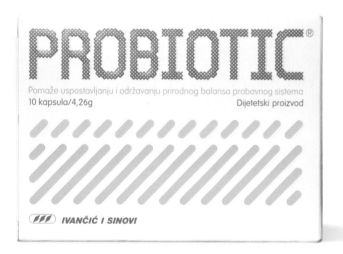

Perricone

client ˥ **Perricone MD**
studio ˥ **Concrete Design Communications, Inc.**
Toronto ˥ **Canada**
art directors ˥ **Diti Katona, John Pylypczak**
designer ˥ **Stéphane Monnet**
www.concrete.ca

Conocido como el dermatólogo gurú de las estrellas, el
Dr. Perricone y los productos Perricone MD han tenido
una gran cobertura mediática en programas como
Oprah, PBS y Larry King, y en publicaciones como Vanity
Fair, Vogue ay el New York Times. La gama de productos
incluye preparados tópicos antiinflamatorios para
invertir y prevenir los daños a la piel, así como
suplementos diseñados científicamente para promover
una piel más sana y más joven.
Tras un diseño de packaging que no tuvo éxito, y
resultó en una caída de las ventas y la pérdida de
identidad de marca, Perricone MD se dirigió a Concrete
para revitalizar la marca. Concrete desarrolló una
campaña integral que incluía la actualización de la
identidad visual, la creación de un nuevo diseño de
packaging, la revisión de la página web y el desarrollo
de la publicidad de la marca y de la publicidad táctica.
El enfoque del diseño era una interpretación moderna
de las boticas tradicionales: una tipografía elegante y
sobria, fotografía científica y vidrio ámbar esmerilado.
Otro componente clave era el retorno del Dr. Perricone
como la "cara" de la marca.

Known as the guru dermatologist to the stars,
Dr. Perricone and Perricone MD products have had
extensive media coverage on Oprah, PBS and Larry
King as well as in publications such as Vanity Fair,
Vogue and the New York Times. The range
of products includes topical anti-inflammatory
formulations to reverse and prevent damage to skin,
as well as dietary supplements that are scientifically
designed to promote healthy, youthful skin.
After an unsuccessful packaging redesign that
resulted in sagging sales and a loss of brand identity,
Perricone MD turned to Concrete to revitalize the
brand. Concrete developed a comprehensive
campaign that involved updating the visual identity,
creating new packaging design, overhauling the
website and developing both brand and tactical
advertising.
The design approach was a modern interpretation
of traditional apothecary – understated, elegant
typography, scientific photography and frosted
amber glass. Another key component was
returning Dr. Perricone as the "face" of the brand.

...ricone MD

...EUTICALS

...cone
... Antioxidant

...Supplement

...zed to provide superior
...ant protection.

...olets

...ricone MD

...ICEUTICALS

...ega 3

...y Supplement

...ts normal cardiovascular health.

...oftgels

Perricone MD

NUTRICEUTICALS

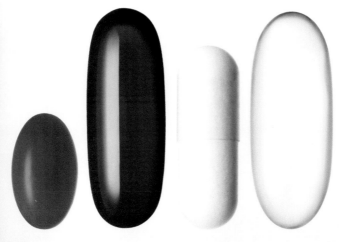

Health & Weight Management

Dietary Supplements

Promotes healthy weight maintenance.

Contains 90 packets. Each packet contains: 3 softgels, 4 capsules and 1 caplet.

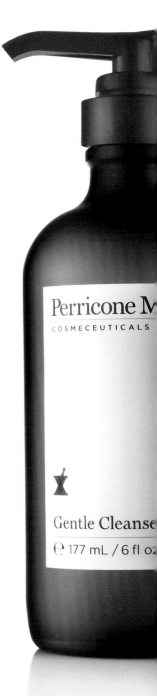

Perricone M...

COSMECEUTICALS

Gentle Cleanse...

e 177 mL / 6 fl o...

Perricone

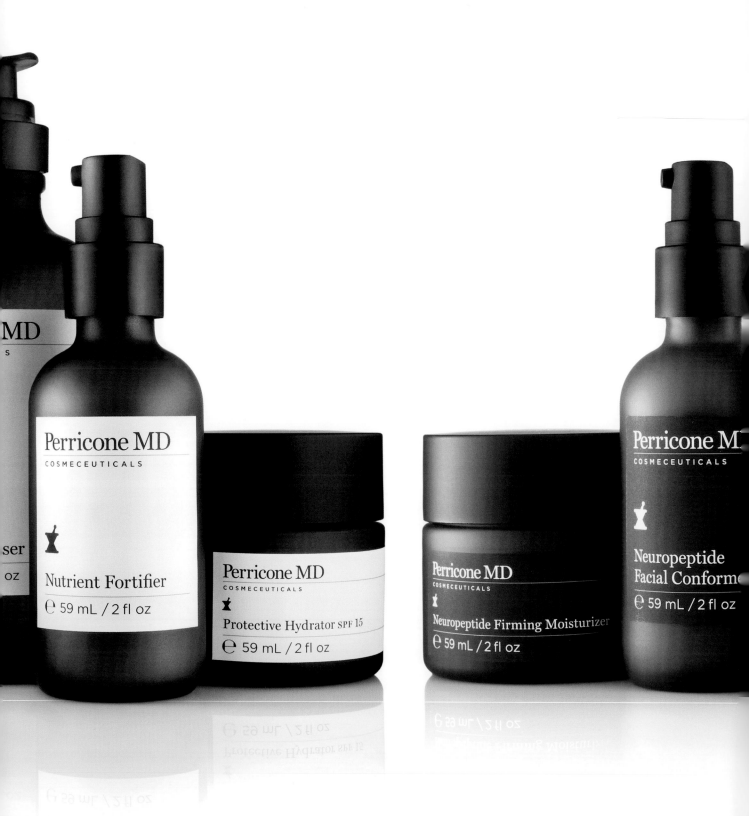

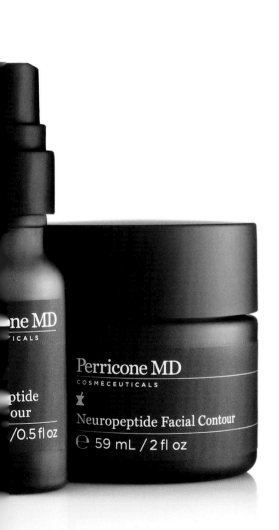

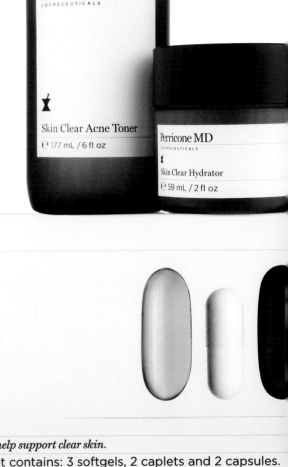

Perricone MD
COSMECEUTICALS

Skin Clear Acne Toner

℮ 177 mL / 6 fl oz

Perricone MD
COSMECEUTICALS

Skin Clear Hydrator

℮ 59 mL / 2 fl oz

Perricone MD
NUTRICEUTICALS

Skin Clear

Dietary Supplements

Works from the inside out to help support clear skin.
30 packets. Each packet contains: 3 softgels, 2 caplets and 2 capsules.

Perricone MD
COSMECEUTICALS

Neuropeptide Facial Contour

℮ 59 mL / 2 fl oz

ne MD
TICALS

ptide
our

/0.5 fl oz

Zinia

client ⌐ **Zinia**
studio ⌐ **Puigdemont Roca design agency**
Barcelona ⌐ Spain
designer ⌐ **Albert Puigdemont**
www.puigdemontroca.com

Gama de productos orientados a las terapias
naturales, cuya imagen necesitaba transmitir
sencillez y pureza, tanto en la línea como en el color
y la composición. Se consiguió creando una indiana
que simboliza un entramado de hojas sobre un
fondo blanco y nítido.

A range of products focussed on natural therapies
with simplicity and purity the impression which
needed to be put across equally in terms of the
range, the colour and the composition. This was
achieved by creating a decorative "Indiana" which
symbolizes a set of leaves on a clear white
background.

 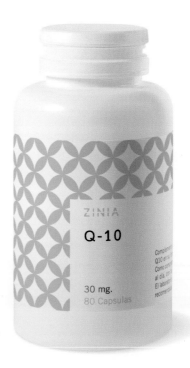

28°

client ⌐ **28°**
studio ⌐ **Puigdemont Roca design agency**
Barcelona ⌐ **Spain**
designer ⌐ **Albert Puigdemont**
www.puigdemontroca.com

28 °C es la temperatura de fusión en boca del chocolate.
De ahí se toma la denominación del producto, un chocolate
negro de gran calidad con diversas especias, distinguidas
mediante colores sobre un elegante fondo negro.

28 °C is the temperature chocolate melts in the mouth.
The product takes its name from just this, a high quality
dark chocolate with a variety of spices, illustrated by
different colours on an elegant black background.

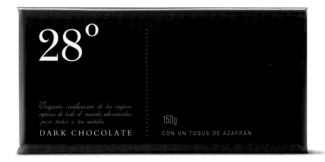

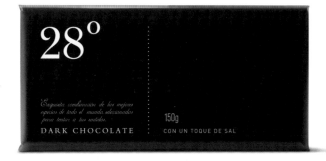

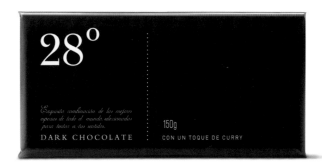

Tyten

studio ˥ Yvonne Niewerth
Düsseldorf ˥ Germany
designer ˥ Yvonne Niewerth
www.yvonneniewerth.de

La gente ya no compra lo que necesita, compra lo
que creen que refleja su imagen personal.
Los contenidos del carrito de la compra se convierten
en un espejo de la identidad.
Un paquete de pudding para cada tipo de pudding.

People no longer buy what they need, they buy
what they feel is a reflection of their self-image.
The contents of the shopping trolley become a
mirror of identity.
A pudding packet for every pudding type.

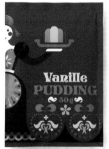

Callis

client ˥ Callís, Xocolaters i pastissers
studio ˥ Estudio Rosa Lázaro
Barcelona ˥ Spain
www.rlazaro.com

Identidad y sistema gráfico de presentación de
producto para una pastelería.
El objetivo de la gráfica era presentar el producto
con una cinta impresa puesta en la forma tradicional
en que se envuelve un regalo. A partir de aquí se
creó la identidad.
Para la presentación del producto, el sistema parte
de la pieza que tradicionalmente contiene el bombón,
revisada y actualizada en una forma cuadrada.
Esta pequeña pieza sirve para modular las cajas de
bombones, turrones y trufas, y a su vez es el punto
de partida para desarrollar las bandejas de pasteles,
repostería y autoservicio.

Identity and graphics presentation system for
patisserie products.
The objective of the graphics system was to
present the product with a printed ribbon
wrapped around in the same way as on a gift.
The identity stemmed from just this.
For the presentation of the product, the part of
the system which traditionally contains the
chocolate is modified and restructured in the
form of a square. This small part serves to
transform the boxes of chocolates, "turrons" and
truffles as well as being a starting point for
initiating the trays of cakes, confectionery and
self-service.

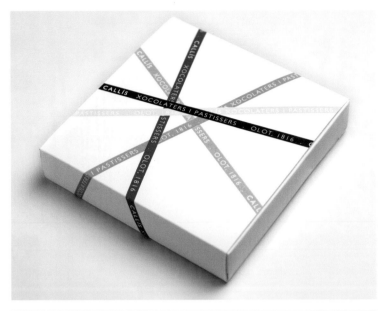

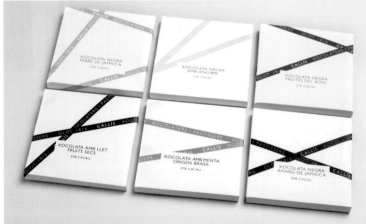

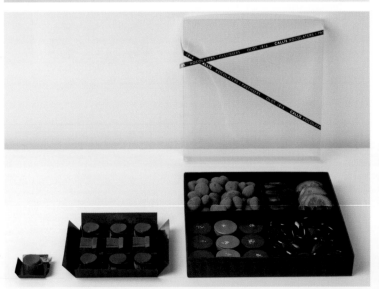

client ⌐ Chocolat Factoy
studio ⌐ Ruiz+Company
Barcelona ⌐ Spain
creative group ⌐ Ruiz+Company
art director ⌐ David Ruiz
designer ⌐ Ainoha Nagore
copy ⌐ Maria Ruiz
www.ruizcompany.com

Línea de packs diseñada para Chocolat Factory
distribuida en los aeropuertos de las principales
ciudades españolas. Con una caja-postal y una frase
homenaje a James Bond, los bombones de chocolate
se convierten en el mejor souvenir "made in Spain".

Set of Packs specially designed for Chocolat
Factory on sale in Spain's major city airports. With
a post box and a phrase in honour of James Bond,
the chocolates have become the best "made in
Spain" souvenir.

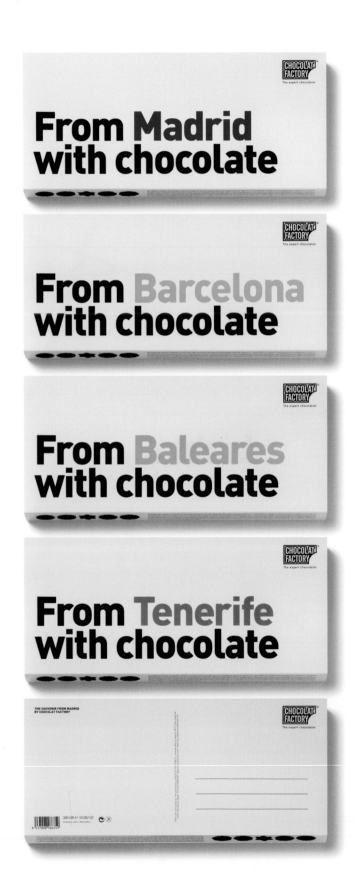

white
without
sugar

black
without
sugar

white

80%

milk
without
sugar

70%

grenade

with
caramel

java

with
moka

sao
thome

with
milk

Tabletas Chocolate

client ꓶ Chocolat Factoy
studio ꓶ Ruiz+Company
Barcelona ꓶ Spain
creative group ꓶ Ruiz+Company
art director / designer ꓶ David Ruiz
copy ꓶ Maria Ruiz
www.ruizcompany.com

Bajo el criterio gráfico de la identidad de la
marca, lujo austero, la nueva línea de tabletas
se ha creado a partir de un código de color
relacionado con el tipo de cacao de cada una,
y dando única y exclusivamente la información
escrita que es relevante, como el tipo de cacao o
su origen. Contundencia, diferenciación y
personalidad de marca.

In keeping with the graphics used to identify
the brand and the austere luxury, this new
selection of chocolate bars has been created
using a colour codes system relating to the
type of cocoa used for each one, providing
each one with the unique and exclusively
relevant written information such as the type
of cocoa and from where it originates.
Strength, distinction and identity of the brand.

Delishop + Delishop BlackLabel

client ⌐ **Delishop**
studio ⌐ **Enric Aguilera Asociados**
Barcelona ⌐ **Spain**
art director ⌐ **Enric Aguilera**
designers ⌐ **Gaizka Ruiz, Jordi Carles**
www.enricaguilera.com

Delishop, es una cadena de tiendas especializada en productos Gourmet de todo el mundo, de los cuales, hace una selección para comercializarlos con su propia marca. Con en el código de barras se diseñó un icono contundente y muy reconocido para poderlo utilizar también como imagen corporativa y como visual de toda la linea de pack. El proyecto de BlackLabel consistía en presentar una nueva línea de productos Premium continuista con el concepto inicial de la marca.

Delishop, is chaín of stores specialising in Gourmet products from all over the world of which a selection is made and marketed under the company's own brand name.
With the barcode a convincing and easily recognised icon has been designed which can also be used as a corporate and visual image for the entire collection of packs.
The BlackLabel project has been based upon introducing a new line in Premium products in keeping with the brand's initial concept.

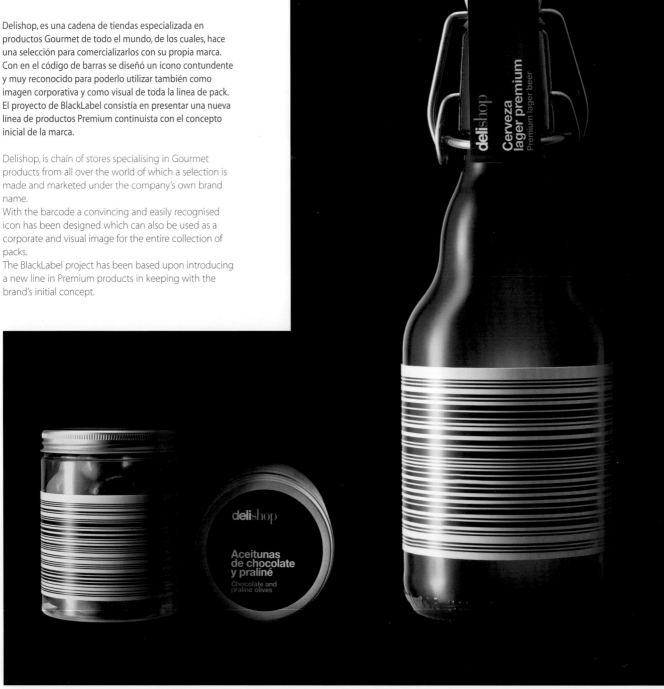

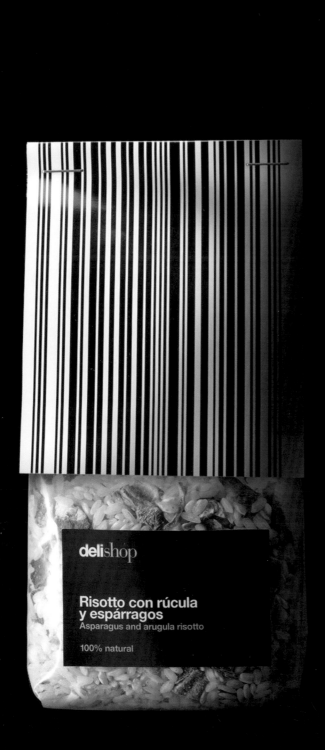

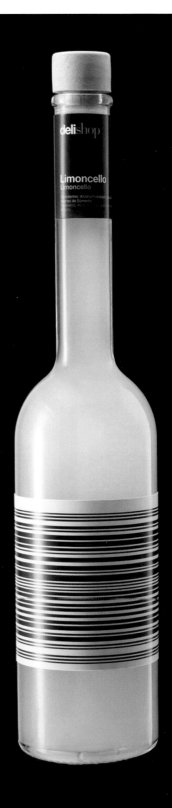

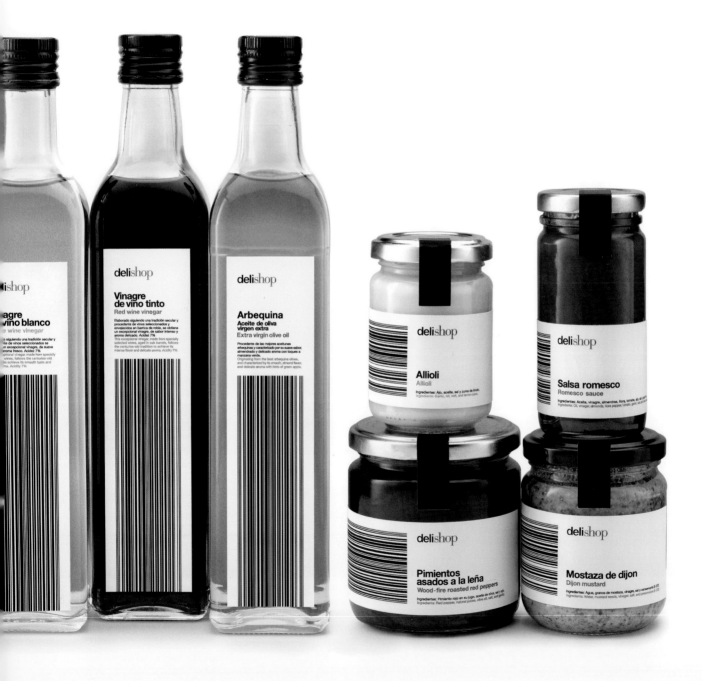

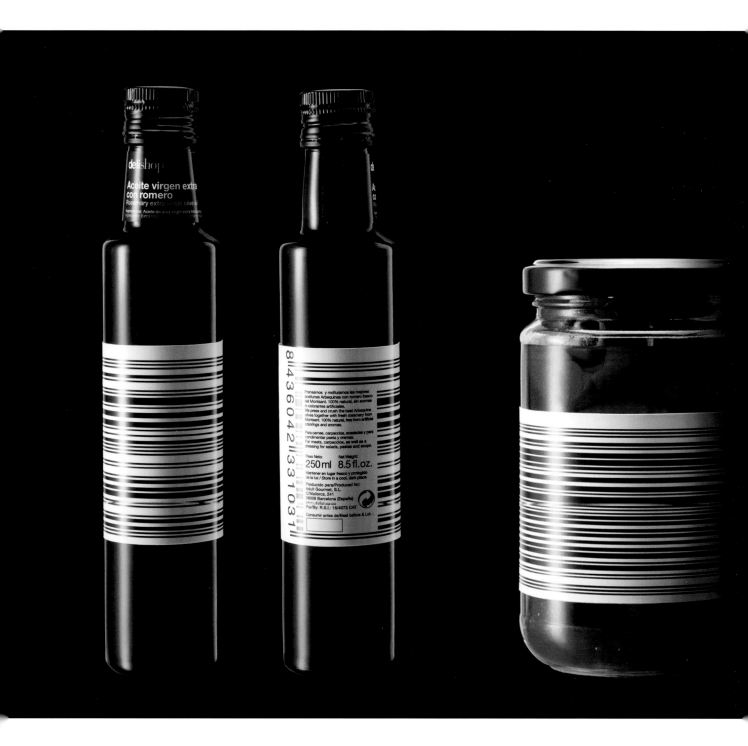

Kefalonia

client ˥ **Kefalonia fisheries**
studio ˥ **Mouse Graphics**
Athens ˥ **Greece**
creative director ˥ **Gregory Tsaknakis**
illustrator ˥ **Ioanna Papaioannou**
photographer ˥ **George Drakopoulos**
food styling ˥ **Tina Webb**
www.mousegraphics.gr

El embalaje revela la limpieza y el frescor del
producto. Un producto biológico que el cliente se
sentirá seguro comprando para la mesa familiar.
Las imágenes del limón y el perejil se utilizan como
elementos clave que sugieren pureza y simplicidad.
Para el logotipo (Kefalonia Fisheries), un adorno floral
dentro del emblema nos remite a la Kefalonia
tradicional; la famosa isla griega de donde proviene
el pescado.

The packaging reveals the cleanness and
freshness of the product. A bio product that
customers will feel safe to purchase for the family
table. The lemon and parsley visuals, are used as
key food elements suggesting pureness and
simplicity.
For the logo (Kefalonia Fisheries), a floral ornament
within the emblem refers us to traditional
Kefalonia; the famous Greek island where the fish
originates.

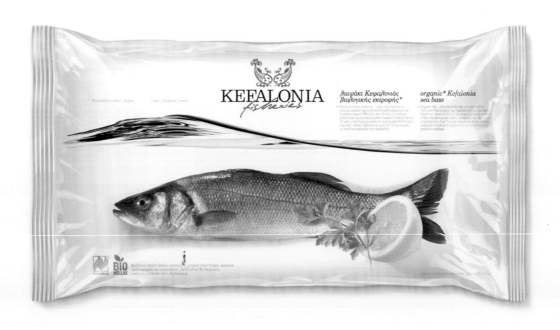

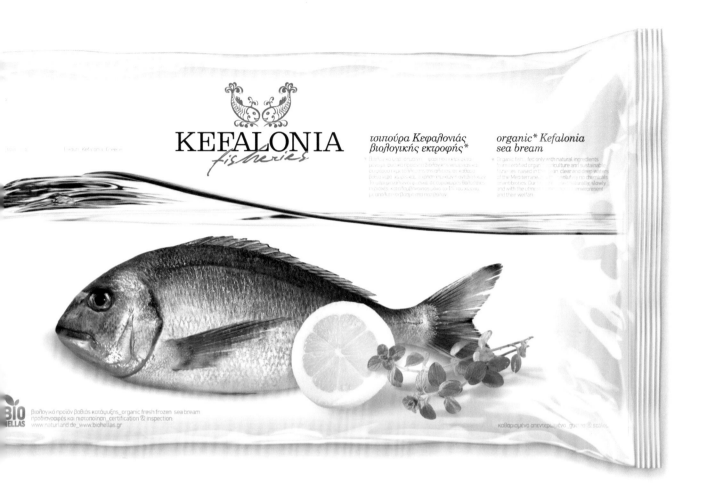

KEFALONIA
fisheries

τσιπούρα Κεφαλονιάς
βιολογικής εκτροφής*

Βιολογικά θρεμμένη τσιπούρα, γαλακτοκομικά προϊόντα, βιολογικής υγιεινής και θρέψης από φυτικές ουσίες και το καθαρό βαθύ νερό, χωρίς μηχανικά προϊόντα και χημικές ουσίες, στις απαλές συνθήκες ενός καθαρού περιβάλλοντος με απόλυτο σεβασμό στα ζωντανά του.

organic Kefalonia
sea bream*

Organic fish, fed only with natural ingredients from certified organic aquaculture and sustainable fisheries raised in the clean clear and deep waters of the Mediterranean, with absolutely no chemicals or antibiotics. Our fish grow naturally, slowly and with the utmost care for the environment and their welfare.

βιολογικό προϊόν βαθιάς κατάψυξης_organic fresh frozen sea bream
προδιαγραφές και πιστοποίηση_certification & inspection:
www.naturland.de_www.biohellas.gr

καθαρισμένο απεντερωμένο_gutted & scaled

Fresh Herbs

client ⌐ Waitrose Ltd
studio ⌐ Lewis Moberly
London ⌐ United Kingdom
designer ⌐ Mary Lewis
www.lewismoberly.com

Waitrose Herbs tiene mucho que decir. Cada una de las bolsas/macetas empaquetadas mínimamente presenta un texto periódistico en negrita explicándote todo lo que deberías saber sobre los contenidos. Las hierbas invitadas tienen una apariencia exclusiva y estacional con una salpicadura de rojo en el titular.

Waitrose Herbs have a lot to say for themselves. Each minimally packaged pot/ bag carries bold tabloid style text, telling you all you may not know, about the contents. Guest herbs make an exclusive and seasonal appearance with a splash of red in the headline.

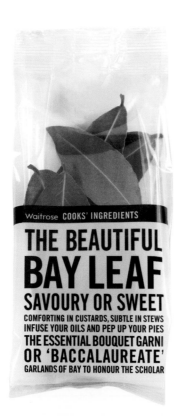
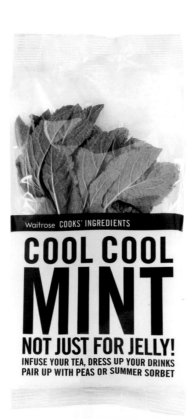
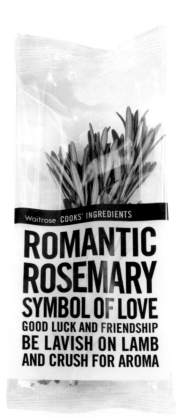

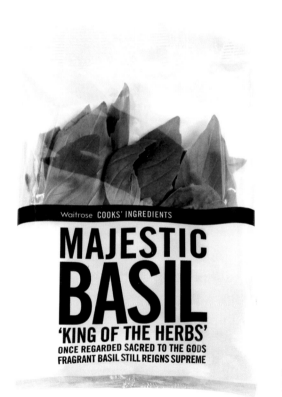

Waitrose COOKS' INGREDIENTS

MAJESTIC BASIL

'KING OF THE HERBS'

**ONCE REGARDED SACRED TO THE GODS
FRAGRANT BASIL STILL REIGNS SUPREME**

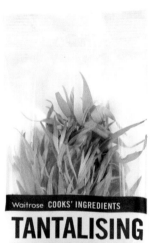

Waitrose COOKS' INGREDIENTS

TANTALISING TARRAGON
'FINE HERBS'

**FAVOURED IN FRANCE
FAMOUS FOR TARTARE
MUSTARD AND VINEGAR**

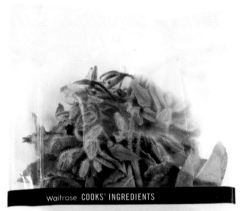

Waitrose COOKS' INGREDIENTS

BORAGE HERB OF THE WEEK

SOMETHING SEASONAL OR SIMPLY SPECIAL

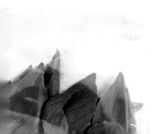

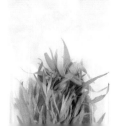

Wanted Snacks

client ⌐ Aroma Food
studio ⌐ Peter Gregson Studio
Novi Sad ⌐ Serbia
art director ⌐ Jovan Trkulja
design & illustration ⌐ Marijana Zaric
www.petergregson.com

Desarrollamos la identidad de concepto y la identidad visual del nuevo envase para frutos secos WANTED (pistachos, anacardos y cacahuetes). El objetivo de este proyecto era crear un envase atractivo y divertido para los productos más buscados (wanted). Cada uno de los productos presenta una orden de búsqueda y captura sobre un ingrediente. Por ejemplo, el anacardo es un indio. En serbio, anacardo se traduce como fruto seco indio, lo cual explica el turbante en el anacardo.

We developed concept and visual identity for new nut packaging called WANTED (pistachios, cashew nuts and peanuts). The aim of this project was to create an eye catching and funny package for the most desired (wanted) products. Each product has a warrant for a wanted person - ingredient on the front. For instance cashew nut is an Indian. In a Serbian cashew nut is translated as Indian nut, which explains the turban.

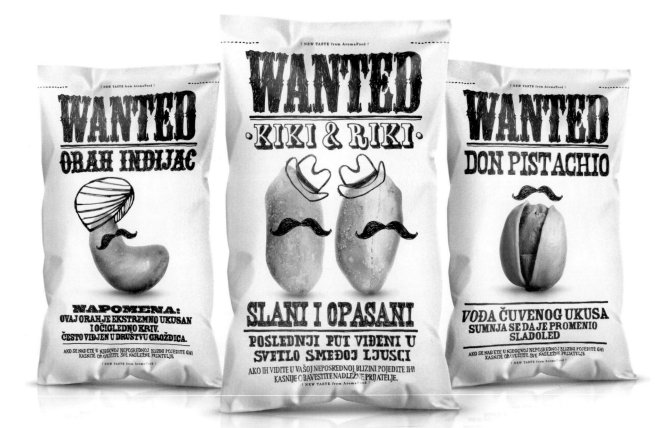

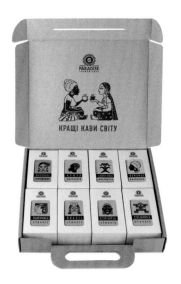

"World's best coffees"

client ⌐ Paradise. Gourmet-club
studio ⌐ Artel Artyomovyh graphic design bureau
Kyiv ⌐ Ukraine
designers ⌐ Katerina Voytko, Gera Artyomova,
Sergey Artyomov
art directors ⌐ Gera Artyomova, Sergey Artyomov
www.designartel.com.ua

La personificación de los tipos de café se ha realizado utilizando pegatinas individuales con imágenes gráficas estilizadas de culturas étnicas sobre la superficie de las briquetas.
La caja de regalo de "World's best coffees" representa la maleta de un viajero.

Coffee types personification has been realized using individual stickers with vivid stylized images of ethnic cultures attached to a briquettes surface.
"World's best coffees" gift set's package designed to symbolize traveller's suitcase.

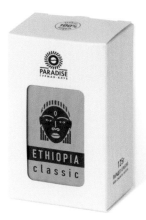

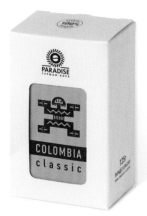

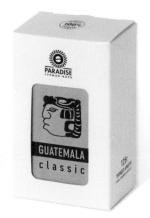

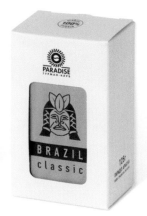

Utensilios - La Sirena

client ⌐ **La Sirena**
studio ⌐ **Marnich Associates**
Barcelona ⌐ Spain
designers ⌐ **Wladimir Marnich, Erola Boix. Marnich Associates**
www.marnich.com

Utensilios de cocina para las tiendas La Sirena. La Sirena es el
especialista en comida congelada del mercado español.
El cliente nos pidió que creáramos un nuevo diseño familiar con la
simplicidad y los colores de los paquetes A TU GUSTO, puesto que
comparten el mismo espacio en la estantería y son productos
"especiales" en la tienda.

Own brand kitchen utensils for La Sirena stores. La Sirena stores are
a frozen food specialist within the Spanish market.
The client's briefing was to create a new family design with similar
colours and simplicity to ATUGUSTO packs as they both share the
same shelf placement and are "special" products in the store.

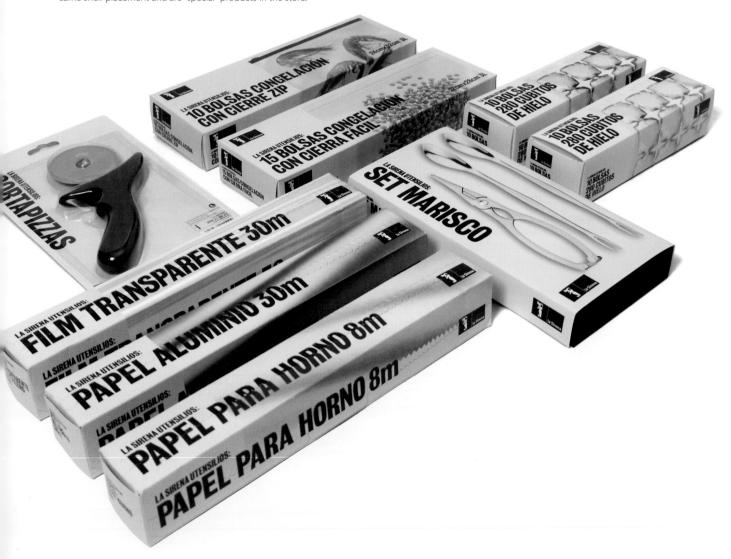

Quely 3

client ⌐ **Quely**
studio ⌐ **Enric Aguilera Asociados**
Barcelona ⌐ **Spain**
art director ⌐ **Enric Aguilera**
designers ⌐ **Gaizka Ruiz, Berta Rodón**
www.enricaguilera.com

Diseño de los envases para un nuevo lanzamiento de la marca Quely. Asocia al producto valores como exquisitez, originalidad y refinamiento.

··················

La premisa era crear un diseño para Quely3 que posicionase el producto como referente de calidad y creaciones.

Newly designed packs for the latest Quely products to be launched. These products are associated with values such as exquisite, original and refined.

··················

The established premise was to create a design for Quely3 which was to establish these as quality creative products.

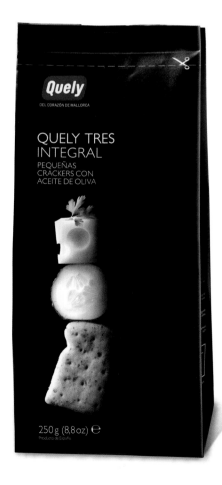

Tubenhonig (Honeytube)

client ˥ The Deli Garage
studio ˥ KOREFE / Kolle Rebbe From und Entwicklung
Hamburg ˥ Germany
creative director ˥ Katrin Oeding
art director ˥ Reginald Wagner
copywriter ˥ Katharina Trumbach, Madelen Gwosdz
graphic ˥ Jan Simmerl
illustrator ˥ Santa Gustina
www.korefe.de

"Tubo de miel" es una miel de acacia con sabor a limón, canela y chocolate. Puesto que la miel se parece al pegamento, se puso dentro de tubos en lugar de tarros y se ilustraron con pequeñas imágenes de fábricas.

"Honeytube" is a honey made from acacia and flavoured with lemon, cinnamon and chocolate. As honey being compared to glue it was filled in tubes instead of glasses and lovingly illustrated with little factory scenarios.

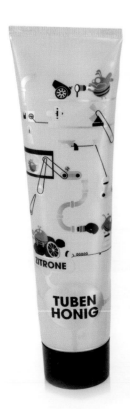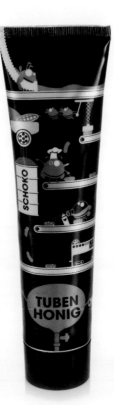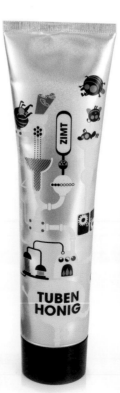

Ölwechsel (Oilchange)

client ⌐ The Deli Garage
studio ⌐ KOREFE / Kolle Rebbe From und Entwicklung
Hamburg ⌐ Germany
creative director ⌐ Katrin Oeding
art director ⌐ Reginald Wagner
copywriter ⌐ Katharina Trumbach
graphic ⌐ Jan Simmerl
illustrator ⌐ Reginald Wagner
www.korefe.de

"Cambio de aceite" es un aceite de oliva de primera calidad con sabor a chile, cilantro y limón. Para hacer referencia a los garajes, los aceites se pusieron en pequeñas botellas de aceite que permiten poner el aceite directamente en la comida. Las ilustraciones recuerdan a manchas de aceite y, cuando se miran a través de la botella, parece que sean monstruos saliendo de ella.

"Oilchange" is a premium olive oil flavoured with chilli, coriander and lemon. To match the garage character the oils were filled in little oil bottles from where one can squeeze the oil on the food. The illustrations remind of oil stains and have the effect, when looked at through the bottle, monsters emerge from it.

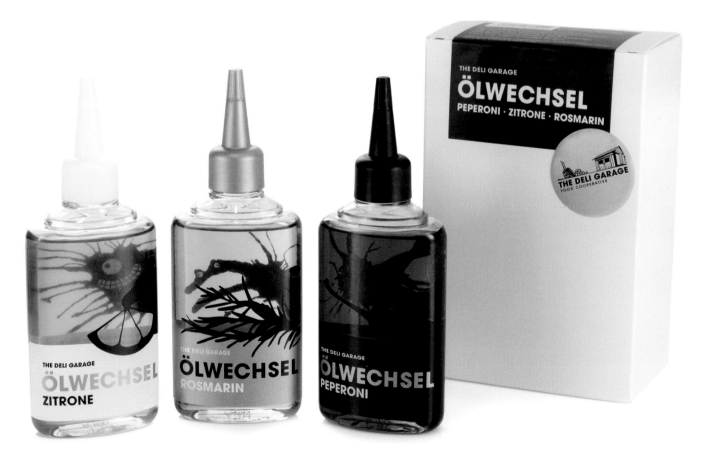

Private Label Juice

client ˥ AB Vassilopoulos
studio ˥ Mouse Graphics
Athens ˥ Greece
creative director ˥ Gregory Tsaknakis
art director ˥ Eya Bre
illustrator ˥ Ioanna Papaioannou
www.mousegraphics.gr

Esta línea de zumos frescos privada proporciona un enfoque de diseño bien cuidado que pretende darle una impresión muy realista al cliente. Una tipografía simple, el uso de colores primarios y la falta de efectos, permiten que el espectador perciba el frescor del producto y se dé cuenta de que es totalmente natural.

This private line of fresh juices provides a clean cut design approach that attempts to create a realistic impression to the buyer. Simple typography, use of primary colours, zero use of effects, so that the viewer can both relate to the product's freshness as well as realize that the juice is all-natural.

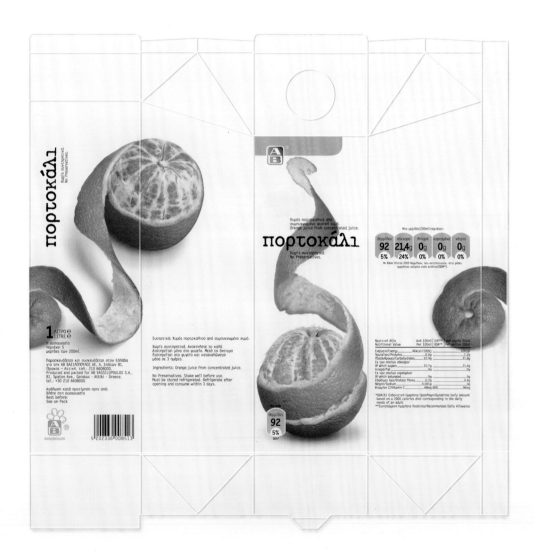

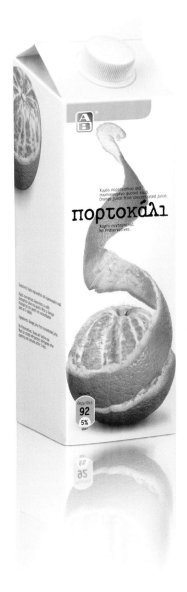

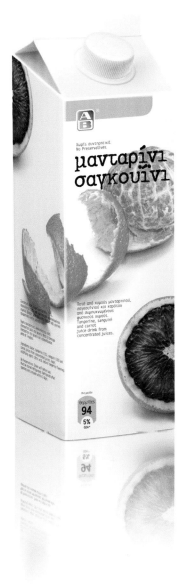

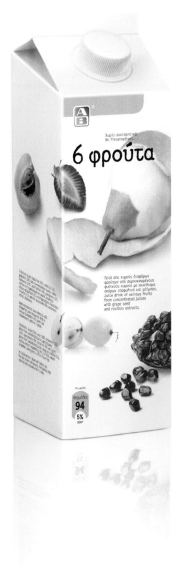

ELLA Milk Products

client ˥ Mlekara Subotica
studio ˥ **Peter Gregson Studio**
Novi Sad ˥ Serbia
art director ˥ Jovan Trkulja
designer ˥ Marijana Zaric
www.petergregson.com

Había que volver a diseñar el packaging de los productos lácteos "ELLA" bajos en grasas.
Creemos que el mercado está repleto de diseños de packaging equivocados, especialmente para productos lácteos bajos en grasa. Por este motivo quisimos diseñar algo totalmente distinto.
Escogimos un estilo derivativo con una tipografía fina con serif y colores simples.
Puesto que el producto es consumido principalmente por mujeres, el diseño presenta elementos que recuerdan a revistas femeninas e iconografía de la moda.
Con este envase nuevo y progresivo queremos satisfacer las expectativas de los consumidores y dar a conocer mejor la naturaleza de este producto.

Packaging redesign of old brand name "ELLA" Milk products with low milk fats.
We have a meaning that market is overloaded with wrong packaging design especially for low fat dairy products, and that is why we wanted to design something completely different.
We have chosen derivative style with fine, serif typography and simple colors.
Since the product is mostly consumed by women, the design has elements that remind of women magazines and fashion iconography.
With this new and progressive packaging we want to inflect the consumers expectations and make them more aware of the nature of this product.

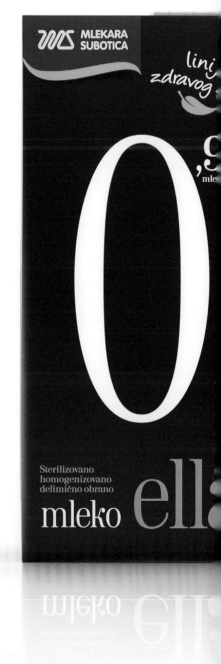

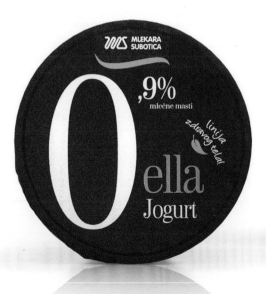

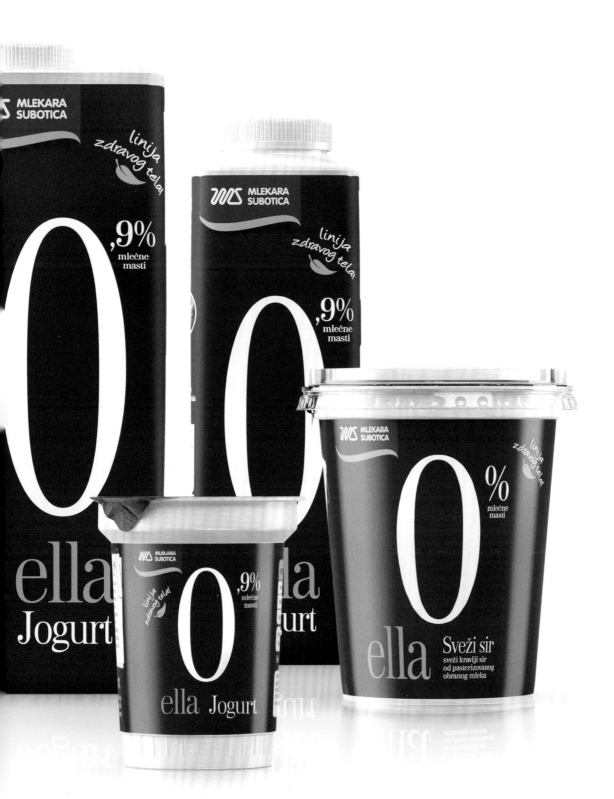

Packaging for swiss
chef Andreas Caminada

client ˥ Andreas Caminada & Globus Switzerland
studio ˥ Remo Caminada
Sagogn ˥ Switzerland
designer ˥ Remo Caminada
type and illustration ˥ Donat Caduff,
Michael Häne, Remo Caminada
photographer ˥ Thomas De Monaco
www.remocaminada.com

Andreas Caminada cocina en un castillo.
Los iconos y los textos de la parte posterior te invitan
al mundo especial de la comida gourmet en una
atmósfera especial. Los triángulos, los cuadrados,
las líneas, y a veces un pequeño círculo, son el
vocabulario de este diseño modular.

Andreas Caminada is cooking in a castle.
The icons and the texts on the backside invite you
to a special world of delicious food in a special
atmosphere. Triangle, square and line, also
sometimes a small circle: That is the vocabulary for
our modular sketching.

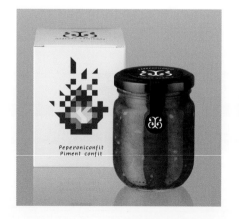

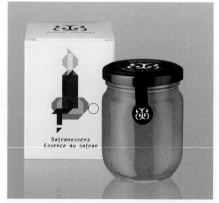

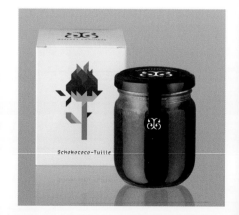

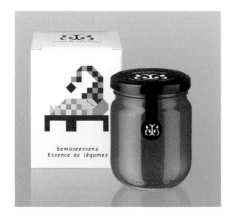

Gemüseessenz
Essence de légumes

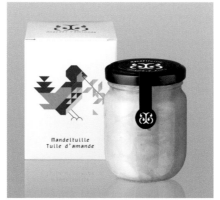

Mandeltuille
Tuile d'amande

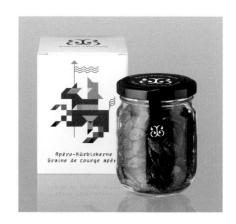

Apéro-Kürbiskerne
Graine de courge apé

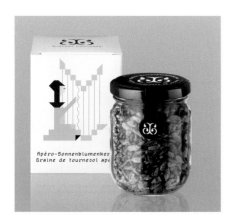

Apéro-Sonnenblumenker
Graine de tournesol ap

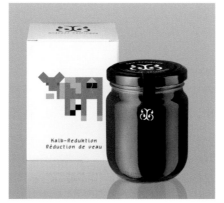

Kalb-Reduktion
Réduction de veau

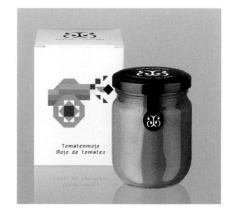

Tomatenmojo
Mojo de tomates

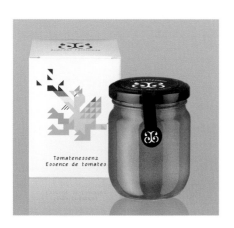

Tomatenessenz
Essence de tomates

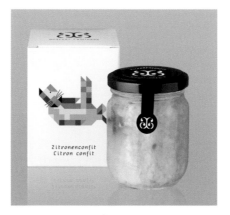

Zitronenconfit
Citron confit

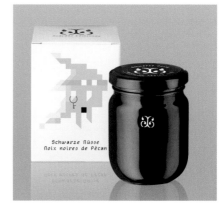

Schwarze Nüsse
Noix noires de Pécan

Smoothies Swell

client ┐ **Envasados Eva**
studio ┐ **Ruiz+Company**
Barcelona ┐ **Spain**
creative group ┐ **Ainhoa Nagore · David Ruiz**
art director ┐ **Ainhoa Nagore**
photography ┐ **Joan Miquel Horrillo**
copy ┐ **Maria Ruiz**
www.ruizcompany.com

Swell es una marca de bebidas naturales con una amplia gama de productos en el mercado. Los smoothies de Swell deben mantener un equilibrio entre la "inocencia" característica de este tipo de bebida, y el carácter premium que caracteriza a la marca. Un naming descriptivo y una fórmula visual permiten hacer un pack que se distribuye en 60 países distintos y se mantiene fiel a los códigos de la marca.

Swell is a brand name for a wide range of natural drinks currently on the market. Swell Smoothies have to strike a balance between the "pure" aspect typical of this type of drink and the premium quality associated with the brand. A descriptive title and a visual formula have resulted in a suitable pack now distributed in 60 different countries which also remains loyal to the brand's principles.

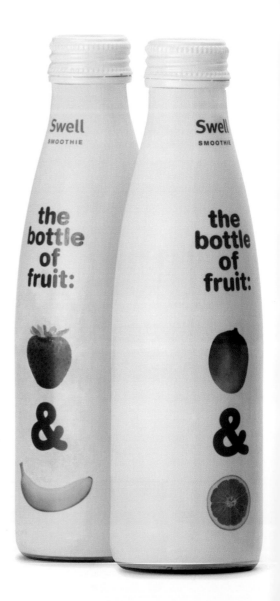

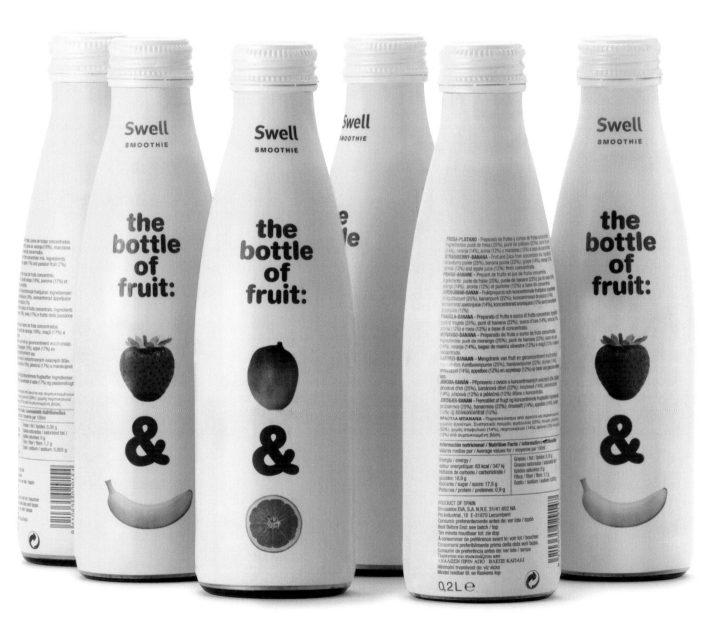

Supernatural hair care packaging

client ⌐ **USPA**
studio ⌐ **Container Ltd.**
Sydney ⌐ **Australia**
creative directors ⌐ **Brenan Liston,**
Jonnie Vigar, Todd Gill
designer ⌐ **Mark Evans**
www.containermade.com

Productos capilares Supernatural de USPA, una gama de champús, acondicionadores y tratamientos que utilizan solamente elementos puros y extractos de plantas naturales.
Una combinación entre sabiduría botánica y tecnología moderna global dessarrollada in situ por U skincare Australia. Para el lanzamiento de la gama de cuidados capilares Supernatural se han desarrollado botellas de 150 y 250ml y botellas de muestra de 30ml. El diseño del envase tenía que expresar la filosofía de USPA de utilizar ingredientes botánicos y emplear la tecnología más avanzada. El público de USPA está formado por consumidores modernos cultos que quieren un producto natural y efectivo.
El envase se diseñó para que fuera tan único como las fórmulas que contiene en el interior.
El diseño del envase de la gama "Supernatural" de USPA tenía que expresar su filosofía de combinar la antigua sabiduría botánica con la química más avanzada. El tapón de rosca que se extiende hacia arriba y sale de la botella representa la naturaleza y el crecimiento, mientras que su translucidez revela la tecnología del mecanismo que hay en el interior.

USPA Supernatural hair care products. A range of shampoos, conditioners and treatments. Using only pure elements and natural plant extracts.
A combination of age-old botanical wisdom and modern global technology developed in house by U skincare Australia. For worldwide launch of the Supernatural hair care range. 150, 250ml bottles and 30ml sample bottles. The package design needed to express the USPA philosophy of harnessing botanical ingredients and employing the latest technology. The USPA audience is knowledgeable modern consumers wanting natural yet effective product.
The package was designed to be as deliberately unique as the formulations contained within.
For USPA's "Supernatural" hair care range the package design needed to express their philosophy of combining age-old botanical wisdom with the latest chemistry. The twist-cap extending up and out of the bottles represents nature and growth while it's translucency reveals the technology of the mechanism within.

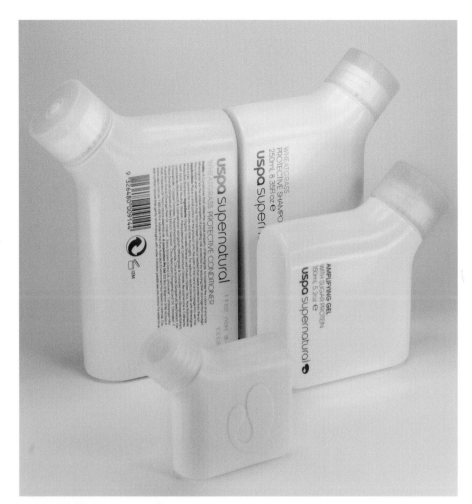

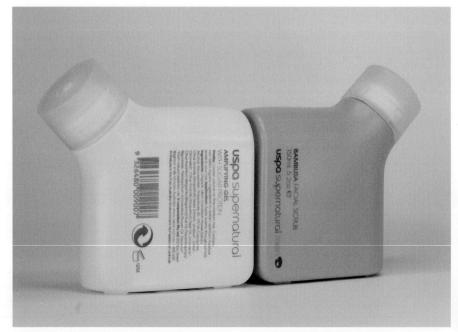

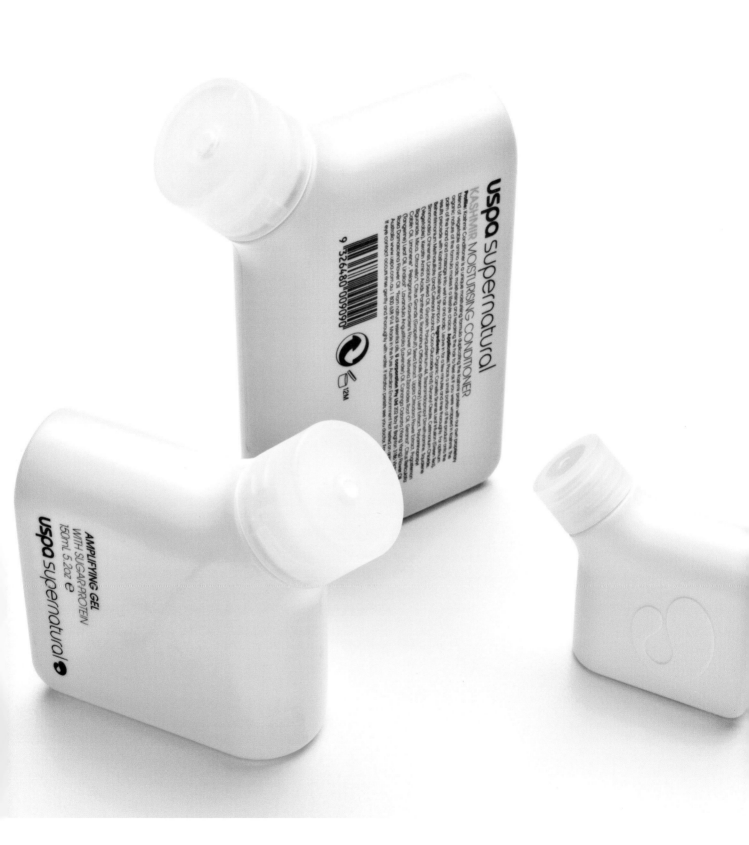

uspa supernatural

KASHMIR MOISTURISING CONDITIONER

9 326480 009090

AMPLIFYING GEL
WITH SUGAR PROTEIN
150ml 5.2oz e

uspa supernatural

Crema dental

client ˥ Dermocosmética Korott
studio ˥ Lavernia & Cienfuegos
Valencia ˥ Spain
www.lavernia.com

Uno de los objetivos del diseño era el de transmitir la idea de una
línea de higiene bucodental eficaz, cuidada, pensada para solucionar
problemas reales y, a la vez, que se diferenciase de las marcas más
importantes ofreciendo una imagen de calidad equiparable.
Se ha utilizado una solución tipográfica, que es muy funcional porque
se lee con facilidad y porque se define claramente la utilidad de
dentífrico, y en la que las superposiciones de letras y sus
transparencias aportan la riqueza formal necesaria para personalizar
la gama, connotar calidad de productos y evocar el esmero con que
han sido formulados y fabricados.

One of the objectives of this design was to put the idea across of
an efficient and thorough form of oral hygiene, designed with a
view to deal with real problems as well as to stand out from the
biggest names with a comparably high quality image.
A typographical solution has been used which is highly practical,
being easy to read and clearly explains the use of the toothpaste,
and in which the superimpositions of letters and their clarity add
the formal richness necessary to personalise the range, suggest
product quality and evoke of the great care with which they have
been formulated and made.

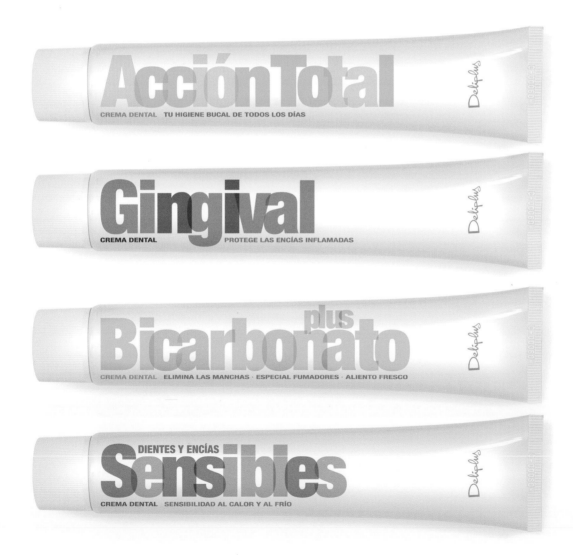

client ˥ **Mesoestetic**
studio ˥ **Espluga + Associates**
Barcelona ˥ Spain
www.espluga.net

Packaging para los productos de tratamiento de Photogen
System. Una máquina de cosméticos que combina
4 tecnologías para lograr la mayor penetración de los
ingredientes activos en las capas más profundas de la piel.
El embalaje refleja la mejora tecnológica que la máquina
representa: combinación de tecnologías, futuro y diversidad
de los tratamientos. Los colores de cada uno de los tipos de
tratamiento se identifican fácilmente por su tono e
intensidad con tipografía LED.

Packaging for the treatment products of the photogen
system. a cosmetics machine that combines 4 technologies
to achieve the major penetration of the active
ingredients in the deepest layers of the skin. The pack
reflects the technological improvement that this
machine represents: combination of technologies, future
and diversity of treatments. The colors of every type of
treatment are easily identified for their tone and
intensity.

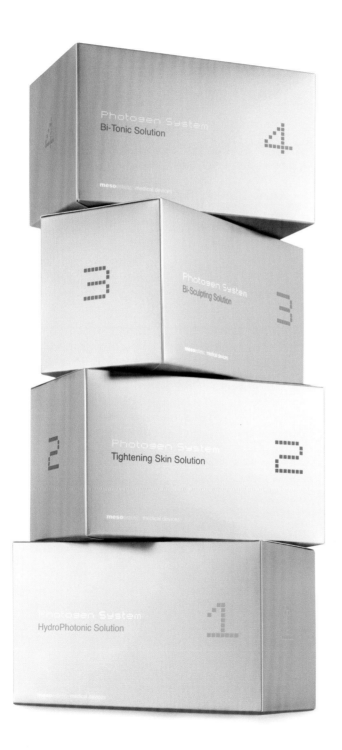

Monogotas

client ˥ RNB Cosméticos
studio ˥ **Pati Núñez Associats**
Barcelona ˥ **Spain**
designer ˥ **Pati Núñez**
www.patinunez.com

Colección de fragancias para adolescentes, basada
en aromas de frutas y postres.
El briefing de RNB Cosméticos, decía: "En esos años, el
perfume ideal es un aroma que combine la
seducción con la inocencia, como el olor de la fruta
preferida, el postre exquisito o el de la ropa limpia,
olores dulzones que evocan aún la niñez".
Tomamos las palabras "inocencia y seducción" como
conceptos clave para el desarrollo del proyecto.
Se escogió una botella de cristal estandard que
recuerda los clásicos frascos de farmacia, una forma
fácilmente identificable y no sofisticada que encaja
con el lenguaje adolescente.
Las etiquetas están impresas sobre material adhesivo
transparente. El fondo blanco mate reproduce en su
base una blonda (inocencia, postre, ropa limpia).
Las letras correspondientes al aroma son
transparentes, permitiendo la visión de la fragancia
coloreada. El logotipo "Monogotas" está impreso en
stamping "espejo" (seducción), a juego con el alto
tapón de aluminio brillante.
La tipografía también está compuesta con frescura
adolescente: una Helvética Black trocea las palabras
para elevar el tono de la locución, convirtiendo el
texto en una exclamación.

A collection of fragrances for teenagers with the
aromas based on fruits and desserts. The briefing
from RNB Cosméticos, stated: "These days, the
ideal perfume is a scent which combines seductive
charm with innocence, such as the smell of our
favourite fruit, that exquisite dessert or even the
smell of clean clothing, sweet scents reminiscent
of childhood".
The words "innocence and seduction" have been
taken as key concepts for the project's development.
A standard glass bottle has been selected, rather
like traditional pharmacy bottles, easily identified
and unsophisticated, in keeping with teenager's
language.
The labels are printed on transparent adhesive
material. The matt white background depicts a
blonde at the bottom (innocence, dessert, clean
clothing).
The text corresponding to the scent is transparent,
allowing the coloured fragrance to be seen.
The "Monogotas" logo is stamped onto the "mirror"
(seduction), matching the tall shiny aluminium
stopper.
The typography is also suitably teenager-friendly:
Black Helvetica cuts up the words to raise the
tone of the phrase, effectively converting the text
into an exclamation.

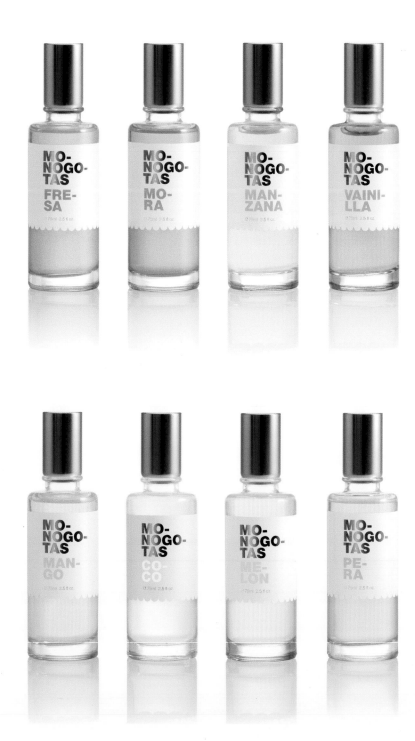

Premium

client ꓤ Laboratorios RNB
studio ꓤ Lavernia & Cienfuegos
Valencia ꓤ Spain
www.lavernia.com

Gráfica para línea de productos de tratamiento facial.
El uso de metalizados y cromados pone de manifiesto el
posicionamiento del producto: cosmética de lujo con
ingredientes de alta calidad a precios muy competitivos.

Graphic illustration for a range of facial treatment
products.
The use of metallic and chrome make the status of this
product quite clear: a luxury cosmetic with high quality
ingredients at highly competitive prices.

Fruits & Passion

client ⌐ Fruits & Passion
studio ⌐ Identica
Montréal ⌐ Canada
creative director ⌐ Barbara Jaques
art director / designer ⌐ Julie Brassard
illustration ⌐ Julie Brassard
production artist ⌐ Daniel Cartier
www.identica.com

Fruits & passion crea y fabrica una línea de cuidado personal y productos para el ambiente que destacan por su calidad y originalidad.
La marca F&P tiene un gran renombre en Canadá y ahora se está estableciendo por todo el mundo.
Diseñamos una nueva línea de productos afrutados para el cuidado personal en 3 fragancias, creando un mundo imaginario de evasión con un collage estético aromático.

Fruits & passion creates and manufactures a line of personal care and ambiance products that stand apart in quality and originality.
F&P brand is well established in Canada and is now branching out around the world.
We design a new line of fruity personal care decline in 3 fragrances by creating a imaginary world of evasion with a aromatic esthetic collage.

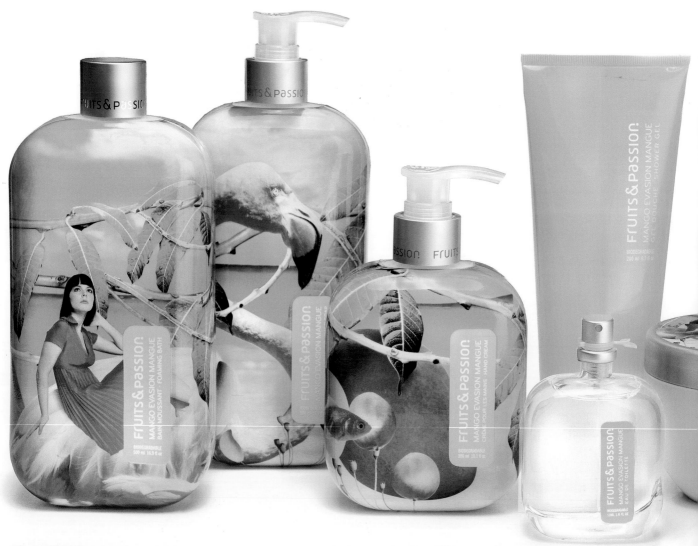